A NEVADA LIFE

Richard Guy Walton

A NEVADA LIFE

Richard Guy Walton

ANTHONY SHAFTON

AMERICA
THROUGH TIME®
ADDING COLOR TO AMERICAN HISTORY

America Through Time is an imprint of Fonthill Media LLC
www.through-time.com
office@through-time.com

Published by Arcadia Publishing by arrangement with Fonthill Media LLC
For all general information, please contact Arcadia Publishing:
Telephone: 843-853-2070
Fax: 843-853-0044
E-mail: sales@arcadiapublishing.com
For customer service and orders:
Toll-Free 1-888-313-2665
Visit us on the internet at www.arcadiapublishing.com

First published 2021

Copyright © Anthony Shafton 2021

ISBN 978-1-63499-309-8

Typeset in Constantia 9.5pt on 13pt
Printed and bound in England

I entered Reno and was never quite the same

My life seems to have begun in some strange way when I came in on a train, in the late Twenties, and looked out the window just above Verdi [VURR-dye], when I picked up the feel of this country. It was in winter, and I will go to my Pyramid book and see what I have on that.

Now this book may not amount to anything more than a sentimental tract by a greenhorn writer. But the principal character says, at one point when asked:

"When I was a boy and came here, not to this place but to this country, I'd not yet started smoking. Sometimes I'm afraid that I am still on a train, and didn't stop and get off for all the years. The water was cold and clear, and I was a valley lad and used to valley water, flat and deader than all the dead fish squeezed together in the boxes at the Chinese store. I was impressed. Overnight on the whistle-stop train, waking in the pine hills, opening my eyes and looking from the berth window. The trees, the trees, the trees. And the mountain feel, racing down the draw where the tracks run.

"So, I entered Reno, got off the train, and was never quite the same."

.

Richard Guy Walton (1914–2005) came over the Sierra Nevada to Reno on a train from Stockton, California as a boy of fifteen in 1929. He is telling the story to a Panasonic portable tape recorder he began using in 1974 to document his life. He reads from his "Pyramid book," his "greenhorn" novel written in just one month from December to January, 1950–51, also largely a record of his life. "Pyramid" is Pyramid Lake, cupped in desert mountains thirty-odd miles northeast of Reno.

Immediately after *Pyramid* he wrote a second and a third novel in a month apiece, these also largely autobiographical. Later all would be rewritten, and he would write other novels, again autobiographical. None was published, nor any of his other books. Few people got to read them, apart from the editors who returned them. The world knew Walton as a painter if at all; Nevada knew him as a painter who occasionally contributed articles and photographs to local magazines.

In 1993 and 1994, at the age of eighty, Walton was given an unprecedented three retrospective exhibitions at the Nevada Museum of Art in Reno, the first for oils, then mixed media on paper, and a third for his photographs of Virginia City. Curator Howard DaLee Spencer introduced Walton in the catalog of the oils retrospective as "the preeminent 'Grand Old Man' of abstract art in Nevada." He continued: "Walton has been a dedicated abstractionist since the mid-1940s, and

his work has remained at the cutting edge of abstraction for six decades." Spencer aimed to remedy the art world's ignorance of Walton, whose obscurity the curator set down to Walton's devotion to Nevada: "Walton's art has unfortunately not received the level of national recognition that it so justly deserves simply because he has adamantly gone his own way, refusing to compromise his lifestyle for the opportunities of the big city." Instead, Walton "remained in the state that so inspired his life's work."

Yet for all Walton's attachment to his adopted state, acknowledged Spencer, "few of the younger generation of Nevada's artists now recognize" the name of Richard Guy Walton. That was in 1993, when the "Grand Old Man" had twelve years to live.

Walton created a trust in 1999 leaving his unsold inventory, nearly a thousand pieces, to this same Nevada institution, deliverable upon the death of his wife Vivian Walton, who in the interim could sell them for her own benefit. He had good reason to expect Vivian would outlive him. Thirty years Walton's junior, Vivian is alive and healthy as I write. But sooner or later the museum will have to decide whether to accept the gift, which Walton burdened with conditions. They would eventually deaccession (sell) most of the huge collection, as Walton feared, and the remainder would rarely be seen by the public. The NMA is fulfilling ambitions to become an international hub of contemporary environmental art and a top-tier museum receiving and eventually mounting traveling exhibitions and so on. Nevada artists of the past aren't as high as formerly on the agenda of an institution outgrowing regional status. All the more will this reinvention advance as sustainers die out who respond to names like Meyer-Kassel, Caples, Sheppard or Walton.

The NMA didn't buy any Waltons out of the three retrospectives, Spencer told me when I reached him in Norman, Oklahoma. Walton "pissed some people off." I checked with the museum: they only ever owned two Waltons, and presently retain just one, a pencil drawing from the 1950s. Spencer himself liked and got along with the artist, although "Walton was a real character. And he could also be a major pain in the ass. I've worked with some real humdingers! But he was among the top tier of bohemian eccentrics."

A spectacle never forgotten

A horse awaited the return of its driver on a slow rise of cobblestone in a San Francisco street – the year was 1918, and this painter was four. The slope increased toward westward Oak Street above Divisadero; my father's grocery store was on the southwest corner across the way and my sister had left me where I was standing – she loved horses and we had crossed the street so she might stroke the animal's velvet nose.

At the rear of the horse's wagon I was looking into the gutter and saw a spectacle never forgotten. As our horse relieved nature's need, a meandering trickle ran down through the cobblestones in order for me to witness a color spectrum in

early sunlight as gutter waste flowed in many-sided directions to present a color production for the eyes of a small boy who one day would understand what he saw.

.

This keen memory of an early growth of consciousness opens the "Artist's Statement" in the first retrospective catalog. Of the artist's statements he wrote during a long life, this was Walton's most accessible, probably thanks to Spencer's editing. By the early 1990s Walton was beginning to show signs of deterioration. The Grand Old Man had to be feeling his age in 1993 to add the maudlin subtitle, "Words in Passing."

The day would come, as he said, when he would understand what the small boy saw refracted from horse urine in a San Francisco gutter. The revelation came in Chicago's Art Institute in 1936 as he stood for hours studying Seurat's *A Sunday Afternoon on the Island of La Grande Jatte.*

What took Walton to Chicago in the fall of 1936 at age twenty-two makes a good Reno story. In the spring of that year Walton had broken off his course at the Chouinard Art Institute in Los Angeles. He claimed he left on an impulse after Mrs. Chouinard offended him, but the reality was otherwise. For most of two years Wilber Guy Walton (1885–1963) had been supplementing his son's work scholarship with a meager twenty-five dollars a month – twenty went for rent, while his roommate, caricaturist Justin Murray, covered food. Now Wilber, an immigrant from rural Missouri to Stockton via San Francisco and Fresno, penciled a letter on a blank sales slip from his distressed grocery store, the Golden Rule: "Dear Richard: Take this check, but do not look for more as it cannot be done I certainly do need this money. You must make your way from now on Yours Truly W G Walton." Shame may explain Wilber's abruptness. Longer excuses had accompanied late remittances from the noted skinflint up till then.

Walton heard he might get taken on as an artist on relief in Reno. Within days he was on a bus, armed with a letter of recommendation from one of his Chouinard Art Institute teachers, Phil Paradise, addressed to the head of the Nevada branch of the Federal Art Project (FAP), Robert Caples. Paradise knew Caples from student days at the Santa Barbara Community Arts School. Before submitting the sealed envelope, Walton snuck a look. Paradise described the bearer as someone "who has quite some considerable talent." The praise struck Walton as "evasive," as "negating itself with every other word." Incensed, the penniless aspirant threw the letter in the toilet, and when it wouldn't go down he fished it out with kitchen tongs and flung tongs and all into the incinerator, where the soggy paper took several days to burn.

Walton got the position from Caples anyway. At age twenty-seven Robert Cole Caples (1908–1979) was a man about town and successful artist whom Walton already knew by reputation in both regards. Caples recognized Walton's worth, and thus began their lifelong friendship.

I was innocent when I came to Nevada

This was to be a long and solid friendship over the years, a long span, with long periods of silence on both sides. People like Zoray [Andrus] and Bob Caples have taught me how to go down the road. If it weren't for some of my people, I wouldn't know very much today. Because I was innocent when I came to Nevada. Completely innocent. I didn't know what irony meant. Or innuendo. If there was a perspective to be gotten from an incident, Caples wouldn't miss it. I learned a great deal from him. I owe him enormous debts of – how can I say it? They're strange debts that I owe him. He's done me many favors, and he's marked my life as much as any person on this earth, past or present.

•

In short order Caples helped Walton place drawings in the window of Brundidge's, the art supply and blueprint shop on Virginia Street across the Truckee River from the Riverside Hotel. Walton thought big Al Brundidge a "cold fish" and "grumpy bastard," perhaps because the merchant preferred Caples, whose window exhibitions were noticed by the *Reno Evening Gazette* and the *Nevada State Journal*. In 1945 Walton would ruin the arrangement for everyone.

He couldn't stand it

I put in some paintings that were rather extreme, and I put high prices on them. And the customers would come in and say, "How about two of those $1,000 paintings, haw haw." And he [Brundidge] couldn't stand it. And that ended the exhibiting, he wouldn't show anybody's work anymore. He said it was too damn much trouble. And that was Al Brundidge.

•

And that was Richard Guy Walton.

But in 1936 Brundidge's got Walton an important exhibition. Inez Cunningham Stark, remembered as patron and mentor of Gwendolyn Brooks and other Black poets and artists of Chicago's Bronzeville, was in Reno for a divorce. She saw Walton's "latest character drawings" in Brundidge's window. He related the circumstances in yet another autobiography, *Beyond Holland House*.

The life of Riley for a month

It was because of one of these window displays that Inez Cunningham Stark came by. And she was the art critic for the *Chicago Tribune* and president of the University of Chicago Renaissance Society. And she wanted me to contact her, and I did. And she lived at Professor Wilson's house up on the hill near the university, University Terrace, she'd rented for the summer. So I had an exhibit at the University of Chicago, sponsored fully – all the shipping and my ticket there. [Stark met his train at Union Station, bringing along Thornton Wilder.]

[Ansel] Adams came to my reception; he'd come with his dealer Katherine Kuh who had a downtown gallery. I always thought they both attended to hustle my

sponsors. I hadn't heard of Adams, he said little. The Pullmans, the McCormicks, and lord knows who were there.

I was the houseguest of my benefactor. Stayed the month at her Lake Shore Drive apartment that took the entire floor of a highrise building. And she was a most gracious hostess. I lived the life of Riley there for a month.

.

Walton's exhibition was a big deal. Upper echelons of the WPA bureaucracy had to authorize keeping him on the rolls in spite of his absence, and did so, he said, "because it was such an honor for a Nevada artist to be given an exhibition of this importance." Inez Cunningham Stark circulated an announcement leaving no doubt of the prestige she expected to confer on young Walton and the other American artists she selected for the Renaissance Society's exhibition schedule that prewar winter:

"We stand at the threshold of the most exciting moment civilization has yet known. America is the hope of the world, not only for peace, but for the future of constructive social and artistic movements as well. The Renaissance Society of the University of Chicago along with the Museum of Modern Art and the Art Institute of Chicago, wishes to be among the first to call attention to and to foster this movement. Therefore, it will present in its gallery this winter several exhibitions from various parts of the United States by living American painters who have captured the spirit of their times. All were chosen for excellence and a spirit indigenous to our culture."

If anything captured the spirit of the times and culture it was Stark's manifesto. The wealthy art maven obviously overhyped her project. That winter, from November through March, the Renaissance Society featured twenty-one American Artists in four one-person shows and a group of seventeen. None of the names jump out today.

As for Walton, whose paintings, watercolors and drawings rated a one-person slot – in fact the first in the series – he doesn't say whether he sold anything out of the show, except that toward the end of his life he included his benefactor Stark on a very short list of his important collectors. He wasn't picked up by Katherine Kuh or another Chicago gallery. What he chiefly got out of the adventure was a highlight for his CV ever after, as well as exposure to "the best Impressionists" and intimate knowledge of the color and light effects behind Seurat's pointillism as analyzed by himself at the Art Institute. He returned to Reno and his FAP position, "artist certified in need," with a heady interlude of worldliness behind him and great expectations that would never pan out to his satisfaction. Not that he didn't possess the love for Nevada invoked by curator Spencer to account for the world's neglect. "What could I do in an asphalt world?" he rhetorically asked a Las Vegas feature writer in 1982. "I couldn't leave Nevada and its space." But in 1936 he would have seized "the opportunities of the big city," I suspect, had they been directly offered.

Early recognition in Chicago portended a lofty destiny. Instead he would go on to achieve some success and undergo many disappointments. His was to be an interesting life, to be sure, an artist's life, but just another life, a Nevada life. Yet judging from what Vivian Walton and others who knew him say, and from his tapes, Walton's conviction of worthiness for fame never expired.

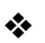

A celebrated fighter

Grandfather Jesse Foose was a Civil War vet and had been a famous brawler. Like any good German-Americans the Fooses were hundred percent Yankees. Hadn't grandpa marched with Sherman to the sea? He'd come from Pennsylvania stock predating the republic farther back than I could trace. When mustered out Jesse *Foos* gained an 'e' through an administrative error, *Foos* was now *Foose*.

Of the Fooses I have nothing but memories and the tales my maternal grandpa told me when I teetered toward ten in Newport, Indiana in my grandparents' care. Florence [his sister (1906–1997)] and I were with them in the bad year my father went broke in Fresno, California. We arrived in the summer of '23 and stayed with them through the summer of '24, a time of stories. My grandpa was already an old man with a white beard and a too-steady stride; he enjoyed his rocking chair, spit tobacco in a coal scuttle, and came on with the day he shook Lincoln's hand in Washington.

His mother, the former Charlotte Maria Hinton, was a school teacher from New England but Jesse neither read nor wrote and only signed his name, mainly on pension checks. His wife, Becky, had been Rebecca Taylor of Clinton, Indiana and he called her "Old Woman" when annoyed. Becky read the mail to him, the weekly paper and the Sears Roebuck catalog. They'd left Indiana and raised a large family in the Missouri Ozarks where Jess Foose was noted as a rough and tumble fighter with a short wick. It was a time when men wore hobnail boots and used them in a scrap. A celebrated fighter, Jess Foose challenged the champion fighting dog of those parts to a contest dog-style – chased the beast under a church and it was said they had to drag grandpa out from under it. He'd provoke fights for his big cowardly friend, Lon Hood, when a bunch of the boys were talking in front of the general store. He'd shove some stranger from behind Lonnie and there'd be a fight with Lonnie flailing his arms defending himself; chuckling to his grandson he'd tell me, "When I thought Lonnie had enough I'd tell the stranger I'd shoved him then take over the fight, myself."

My sister, Florence, spoke of men bringing their sons to the street to shake hands with Jesse Foose, the fighter.

.

This genealogical passage is again from *Beyond Holland House*, Walton's fourth autobiographical novel brought to completion (there were others), undated but from the 1980s on the evidence. Surprisingly for someone so bent on documenting his life, Walton was mostly negligent about providing dates. And I say autobiographical, for that straight up is what this book is by any reckoning except Walton's, who sought to make a distinction, as on a tape from February 16, 1975 – and what does it say about his mindset that he nearly always wrote the date of recording on his cassettes but regularly failed to mention even the year of past events they memorialized. I'm only certain that in 1975 he regarded his tapes as notes for a book, to be the journal of one year in the life of Richard Guy Walton, exemplar of his era. The audio-journal of a year ran over into the following years, ultimately to be reduced and adapted from 4,000 pages in rough draft down to the 600 double-spaced pages of *Beyond Holland House*, another autobiography, structured unlike the book he first assayed in that February, 1975 recording.

A biography of my own life

I told Jim [historian James Hulse] that I was doing it as a work in depth, kind of a biography as well as an autobiography. That I meant to do it in the third person, and see myself as an individual as well as give this intimate report that I'm taping.

I told Joanne [artist and poet Joanne de Longchamps], I said I'm doing sort of a biography of my own life. She said, "You mean autobiography." I said, "No," I said, "oddly enough, I'm taping my recall and then I mean to comment on it – critical comments as an outsider." I said, "Gertrude Stein did it in the Alice book [*The Autobiography of Alice B. Toklas*], and," I said, "it's not quite an autobiography."

.

Walton wrote about himself, and talked about himself. He was one of those people who don't know how to stop talking – literally don't know how. Their off switch is faulty. "Sometimes when I'm talking, and you think the man will never quit," he wrote in 1988 to friends who knew his ways, "I may be thinking I'm boring these bastards. And I don't want to bore anyone." When Mary Beth Hepp-Elam interviewed him for a 1999 *Nevada Magazine* feature and then for a 2000 book about Comstock artists, she found him, she told me, "exhaustive." "Exhaustive or exhausting?" I asked. "Both!" The interview over, between the old man's door and her car might take another forty-five minutes. More than once she left her photographer husband Gary Elam behind to decoy the compulsive raconteur while she drove away. Walton had a prodigious memory for the details of his life and discriminated poorly, a trait that can afflict prodigious memories. The 600 pages of *Beyond Holland House* are crammed to the margins with first-person anecdotes unfiltered by the third-person overview promised in his statements of intention to Jim Hulse and Joanne de Longchamps.

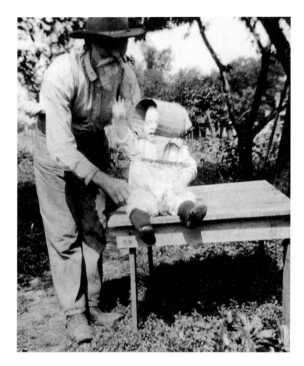

Figure 1. Walton's maternal grandfather Jesse Foose and baby Richard, ca. 1915

But – "oddly enough" – here I am writing a book rather like the one Walton intended, "not quite" a biography, this meandering selection from his mostly unpublished writings and recordings, filtered and annotated and occasionally edited by "an outsider," a "third person" with respect to Walton, so as to render the tone and shape of the life.

Walton's chapter on his maternal grandparents retained the boy's adulation of Jesse the fighter (figure 1). Here was a role model. Walton, no scrapper himself, admired the manly virtues – the fighting kind but not only. Wilber the grocer, his father, comes across as inadequate in Walton's second novel, the story of his boyhood, *The Delta Queen* and its rewrite as *Hey, Jesus*. Wilber is treated for the most part dismissively and satirically, even with pity. He grunts, blusters, wheezes. He builds up a chain of six grocery stores (figure 2), then loses them to drink and gambling, then sells brushes door-to-door and crackers wholesale, then makes a comeback with the Golden Rule, in the novels renamed the Delta Queen, ground floor of a hotel renamed the Gotham, actually the Bronx, 642 E. Main Street, Stockton (figure 3). There Walton spent his mid-boyhood and adolescence (figure 4). Alternately extravagant and tight, the boy's father is a man of ludicrously imaginative get-rich schemes: a tubular passenger plane open at both ends to reduce drag; a sand-dispensing brake for streetcars and trains on wet tracks.

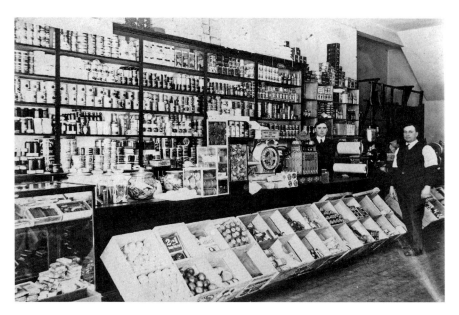

Figure 2. Walton's father Wilber Guy Walton behind the counter of one of his grocery stores, ca. 1920s

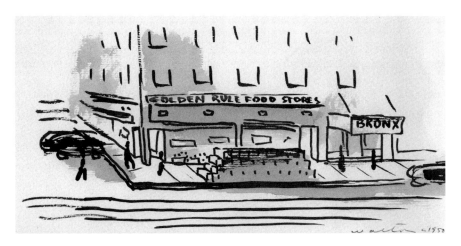

Figure 3. Wilber Guy Walton's Stockton grocery store, the Golden Rule, a Walton sketch, ca. 1950

Figure 4. Walton as a schoolboy,
ca. 1914–15

Wilber, who learned the grocery business in his father's store in Niangua, Missouri, had "been chased out of Missouri by the law; as an enterprising young man he'd buy rabbits to ship in barrels to St. Louis hotels; in the middle of the barrels were hidden quail protected by statute." Walton relished this episode of his father's past. The son's scant praises sound like efforts to compensate for resentment of an avaricious and ignorant father.

Bellying through

Wilber Walton was a powerful man but not a strong man. His strength was in his character, he never backed-off when he saw what he had to do. If he didn't like the situation he would give it plenty of time and, in his own words, belly through. If it were bad enough he was a master of circumnavigation. All he needed was time to maneuver, but if the trouble was fast, Wilber was faster. He could catch a knife by the handle before it dropped to the floor, they had watched him, every time.

Among his forebears Walton found men to identify with. Grandmother Rebecca Taylor Foose's grandfather, John Taylor, Walton's great-great, "had been one of the circuit riders and his worn leather bible is in my care." Grandma Becky claimed two presidents as "kinfolk," James Madison and less remotely Zachary Taylor – "Ole Zack" she called this third cousin. One of Walton's last paintings would be *Cousin Zachary* (1992).

Country heartland ancestors were a double-edged source of pride for Walton, and he wasn't above making a joke of them to amuse another role model of his, Robert Caples, to whom chasing a dog under a church and smuggling quail could be made to sound ridiculous. The occasion was a private oil painting seminar in Santa Barbara hosted by Caples in 1938. In April Caples left the WPA to marry his second wealthy wife, Shirley Behr. "Shirley was the girl with the eighty million sandpaper money," Walton would recount looking back. "And everybody was making jokes in Nevada about Caples' polo ponies." Early that summer, when the couple were back in Reno visiting from their homes in San Francisco and Santa Barbara, Caples introduced Walton to Shirley and issued an invitation which was to have a lasting impact on Walton's art and career.

Rolling with laughter

Bob explained about the matter of Frederic Taubes and his extraordinary information on the technique of oil painting. He said that he and Shirley had arranged to have Taubes with them in Santa Barbara, and to give them a special seminar. And Bob said he saw no reason why I shouldn't join in on the seminar. And that it might be uncommonly helpful in my struggle with the oil medium. Bob and Shirley would sponsor all expenses, and I'd be a guest in their home. I was gone for a week.

Taubes was an irritable bastard. He had rather chocolate red hair. He looked like a merchant. Wholly unartistic in appearance, and had the mind of a merchant. Everything he did – a thought, he'd express it again and again in merchant terms. Everything of art. It was a little distressing, but he did know about the details of the old master methods. And that's where I started from, in my oil painting.

[In 1976] I reminded Bob of the dirty trick he did to me in Santa Barbara, when the Baroness Von Romburg [née Emily Hall] came, and I'd been explaining just before her arrival – I'd been giving these stories about my people in Missouri to Taubes and Bob and Shirley, who were rolling with laughter. Then, by golly, the baroness arrived, with her mink coat almost to the floor, wearing slacks, having arrived in that spotless Cord convertible, L-29. And Robert urged me to tell her the stories. He said, "Oh, do!" And I did. And the first one had no reaction, nor did the second, and on the third, I died. Later on, he told me about her facial affliction, like Buster Keaton's: the Baroness was incapable of laughing. Bob said – after laughing about it himself, to be reminded of this incident, said, "I don't think that I could resist it!" He said, "I'd do it again!" [Walton laughs] And he would.

∎

Caples, before he married Shirley and left Reno, had a studio downtown on the fourth floor of the Clay-Peters Building on Virginia Street, its windows receiving the north light artists cherish. "You could see the treetops and Peavine [Mountain] in the distance," Walton remembered. "Bob liked the view." Walton's studio, "actually a closet" across the hall, had no amenities except proximity to his friend and boss

Caples, who doubtless spoke for Walton to the high-rent building's management, another of Caples' "many favors."

Another was to introduce Walton to Ben Cunningham. Cunningham's ceiling mural at the main Reno post office was then in progress.

Profound visual experience

I recall the scaffold. He was non-objective. Had a composition of space-planes in cadmium reds, a startling open space ran down the long lobby, radiant and free in rectangular depths that led your eyes through the ceiling. It was the most profound visual experience I had to that moment and I have not seen anything as great, since. It was a peak in the American architectural experience although the building, itself, was routine.

∙

Prolific Reno architect Frederic DeLongchamps, Joanne's father-in-law, designed the post office building.

I quote Walton's description of the Cunningham mural because of the mystery surrounding its subject. The mural disappeared almost as soon as completed, thanks to the postmaster, a Roosevelt-hating philistine whom the muses punished with premature death shortly after he got permission from Washington to overpaint the ceiling. Walton's rare firsthand description of the mural as "non-objective" conflicts with information discovered by Reno historian Debbie Hinman. According to her source, the mural "depicted the history of the mail service, from the early Pony Express days to the mail planes." Hinman's description accords with other murals by Cunningham during the Roosevelt era, whereas Walton's matches Cunningham's more abstract style. We'll never know. In recent years a partnership headed by Reno businessman Bernie Carter converted the old post office to commercial space. Carter asked Reno art dealer and expert Turkey Stremmel to examine the ceiling, which she did on a scissor lift in two places. She found the mural under six or seven layers of overpaint, and beyond any practical hope of restoration.

Walton and Caples made sketching trips together. One such "field visit" in 1937, to the derelict remains of Chinatown in Carson City, Walton would describe a decade hence in a magazine article. A year after his exhibition in Chicago and a year before the Taubes seminar, he was still a journeyman artist, tutoring himself by imitating Van Gogh – "One year of Van Gogh influence following Chicago show," he noted elsewhere. The Carson City trip resulted in a fine knock-off in that style, painted back at his studio from a photo he took of the scene. *Chinatown #2* (plate 1) was to be one of two paintings Walton would gift to the Nevada Historical Society with boxes of his tapes and papers in 2000. The eighty-six-year-old artist confided to NHS curator Eric Moody with a laugh that Caples is in the painting, but "you can't see him." Caples "got behind the tree so he wouldn't 'spoil' the scene." Walton expressly withheld copyright on *Chinatown #2* and the other painting until his death – he had hopes of some sort for them at that late date.

For Christmas following the autumn sketching trip to Carson City, Caples gave Walton the present of a book.

The Sparks whale

We'd only known each other six months, and he gave me a copy of *Moby-Dick*. In it was a little drawing on one of the end papers, a drawing in pencil of a whale, and a scriggly sea. He says, "For Moby-Dick Walton, the Sparks whale, from the Bell Street Ahab." It's signed "R." Below, it shows "Christmas, 1937." This book is illustrated by Rockwell Kent, and it's been my treasure through the years.

.

Walton taped this reminiscence shortly after Caples' death in November, 1979. Two years earlier Walton had traveled to the South Pacific, scene of the action in *Moby-Dick*, and from Bora Bora sent Caples a postcard quoting Caples' forty-year-old inscription from memory. The postcard launched an exchange of letters and the resumption of their friendship after many years in abeyance.

Before Caples' death – just days before, it turned out – Walton had recorded an aside as he was reading his Bora Bora notes onto his portable Panasonic: "I wonder at times if I have spent all these years dreaming of Tahiti, and all this effort to get there, just to send Bob Caples his card from Bora Bora."

"Bell Street Ahab" referred to Caples' rental home at 1045 Bell Street, a tiny house familiar to readers of Walter Van Tilburg Clark's novel *The City of Trembling Leaves* as "the Peavine cabin" where Lawrence Black lived, Clark's character modeled on his best friend Caples. The Bell Street location was something I learned while researching a book about the Caples and Clark friendship. And "Sparks whale," because in 1937 Walton was staying with his older sister Florence Mayberry and her new husband David in Reno's conjoined city Sparks. That's something I discovered recently. But why Caples cast himself as Captain Ahab and Walton as the white whale I can only speculate, for neither man broached the question as far as I know. I'm guessing that if the sobriquets spoke to an opposition between them, it was as opposites that complement: Caples, the relentless but flawed pursuer of ultimates; Walton, whose dark and forceful personality might contain something of the ultimate. The cartoon whale Caples drew with his inscription definitely has a fierce and steady eye.

Today I can contemplate the drawing here at my desk, because Walton's treasured copy of *Moby-Dick* is now my treasured possession (figure 5). That came about through the goodness of Vivian Walton, who read my face when she handed me the book after I'd asked if by any chance she knew of it. She would soon give it to me to keep when I was at her house going over Walton's slides of his art. Sitting beside me at the table, she wondered if I'd like to have the yellow brick she'd placed there for me in advance, a souvenir from the ruins of the old Virginia City Gasworks adjacent to her and Walton's former home and studio on the Comstock. I hesitated, then blurted ungraciously that no, but there was something I would

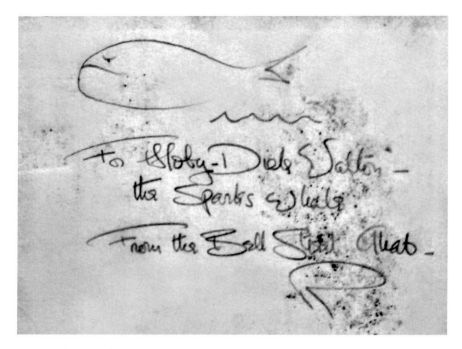

Figure 5. Robert Caples' inscription to Walton in *Moby-Dick*, Christmas, 1937

like to have – and she started smiling and nodding before I could say "the *Moby-Dick*," and she told me she'd already decided to give it to me, just not then, but she went and got it. So I spoiled her surprise, though in a way I made it even better. Walton once said of Vivian that she was "the nicest person I had ever known." She was aware I had published a book about Caples, and perceived that what the *Moby-Dick* meant to me was not mainly on account of her husband, the Sparks whale, who was someone I hadn't heard of until I came across his name on the hunt for the Bell Street Ahab.

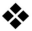

 The City of Trembling Leaves by Walter Van Tilburg Clark (1909–1971) is a celebration of Reno, the region, nature, youth, friendship, the life of art, and a girl loved and lost. As a young man from the Midwest I had sent Clark a fan letter for this his least read novel. Clark was known then and now for *The Ox-Bow Incident*, his first novel. *City*, published in 1945, was all but forgotten except in Reno by then

in 1963. In appreciation, and because he was always generous to young writers, Clark invited me to visit him if I had the chance. That fall I did come through Reno – and I can say with Walton that I was never quite the same.

Clark took me to Pyramid Lake, the mysterious desert water which is almost a character in the novel. There Clark told me that his best friend Robert Caples was the model for Lawrence Black, the moody, reckless and brilliant painter in *City*. Seeing how I admired Black, Clark put me in touch with his friend, who five years before had left Nevada with his fifth wife. The next summer, 1964, I overnighted with Robert and Rosemary at Turtle Hill, their estate in rural Connecticut, and then for fifteen years until his death I corresponded with Caples – and I can say again with Walton that Caples has marked my life as much as any person on this earth. From a distance through his letters I watched him age and face the end with humor and grace.

My Caples and Clark research was on the way to becoming a manuscript in 2012 when I followed a lead to local historian Andria Daley in Virginia City, where Caples and Clark had both lived in the years surrounding 1950 and Clark again from 1968 until his death. Andria Daley, who herself qualifies as a Virginia City character, is voluble in a quiet way that commands attention, and beautiful to watch as you try to follow her fast patter of associations. She told me stories about Caples, mostly gathered in 1992 in the course of interviewing the even more digressive Richard Guy Walton when she was researching Lucius Beebe. Walton, a resident there straight through from 1958 to 2003, had known Virginia City's presiding spirit Beebe during the resurgence he masterminded of the old mining town as tourist destination, celebrity pit stop, artist retreat, and haven for deviants of all varieties. From Andria I learned that Walton had made tape recordings which would contain more about Caples. She didn't know where the tapes were, but assumed Walton's widow Vivian did. Vivian whom I reached by phone told me they were at the Nevada Historical Society. What I found there were three double-sided carrying cases holding 180 cassettes, 90 or 60 minutes each, or roughly 250 hours total. Notes Walton made on and in the cassette boxes guided me to half a dozen or so mentioning Caples.

That was in 2012. In 2018, after my Caples and Clark project had wrapped up, I came back to Walton's trove of tapes to see what other local history was there to be extracted, and ended up engaged by Walton himself.

"I remember Bob Caples' joke," Walton told me in the listening room of the Historical Society, me and whatever audience he imagined – "I remember Bob Caples' joke about the guy who got the big novel down to one word, and then finally threw that away."

I can imagine Caples' soft smile telling Walton what is less a joke than a parable pointing to self-transcendence, the true purpose of all endeavor, believed Caples in maturity. He liked to muse about the virtue of empty frames hanging on plain white walls. Walton, who remembered the big novel story as he reviewed his

reasons for taping, didn't absorb the Caples lesson, not consciously at least, as he deliberated whether he might not have to shorten the book he was rough-drafting aloud, down from an estimated 7,500 pages to 1,000!

Or, "in the case of my death," he correctly predicted, the tapes "would be the raw material for some biographer, God knows who."

Or, he hoped in a certain mood, the tapes would be discovered in a better future.

My socialist people

Now I recognize it's one of my key problems, is that my socialist group is not on this earth as yet. And I have prayed for my socialist people throughout my life. And I hope that posthumously we will find each other. And that's why I make this rather elaborate effort to record so much of my thoughts.

·

Walton to my knowledge never endorsed a specific brand of socialism. His socialism was sentimental not doctrinal, born of the Great Depression and fostered by the boon to him of his WPA years in Reno, then more than now a microcosm of raw capitalism west of the divide: big money, celebrity, sex, criminality, gambling and night life, litigation, banking, mining, ranching, and of course racism and poverty – all uniquely superimposed on top of small town civility and a state university.

His self-image was of a gifted man, a confident man, "someone special and, curiously, I have never – even for an instant – ever doubted it." At the same time he harbored insecurities as a poorly educated boy with country roots. Robert Caples and his father the prominent Dr. Byron Caples, who also befriended Walton, weren't his only connections to Reno society. The biggest little city, permanent population then 20,000, had a top-heavy upper crust into which a person with qualities could readily rise. On different tapes in different moods he processed that attractive milieu with fluctuating measures of self-awareness and resentment.

A gracious place

We had many wonderful afternoons on Dr. Caples' lawn over on Ridge Street [number 241], where he had the two-story house, which was a gracious place. Those were the years that he was married to Hazel Caples. In the living room there, Dr. Caples had the chess set and the great old piano. It was a very moody place, in the rich kind of English manor way. I was ever welcome as an amusing young artist with a battery of homely stories. Despite that, I could never spear an heiress.

Affectations of social position

The townspeople had an easy familiarity with people they could in no way meet in New York. This set a tone for Reno, as a party town – it always was a party town. And its middle classes had affectations of social position, simply because of this influence. Now it always seemed to me that my benefactor and friend, Dr. Caples, was a gentleman of upper middle class.

But this [calling him middle class] would offend him – I can see him getting red in the face – and his son also. They always associated with the wealthy and such high and mighty as they could come by. And I've met some very prominent people through both Robert and his father. But of course the uncle [Ralph Caples] was a tycoon [true], was the president of the Union Pacific Railroad [false]. But what this does mean for a man socially, I don't know. I mean, I know money helps. And all of Bob's recall had to do with the social mighty and the rich. He thoroughly enjoyed somebody who's quite poor, if they're colorful. But they typify pretty well the upper middle class of the Reno area.

I was always hostile to classism.

A rough human article

I have a notion that I must appear in passing as a rather rough human article. Not a smoothie at all. And I think that that's an impediment for me, all my life. And I think that that's like my relationship with Bob Caples and Dr. Caples and all those people. I never went anywhere in the presumptive social set. Never got along with the millionaires, the socialites. Didn't ever go very far with any of them. Because, I believe, this family thing, of my roots, was just a little heavy. It doesn't matter all that much, because you get over there where it counts, and you outdistance these people, and you leave them way in the back. But in the in-between, they'll laugh at you. And maybe this is something that should be a matter of record.

.

You would not imagine, or would you, that an enemy of classism, someone whom merit put ahead of the social high and mighty, would come up with the idea for a book titled *Name Dropper*. Like his father, Walton was a man of schemes. *Name-Dropper* was to be a money-maker, a memory book or album where people could preserve their brushes with the famous. He submitted his book idea to Random House and received a personal answer from publisher Bennett Cerf, a luminary himself. Walton would recite Cerf's letter onto tape, and even make a poem of it. At the top of the page Walton typed "First American Serial Rights Only" for a future publisher.

Cordially

I would like to share
A gracious rejection
Received from a man
Loved by writers,
Readers and televisionists,
A man needing
No introduction—
Words speaking
For themselves.
Anything more said would be garbage. Quote:

The proposed book
Outlined by you
In your letter
Of September 5th
Is certainly something
That I would want
In my own library,
But I must tell you
That as far as
Random House
Is concerned,
This kind of book
Is way out of our line.
I suggest that you
Contact a publisher
Who has done more
Books of a similar
Nature and would,
Therefore,
Be better able
To merchandise it
Than we would.
Good luck to you!
　　　Cordially,
　　　　Bennett Cerf

▪

I can't tell here where Walton's own name dropping leaves off and ironic disdain begins. He knew from experience that no editor, much less one of Cerf's standing, would reply to an unsolicited proposal with anything but a rejection slip had he not found something to admire. On the other hand, Cerf said "Books of a similar Nature"– *What books of a similar nature?* Walton ignored Cerf's advice to submit elsewhere. That was his way when rejected, to toss his head and move on.

As for Walton's head toss at Reno's social set, the crowd with whom, as he put it, he didn't ever go very far, really he did go fairly far. Like many artists he was an outsider-insider both in disposition and behavior. You can tell by his recollections of Dr. Caples' home that he didn't visit there quite as a peer, even allowing for his youth. With the doctor's son he also didn't stand altogether equal – socially, that is. As an artist Walton held himself to be superior to his friend, except in graphic gifts, something Walton didn't rate very high. For his part Caples rated himself high only for spiritual ambition, the most important thing. He doubted that his art ever properly expressed the insights inspiring them, indeed in his sixties he would quit painting for that very reason. Whatever personality issues may have

lain beneath this chronic self-doubt and the dread of public recognition that went with it, socializing was something else, and Walton, the rough human article, had Caples wrong, mistaking his social poise for snobbishness.

Where Caples was a good listener and a quietly witty conversationalist, his friend Walter Van Tilburg Clark dominated social settings and ran overtime extemporizing brilliantly from the podium. But neither the national reputation he earned with *The Ox-Bow Incident* in 1940 when barely thirty nor other pretexts gave him airs, and least of all his family's status in Reno society. Quite the opposite, growing up in the home of a wealthy university president instilled a reactive abhorrence of classism and all pretension. I bring Clark into it because of what he once shouted during an argument he had with Walton.

Clark had never liked this friend of Caples, whom he described in a letter to his wife Barbara some years earlier as brashly overconfident in manner while lacking real confidence and direction. "It is pitiful, in a way," Clark wrote in 1952, "and painful. But none of it excuses his public condescension and discourtesies." On his side Walton resented not being shown enough respect as a fellow author by Clark, who had long been aware of Walton's aspirations.

A suitcase full of rejection slips

Walter Van Tilburg Clark told me, before his first book *Ox-Bow Incident* was published – well, that's his second book, he published his first one himself, in a vanity press, *Seven [Ten] Women in Gale's House* [1932, poems]. I was complaining to Walter about rejections by publishers. I said I get all these god-damned notes all the time, and it makes you tired. I said the best I seem to get is a letter now and then. I said the last one I got was from *Atlantic Magazine*. He said, "Well, I've got a whole suitcase full of rejection slips," he said, "you're doing better than I am." He said, "I never get a letter." Well, then he went into orbit.

.

The only of Walton's early writings to survive is a two-page story from 1936 about a woman who inherits a boat from an old lover who believed she had borne his child, when really she'd miscarried.

The conversation with Clark about writing took place at the home of Robert Caples in San Francisco, who'd moved there after marrying Shirley. The argument between Clark and Walton took place thirty years later when they ran into each other at the post office in Virginia City where both then lived. At that point Clark was in a bad state, more than a little unhinged by the death of his wife, terminally ill himself, and not yet unreconciled to his failure to produce publishable fiction for far too long. And he had always had a temper. Walton displayed the unhealed wound of Clark's insult in letters to Caples in 1978, ten years after the occurrence.

"Name dropper!"

Walter Clark shouted "Name dropper! Name dropper!" at me, because he was mad at his mistaken idea of what had passed when I'd mentioned the name of Margaret Bartlett, calling her 'Monty' as all had at one time. I had spoken out of mystical turn. Christ, how he was hung over that post office bench hanging on with what was actually one long last breath which went on too long like some of his chapters. I left the post office laughing, all the same, wondering what the hell he meant that Margaret Bartlett had destroyed the life of Caples – his ending monologue shouted to the Postmaster General who surely heard him in Washington D.C.

.

If Walton hoped to incite support, he failed; Caples, who had different issues with his deceased friend Clark, wouldn't be drawn about the post office incident, and remained silent as well on Clark's peculiar imputation that Margaret Bartlett had destroyed his life.

Walton, it should be noted on his behalf, had run into Margaret in Reno just before Clark savaged him. Monty Bartlett was the eldest of the three attractive daughters of divorce judge and politician George Bartlett, whose mansion at 232 Court Street was a nexus of the Reno social scene in the 1920s and after, "a haven for many notable figures in American life [and] other famous people who came to visit their divorce-seeking friends" – this from the obituary of Dorothy, the judge's middle daughter. Notables listed there include Clare Booth Luce, Jack Dempsey, Sherwood Anderson, and Tallulah Bankhead – and, as the only local mentioned, Robert Caples. The handsome artist was already a regular on Court Street at age seventeen when he had an affair with Margaret, twenty-four. Margaret briefly became a celebrity herself for flying coast to coast as a passenger in a postal biplane. She advocated for aviation with friends Amelia Earhart and Charles Lindberg, and published poetry in *Saturday Review* and elsewhere. Through two failed marriages she retained an unrealistic attachment to Caples which grew ever more exaggerated in step with mental illness. If any life was ruined it was hers. Her letters to Clark proclaimed undying love of Caples, those to Caples warned him against Clark's sinister influence, all in a sick attempt to tighten the entanglement. Caples handled her from Connecticut with compassion. Clark stopped answering.

All this and more must have been in Clark's mind when he went off on Walton in the post office after Walton reflexively dropped a name out of the past trying to make conversation with a difficult man he knew looked down on him. He said "Monty" and walked into a buzzsaw without knowing the full story.

I had assumed that in the mid- or late-1930s Caples introduced Walton to the Bartlett circle, but I discovered on a tape that Walton knew Dorothy Bartlett as early as 1929, well before he met Caples. A fifteen-year-old new arrival with zero social credentials befriended a socialite of about twenty-five, if 1929 is accurate. It's possible.

The revelation about Dorothy Bartlett comes as Walton recounts on tape a session of reminiscing over gin with Caples in 1976. Caples had just stopped by unannounced during what turned out to be his last return visit to Nevada from Connecticut.

This old friend

And there had been the mention of Dorothy Bartlett. I'd told him about that time when Marijo [Walton's first wife] and a friend of hers, we were having cocktails at the Corner Bar [in the Riverside Hotel]. And I told Bob that I saw Dorothy staggering through the tables, both arms reaching for support. And I told him that I could not bear to see this, having known the family and having adored Dorothy since 1929. This now was after World War II, just before we [he and Marijo] went to New York, that'd be about 1946. So I excused myself and said that I had to take Dorothy home, no question about it. And I went over to Dorothy, and said, "May I take you home, Dorothy?" And I did. And there'd been laughing among the patrons at the bar, laughing at this distinguished person, from a great family, a person in her proper mind who could handle the brightest of them with great facility. Bob says, "Oh. It's a wonder she didn't strike you with her arm." I said, "I knew she was a handful. I knew that." But I said, "I'd always adored her, and I could not help but take her home." I said, "I heard about that later, because Marijo's friend was filling her in on what *she* would do, and what her attitude would be if *her* husband did that." For Christ's sake! This old friend.

·

So Walton was on terms with two of the Bartlett daughters. He didn't bring up the father of the great family, however, Judge Bartlett, still alive the year Walton took Dorothy home – George Bartlett, a friend of Byron Caples, Robert's father. Walton was not that much of an insider.

To Caples he reminisced how Marijo his first wife had given him grief about his ministrations to inebriated Dorothy. If there had been anything going on beyond friendship he would have told Caples – Caples, dangerously handsome, a notorious womanizer between his five marriages, with whom Walton in the old days used to trade war stories. In this case Marijo was wrong, but she had reasons to be distrustful.

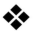

Marie Jeanne Etcheberry (1921–2009) was the daughter of Basque immigrants Jean Pierre Etcheberry (1891–1943) and Marie Simona "Louise" Larralde (1896–1989). John P. emigrated ten years before Louise (or Louisa), she in 1914 just before

World War I on the last ship before the Germans began torpedoing, as family lore has it. That would make John P. a boy of twelve or thirteen coming over on his own. More likely the ten years got rounded by lore and he was sixteen or so coming over in about 1907.

John began in America as a sheepherder near Flagstaff, Arizona, then in Utah and around the West until he landed in Nevada with sheepman Joseph Giraud. Louise began as a housemaid for the Girauds at their Reno town home on High Street. If she continued as a maid after she and John met and married, it would have been at the mansion built for Giraud by Frederic DeLongchamps at the corner of Flint Street and California Avenue, now on the National Register of Historic Places. Signing as witness to John P. and Louise's marriage in July, 1917 was Dominique Laxalt, another Nevada Basque founder and the subject of son Robert Laxalt's classic memoir, *Sweet Promised Land*. Marie Jeanne read it when it came out in 1957 and was tickled by an omission: like John P., Dominique had been a bootlegger during Prohibition, she said, one of the biggest in the area, and Robert Laxalt hadn't mentioned it.

The Etcheberrys can next be found living in Quail Canyon near Pyramid Lake with three children, St. John, called Johnny, the eldest, then Paul, then Marie Jeanne. John P. was range manager for that section of Giraud's ranchlands. After the Quail Canyon house burned down, the family moved to a ranch in what is now south Reno. Then in 1927 the Etcheberrys borrowed money to establish their own sheep operation. For the home ranch they bought eighty acres with a house on a thinly populated bluff called Fairfield Heights west of city limits. Reno eventually incorporated the area as the Etcheberry Addition, now an expensive neighborhood in the wedge where Marsh Avenue meets Sharon Way.

Following the path of other enterprising Basque sheep ranchers, the Etcheberrys diversified into the hotel business. A Basque hotel was a refuge for sheepherders in town from the lonely sheep camps, a place to board, speak the language, eat Basque meals family style, drink in spite of prohibition, and bring women, not necessarily family style. The Etcheberrys partnered in the Santa Fe Hotel with the Orriagas, who over the years held interests in four different hotels or rooming houses, all in the same Lake Street vicinity. An Etcheberry grandson, Paul Etcheberry, Jr., thinks John and Louise bought both the hotel and the home ranch in 1927. Whatever their connection to the hotel in those early years, their name is first associated with the Santa Fe by city directories and newspapers in 1936.

They never owned the Santa Fe outright. From 1920 throughout the Etcheberry years the deed for the property that became the Santa Fe Hotel in 1927 was held by Philip Curti, an Italian-born miner and rancher, then landlord, financier and/ or operator of Reno hotels, clubs, bars, casinos and such. The Etcheberrys never held the deed. Chances are Curti financed the Etcheberrys and Orriagas in an off-the-books handshake deal to be paid off over time. Such things were done back then in Reno. By 1939 Martin Orriaga and wife had moved on to the Martin

Apartments on Commercial Row. In 1943 John P. died of heart failure, age fifty-one. Louise then partnered in the business with their bartender, Martin Esain. After a fire in 1948 the hotel was razed and rebuilt by Paul and Johnny Etcheberry, who by then were in the construction business. Under the terms agreed among the Etcheberrys, Esain and Curti, when the place reopened in 1949 the deed was in Esain's name.

Esain's Santa Fe survived the decline of the sheep business after the Korean war as a popular bar and restaurant, a Reno landmark. When I passed through in 1963, Walter Clark told me there were two things I must do before leaving Reno: see Caples' mural at the county courthouse (where Judge Bartlett once presided), and eat family style at the Santa Fe. In future years Esain's heirs, nephew Joe Zubillaga and his siblings, rather heroically refused to sell the property at a huge price to Harrah's casino for their parking lot. In 2017 the Santa Fe was finally sold to restauranteur Dennis Banks by Joe Zubillaga's son, Philippe, to be remodeled under non-Basque management. The hotel with its own entry door had single rooms for people who couldn't afford the meals downstairs. In the 2020 pandemic, the restaurant and bar folded.

Although Walton's tapes and papers richly describe his courtship of his second wife Vivian, he didn't so much as mention how he met Marijo until age eighty. John Spann, the son of Walton's FAP superior Harriet Spann (who succeeded Caples), brought his date Marijo to Walton's studio apartment on Eighth Street in 1937 or '38. There's much else I don't know about Marijo, an elusive figure, rather like a movie star, both conspicuous and elusive.

To begin with, her name. She was born Jeannette Etcheberry, which she changed to Marie Jeanne (mar-ee-ZHON), to distinguish herself from a younger cousin named Jeanette Etcheberry with one 'n', or perhaps to identify with her mother Marie Simona "Louise" or her father's sister Marie Jeanne in Euskal Herria, the Basque Country, or perhaps simply because, as Walton said, "she was fascinated with the name." In eleventh grade before eloping she was Jeannette to her school; then she signed the marriage license application as Marie Jeanne; but she was Jeannette again in a *Gazette* item about a post-wedding shower given for her by an aunt and cousin. Washoe County has no record of the change, so she may never have made it legal. I suspect it suited her to have a name that made people guess. Others spelled it Marie Jeanne, Mariejeanne, Marie-Jeanne, Mariejean, Marijean, Marijeanne, Mari-Jeanne, Maryjeanne, Mary Jeanne, Mary Jean, Mari Jean, Mariejo, Marijo, Maryjo, and Marijon, or wrote or said MJ or Mj. Walton mostly called her Marijo (mary-JO), so I will. Richard Guy Walton's name had its own ambiguity. People didn't know whether to call him Richard, Rich, Dick or Guy, and as far as I know he didn't correct them.

She was beautiful. She and Joanne de Longchamps were "the most striking girls in Nevada" in Walton's view. Talented poet and mixed media artist Joanne had been a bona fide Hollywood starlet before she married. Born Joan Cullen,

she too modified her name but was very exact about it, upgrading Joan to Joanne and recalibrating the surname of her husband Galen, adopted son of architect Frederic DeLongchamps, as de Longchamps. Walton was more effusive describing his friend Joanne than he was his ex-wife. When talking about Marijo on tape there might come a hush into his voice and – to slightly misapply a description by novelist Thomas Bernhard, but only slightly – "he spoke of the child as a beloved person, very quietly and without having to consider his words." Besides, those we most love can be hardest to visualize. Joanne he could imagine.

Radiantly endowed

She was the most radiantly endowed person – you could see her from a block away. One of these showy lovely girls, very flashy – you could see her for two blocks away, you'd see Joanne coming. My god, there was somebody.

[Joanne's] a very bright person, she has a very good mind. Accomplished poet and accomplished painter. And she came to my classes, not so much in the spirit of a student as in the spirit of community activity. And she knew plenty. Very perceptive.

"Joanne, in doing these tapes you appear stronger than you would imagine," I said. "You're back and forth throughout the text." I said, "I do appreciate that there was this time in my life, when I was with Marijo, that I needed you very badly. I needed to talk with someone, to share, and to explore." And I said, "Since I've married Vivian, there's been no one" – that does not apply to my marriage to Vivian, because we have a community of that sort. But I said, "All through the marriage with Marijo, there was always some person, some woman, from time to time, with whom I could talk." I said, "You can't talk to men very well – at least I can't. But I can talk to women."

·

Marijo was also bright and multi-talented, though not in Joanne's league. She drew constantly in grade and high school, something her mother discouraged at home for unknown reasons. At Billinghurst Junior High she was once found in a closet drawing and told to go to class; when she refused, they let her go on drawing. Marijo's jobs in adulthood reflected her artistic bent: window display, newspaper graphics, art education, advertising. She exhibited intermittently, took portrait commissions, and with the support of her second husband, a businessman, opened a gallery in Verdi upstairs in their home to sell her paintings and drawings. She had a darkroom, too. Verdi is a small community just west of Reno in the foothills. When I stopped by to see Marijo's home, I found the property surrounded by a chainlink fence, the ungainly house in need of paint. Marijo's studio, on the ground floor to the right, was boarded over. Toward the end of her life, I'm told, Marijo would get up in the middle of the night to paint, a touching image not diminished by her then progressive dementia.

Posthumously a children's book Marijo wrote and illustrated was published by the Center for Basque Studies at the University of Nevada, Reno. The author's name

is Mary Jean Etcheberry-Morton, while her manuscript at the Verdi History Center is by M. J. Berry, a gratuitous pseudonym, another name shift. The Etcheberry great-nieces who saw to the publication wanted her name and the family's recognized. *Oui Oui Oui of the Pyrenees* (2012) is a pleasant read, until it trips over a prejudice against gypsies.

Early and late in their marriage of twenty years the Waltons collaborated in the arts, he predictably taking the lead. Newspaper archives document a mural they did together for the 1940 State Fair in Fallon. At a 1952 exhibition which featured his latest abstractions, "Mariejeanne Walton, the artist's wife, and herself an artist of much experience, reveals her talent with a large gaily colored papier-mache chicken which is rakishly suspended from the center of the gallery ceiling." Unpredictably, in 1955 Walton and "Marijon" together choreographed and danced in a ballet at the Twentieth Century Club. Although she was the one with experience as a dancer (as well as director and costumer), "Instruction in Art" starred him as the instructor. Marijo took a supporting role in a cast of twelve.

Like Joanne, Marijo also acted, in her case without professional aspirations. She performed as an amateur on and off for decades at the Reno Little Theater. A 1948 reviewer praised her in *The Voice of the Turtle* playing Olive the "man-killer": "At one time I thought Mrs. Walton might be overdoing the hip-swinging just a trifle; on second thought, it wasn't a bad idea." She was approximately type-cast. Definitely she was captivating in the photographs I've seen, all black & white, leaving me to imagine the red of her long hair and unfailing lipstick, and her blue-green eyes (figures 6, 7). If Joanne was a spiritual Rita Hayworth, Marijo in black & white was some sort of Audrey Hepburn, or Hedy Lamarr, or Ida Lupino, I can't quite say.

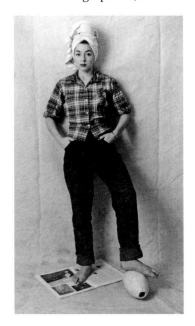

Walton, who tried his hand at just about every literary genre, wrote one stage play, about an artist, of course, and the artist's wife, obviously Marijo. *Darling I Love You* is extant only on an undated tape, recorded well after the marriage ended. The tape begins with Walton's lengthy stage directions, followed by a partial reading of the script by himself and unidentified friends – one of his very few tapes with other voices. The directions call for an actress "as beautiful as casting allows," and stipulate the artist's "surpassing love" for her. The marriage is "an enigma," and "while she is not bitter, she seems to have had it." Which after twenty years of marriage is what happened.

Figure 6. Marijo Walton

Figure 7. Marijo Walton

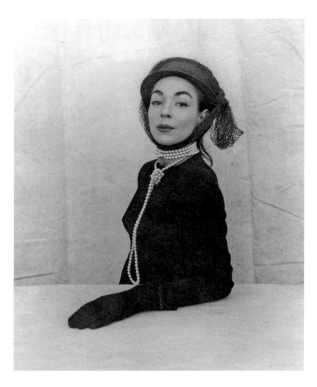

Figure 8. Marijo Walton

After she ordained their separation in 1958, Marijo spent a year in France, mostly in the Basque Country. She did some modeling in Paris, I'm told – she had previously modeled in Reno (figure 8) and would again. My informant was Barbara King of the Verdi History Center, who also told me about Marijo painting at night. The house with the studio/gallery that second husband Hal Morton built for them in Verdi is visible from the History Center. Marijo, who loved her flower and rock garden, was never seen in her yard disheveled at all, Barbara said, was always neatly dressed and made up.

Andria Daley, the historian who interviewed Walton about Lucius Beebe, was employed in the same combined business office of the Reno newspapers as Marijo in the 1960s. That was before the morning *Gazette* and evening *Journal* merged their editorial staffs to become the *Reno Gazette-Journal*. Marijo did advertising graphics and layout. In terms of her work, said Andria, who may not have cared much for Marijo, she was "a lousy graphic artist": her paste-ups were sloppily done and she was always pushing the deadline. In terms of her person, she was "glamorous in a Forties way" (figure 9), always made up with very red lipstick that got on her teeth and a painted-on beauty mark and long red hair which Andria and others thought dyed (in old age it was, red-orange). Marijo "did a starlet thing" of flipping it back. She always wore a red Basque beret and drove a sporty convertible MG.

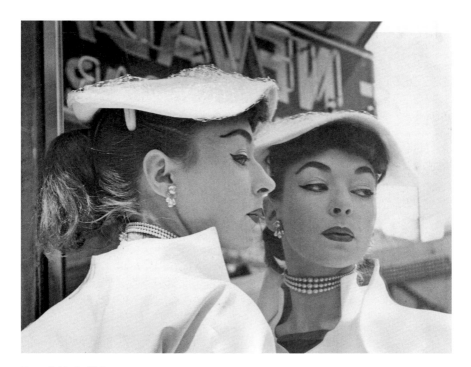

Figure 9. Marijo Walton

And she wore the kind of plaid skirts that convent school girls wear, that Andria once wore herself, she said smiling nostalgically, folded up to show more leg, then down for school. Marijo wore hers at the newspaper folded up.

She was still a student who might have worn such skirts at public Reno High when Walton fell for her. Just how young was she? She was sixteen by the time they eloped in 1938, he twenty-four. Her name isn't on the website for Reno High alumni, indicating that she dropped out of school.

He was living in Verdi with sister Florence and brother-in-law David, the Mayberrys, who had moved from Sparks to a ten-acre ranch, with a barn-studio for Walton. Things had developed between him and Marijo after he returned from the oil painting seminar with Taubes in Santa Barbara.

Age be damned

On my return I was to persuade Marijo to marry me – young as she was. I didn't know how young she was. I think maybe she fibbed to me about her age. Age be damned, I wanted to marry her.

So David and Florence one day – I remember picking up Marijo, I remember sitting there, and this was a portent of things to come: she was very – took a very prolonged time to fix her face up. I thought for a time she was stalling – she may well have been, but she always used that as a device for time, a prolonged making-up period. She was a career makeup person, it proved to be. Anyway, [she] finally made it, we got to the car, drove up to Virginia City, got the licence – and she lied about her age, said she was eighteen . I don't know if I thought she was eighteen. Hell, I don't know. I thought she was eighteen, I guess. She wasn't, she was sixteen. So we were married in the office of the justice of the peace.

Well, it happened that Marijo had a small part in the Little Theatre, a walk-on part. She insisted on carrying it through. I was heart-broken from the beginning in this marriage, because I spent the honeymoon alone. She stayed in Reno with me out at Verdi, a newly married man. A young man. Well, that was a very hard experience for the both of us. I think David went to talk to her, told her about my condition of despair – I was in tears, to tell you the truth, all the time, constantly mourning for my lot. My God, I was abandoned. Finally she came out.

·

They never found a really solid footing. The archive holds no photo of them together. Jim Hulse, who got to know them past the midpoint of their twenty year marriage, said this in an email: "The relationship between Walton and Marijeanne always seemed somewhat chilly to me. Most couples I knew were and are friendly, maybe mock-teasing etc. Banter is part of the game. I sensed a distance between W. and Mj."

Why did he marry a woman, a girl, so young? His protestations of uncertainty – "Hell, I don't know. I thought she was eighteen, I guess" – lose credibility in light of his record: not long after they separated he began courting his second wife Vivian when she was fifteen and he in his mid-forties; and he agreed to prolong the engagement for three years only because Vivian insisted on finishing high school.

And yet, the women Walton took up with in the Marijo years were all mature as far as I can discover, as were those between Marijo and Vivian. So you have to assume that when it came to marriage, some unconscious criterion governed his predilection for teenage brides. If Walton pondered the question, he didn't leave a report of it. What he did leave are stories from his sex education.

The Delta Queen is Walton's second of three novels from his three-month spate of writing in 1950–51. "I get tired faster than years ago," he commented in 1976, "when I used to write from morning to morning without stopping." This novel is set in and around his father's grocery store and their living quarters in the Stockton hotel where Walton spent his boyhood and adolescence (see figures 3, 4). Aside from a bit of family history, an interlude about rats and cats, a nod to his passion for drawing, and a touching coda about his father, the novel consists of stacked episodes about sex. All the characters are involved: his immediate family, the uncles on his father's side employed at the store, shoppers, neighbors, passers-by, friends, whores from the houses across the street. Even the ending where it's decided he'll go to art school hinges on sex, an early affair of his. What did Walton make of all this?

A potential clue is found in his first novel *Pyramid*, his "Pyramid book," in a line spoken by the female character Pandora: "When you speak of the men of your boyhood, the futile knowledge, the hopeless ability and pride, I feel the crushing weight of error and I resent the sadness – a meaning springs from you like a sword – it is you! Now I know this is not a fault but the obscure weight of error."

Did Pandora's comment encompass the quirk in Walton that had him marry mid-teenagers? I don't suppose he meant it that way.

The Delta Queen, Walton's episodic saga of youth, lacks plot. The facts speak for themselves, he insisted, contrasting himself to two storytellers he knew personally: Oscar-nominated filmmaker Laurence Mascott, and his sister Florence Mayberry, who among her accomplishments wrote mystery stories for Ellery Queen.

The real thing

The experts disagree with me on plot. Well, I felt about *Delta Queen* that if you open the door – the front door – and go through the house, go out the back, that that's book enough, for me. I didn't want any phony plot. I wanted the record.

Now this agent in New York, he criticized it from the point of view of plot. And a plot is a shoddy fabrication, compared with the real thing, in my estimation. And for my part, I have to question: May I not forget about what they call plot? I'm not in the slightest interested in their story line. Now Mascott is very heavy on that. So is my sister, and they're both reasonably successful in their ways. My sister's very successful in her plots. And I cannot read that crap. And Mascott can't write at all. And he makes movies. Cannot write at all. Except he does have tempo, he has a skill in that.

So, so much for plot. God, do I hate the typical plot. Oh, God!

I wrote *Delta Queen* in my own name. First person. The first draft was written from the point of view of the individual called 'I'. I even used my father's name, and my uncle's name, and my mother's name – all the names were used, even to the secondary people. Then I knew I couldn't publish such a tract, 'cause I was being as honest as I could write it. I didn't want to do that kind of damage to people. And I was very hesitant about that book, putting forward – I only sent it out a couple times.

·

So the names are changed in the existing version of *The Delta Queen*. He called himself Mark and switched from first to third person, which gave him impetus to fictionalize somewhat. Yet the portraits he drew remained, he insisted, "fantastically accurate."

That's a little shocking where it concerns Lawrence his favorite uncle, his father's younger brother by eight years, renamed Uncle Orville.

"His first ambition was a sordid immortality through women."

"Be mysterious. Say nothing," he instructed his nephew. He meant, to women.

"So, when women say no! pay no attention to it, just do whatever you want."

Mark – Walton – "felt his way through this information, trying to get some idea of what life was like – to what extremes women would go."

When a young woman from Modesto had a flat tire in front of the store, Lawrence came to her assistance to seduce her. She ended up confined in a hotel room as a sex slave for days, with Walton tasked to bring them meals in bed. "I've never known such a man," she told Walton. "He's a beast."

That's not the worst.

When Lawrence first came to San Francisco, he got a job as streetcar conductor.

Pretty young

He told Mark, "I enjoyed the streetcars but they bothered me. It was the vibration. They bounced so much I couldn't stand it. There was a girl out near the

park who bothered me, too. I was in no shape to see something like that. She was bouncing a ball and I was bouncing in the streetcar. It was ridiculous." I saw her the same way, every day. Ordinarily, I wouldn't pay any attention to a girl of her age but she was just getting that way; her breasts were just starting. She was always there, bouncing the ball. And I couldn't get her out of my mind. I even thought about her at night."

"Wasn't she pretty young?"

"She was young, all right. But I couldn't help myself. On my day off, I got dressed up and took my own car [streetcar] and I got off a block below the girl's house. I saw that she was still bouncing the ball, but I didn't know how to go about it. Then I got an idea. As I passed the child I caught the ball and said, 'Why don't you play in the park like other little girls?'

"And she said, 'I've nobody to play with.'

"And I said, 'I will play with you.' We went together to the park and we played catch for a while, until I got another idea." He was laughing. "I threw the ball in the bushes and she went after it, I went in to help her find the ball – it was that easy. I seduced the child in the bushes and when it was over I played catch to cover up. We played catch until I suggested we rest on a park bench." He was laughing again. "Then I got a *good* idea. I put her on my lap and did it again." Uncle Orville snorted with his head back. "Then she wanted to play ball again. I said, 'Little girl, you'd better go home. Your mother will be worried.' She didn't want to go but we left the park, anyhow; and I went with her as far as my streetcar stop. My conscience began bothering me – there was a store on the corner. I bought her a [candy] cornucopia. Then I caught my car, and do you know? The last I saw of her she was still bouncing the ball and eating the cornucopia." When he stopped laughing he said, "Did I ever tell you about Charlotte Blackstone?"

.

Lawrence also tried to cajole his nephew into a threesome with a woman of about sixty, a perversely mitigating factor in this context. Walton declined.

Lawrence isn't the only bad actor in *The Delta Queen*. Another uncle "rented adjoining rooms" with Lawrence where they "traded girls back and forth between them." The brother of a friend of Walton's goes to jail for having sex with the corpse of a girlfriend who died when she fell out of his car. A teenage boy who's having sex with his seven-year-old sister offers her to Walton, who refuses.

Walton himself did nothing grosser in *The Delta Queen* than to lose his virginity to a married woman. Beyond its covers, the most Lawrentian act he avows anywhere in writings or on tape is the avuncular advice he gave the recently divorced Loring Chapman, a younger friend by fifteen years.

He could get lucky

When I visited Loring in Sacramento, he was living in a disturbingly empty condominium, watching the ducks mate on a lawn that edged an artificial lake. I

advised him to keep the apartment empty, and furnish the unit next door. With two apartments, he could get lucky. The female abhors the male vacuum. A dozen ladies in the complex could bring him cookies, so long as they didn't know he lived in the furnished place next door.

.

Some years after *The Delta Queen* was written, Uncle Lawrence disappeared from family view when he fled San Francisco to avoid arrest for what sounds like murder 2: he hit a man on the head with a bottle in an argument over cards.

How much distance did Walton have from this miscreant? Lawrence was "the lad's guru," is "spiritual advisor." Even then Walton "understood that his uncle was a beloved oddity in an over-organized society." Doesn't that describe Walton himself, and, as he aged, increasingly his persona? "Mark seemed to be his uncle." "Mark never forgot."

Say this for Lawrence, he saw that the boy could draw.

Genius

"Sprout, there may some hope for you, after all."

"You really think so?"

"There is a trace of a possibility." He looked at the drawing. "This I consider a work of genius. Believe it or not and strange as it seems, I am moved." Every time he saw Mark's drawings he looked for that particular one. He would break out laughing. "Kkkhow!" he would gargle. "It's murder."

.

Evidently Lawrence had something going for him, because "Both mother and sister were intrigued with Mark's development and were not surprised that his uncle had encouraged him."

What about mother and sister and the question of Walton's wives? As for sister Florence, Walton registered a formative incident on tape, one of the few places where he talks about himself in psychological terms.

A big girl

She had said she was very close to me in her psyche, until I got to be a big boy, and then I went crazy, I was not pleasant anymore after about eight years old, I guess. This occurred in Fresno, I guess an incident where I got into her dime bank, which is a crime, an unforgivable crime, I'm aware of that. I learned my lesson right there, because Florence packs a hell of a wallop. She was a big girl. I was showing my independence, she said, I was becoming obnoxious. She stuffed me in the davenport and sat on it, and I've been phobic ever since about enclosures of that kind.

Now this gave me a psychological problem: Ever since that time, I've had a pronounced fear of big young girls.

.

If Walton was eight, Florence was sixteen, Marijo's age, and Vivian's age when Walton proposed. Once when I ventured to bring up the age question with Vivian, I opened by telling her about the davenport and Walton's professed "fear of big young girls." Could this have a bearing on his marriages? No, answered Vivian definitively, actually he preferred well-proportioned women.

And Walton's mother – Myrtle Foose (1889–1966) of Missouri, spoiled late child of Jesse the fighter and Becky Foose (they came from and would return to Indiana). Myrtle changed her middle name from Cora to Eunice, she never explained why. "At sixteen," Florence wrote, "Myrtle was honey-haired, camellia-skinned, surrounded by beaus from three counties." One beau was steady Wilber the grocer's son, whom Myrtle accepted with Becky's encouragement. But Myrtle, like Marijo, eloped at sixteen, in Myrtle's case pregnant by a redhead named Wilson. Jilted Wilber fled the law to California over the business with the quail. But then after Jesse extricated Myrtle and Florence, age three months, from the insanely jealous, abusive Wilson, Becky urged Wilber by letter to try again. He wrote and even visited. Myrtle wouldn't commit.

The Foose family with Myrtle and infant Florence decided to try their luck in the Texas panhandle. Wilber with Becky behind him kept after Myrtle, and finally she accepted him, again. But one night she ran off with another redhead, a cowboy named Ed Cox. In reality Cox managed a hotel in town where they went to live, without Florence – he couldn't abide another man's child. It lasted six months. Immediately Becky wrote the twice-jilted Wilber, who, bellying through, renewed his suit with the argument that he loved children. "The allure of California," as Walton saw it, "put the divorcee and her young daughter on a west bound train." Florence dates this to 1910 or 1911, Walton to 1913, probably correctly. Walton came along in 1914 (figure 10). The marriage lasted until he was fourteen.

Wilber's talent for catching a falling knife by the handle was "the one thing I remember that my mother had been proud of in my father."

"My mother came to Reno for a divorce in 1928," said a late artist's statement of Walton's, a sanitizing condensation of the facts as set out, succinctly enough, in his novels *The Delta Queen* and its revision *Hey, Jesus*.

A clean break

[Myrtle] ran off to Reno with a gambler from Nevada who later was found only to be a Bank Club shill. The shill lived in one of the whorehouses across the street.

One day [Myrtle] was ill upstairs in the Bronx. [Wilber] was too busy to take her dinner tray up to their room. The shill said he had plenty of time. He'd be glad to do it for him. [Wilber] said, " Well, thanks. I'd appreciate your hep – I cain't git away."

"That's all right, [Wilber]. I'd be glad to do it."

"Good. Then take it up."

In ten days my mother was on her way to Reno without leaving a note or even saying goodbye.

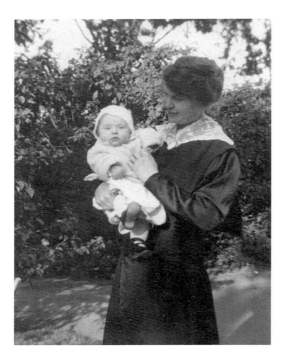

Figure 10. Walton's mother Myrtle
Foose Walton holding baby Richard,
ca. 1914–15

"That son of a bitch," shouted [Wilber], "I'll chug him in the jaw! I'll bash his head in!"

[Florence] left on the same train with another steady customer. The women had left the men, high and dry. It was a clean break, and it hurt us all.

"My mother came to Reno for a divorce," Walton's late artist's statement said, and "I followed her in 1929." That was the occasion when, as Walton the "greenhorn writer" wrote, "My life seems to have begun in some strange way when I came in on a train." He lived with his mother and the shill and attended Northside Junior High.

❖

Florence told the story a little differently. This impressive older sister, who influenced the direction of Walton's life by taking him along to the art museum in Golden Gate Park before he turned "obnoxious" (figure 11), went on to become not only a mystery and children's writer but a leading figure in the international

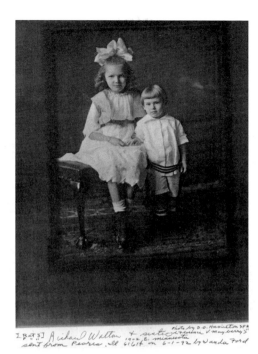

Figure 11. Walton at 3, his sister Florence
Mayberry at 11, 1917

organization of the Bahá'í religion, living all over the world including ten years at
Bahá'í headquarters in Haifa (she is not to be confused with Christian missionary
Mary Florence Mayberry Powell). Florence's spiritual autobiography, *The Great
Adventure* (1994), reveals that her mother's escape to Reno was the final act fol-
lowing prior separations and other men. Beyond that, however, Florence's version
is more diluted than Walton's, omitting all the sordid details of the "clean break":
no decampment with no goodbye, no shill for Myrtle, no "steady customer" for her.
"It was inevitable that Myrtle's children would eventually follow her to Reno," was
all Florence said. "She was the core of our blood-tied family of three, passionately
attached to her offspring."

Be that as it may, Myrtle's fourth husband, Charles (Bob) Robinette, the shill – by
then a waiter – couldn't stand children. So Walton went to live instead with Florence,
who had married the "steady customer" Maxwell (Max) Watson and gone to Puyallup,
Washington where he worked in a blackberry packing plant. In a matter of months
Florence brought Walton back to Reno and divorced, her second: there had been
a teen marriage lasting several months to one Paul Miller in Fresno, another detail
left out of her autobiography. Myrtle's Bob Robinette wouldn't have him, so Walton
went back to Stockton for the summer. "The boy was always excited," he wrote of
himself, "to get back to the Delta Queen." That was the summer a married customer
of Wilber's grocery said, "My how you have grown" and relieved him of his virginity.

Myrtle was "a really nice person," says Vivian, who knew Walton's mother for several years before her death.

"Myrtle loved life more than passionately," wrote Walton in old age, "her outlook folded life on the moment as a souffle in the hands of first chef."

One thing Myrtle did for Walton was to talk him out of marrying young himself. In Stockton he fell for the younger sister of a previous girlfriend. Myrtle told him marriage would ruin his life, he had to pursue his ambition to be an artist, not get stuck in Stockton supporting a wife. But hadn't she married when she was sixteen?

"It was a mistake," she said.

By 1932 Myrtle and Charles Robinette had parted. Walton now spent the school year with his mother. He attended Reno High, but left abruptly when some teacher offended his dignity. That's Richard Guy Walton. He never graduated. That summer he got a road construction job in Surprise Valley through a connection of Florence's. Myrtle, a skilled seamstress, was dressmaking and clerking at the Vanitie Dress Shop. Then from 1933 through 1936 there are no listings in the Reno City Directory for Myrtle E. Robinette (she kept the name). She and Florence moved first to San Francisco, then Florence "bought a small house in Montara" north of Half Moon Bay, where "Dicky Lamb" (figure 12) joined them. A Carmel gallery exhibited his drawings, one a conventional rendering of a hotel in Montara which he preserved (plate 2). In Montara he met sculptor Gertrude Kanno and her husband

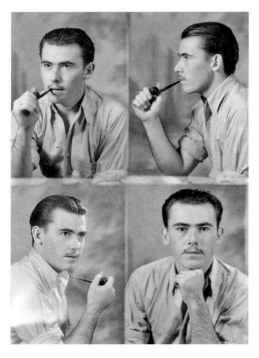

Figure 12. Walton as a young man

Takeshi Kanno. It was Gertrude Kanno who advised Myrtle to persuade Wilber "to see me through art school." So before Chouinard, Wilber first financed Walton's tuition at the California School of Art in San Francisco, a brief enrollment studying sculpture at the then conservative academy.

Florence and Walton had a notion to try New York, but when Myrtle's asthma acted up they all moved away from the ocean together, south to Santa Paula. Florence went on to Las Vegas, where she got a job as a telephone operator. Walton and Myrtle then joined her. They all hated the small but already wide-open town. Florence and Walton still planned on New York. But then Myrtle did a second good deed for her son's career.

Also in the desert for his health was cartoonist and painter James Swinnerton. As a teenager Swinnerton had been hired by Hearst as cartoonist for the *San Francisco Examiner*. In 1897 Hearst sent him to Carson City to make caricatures of the Corbett-Fitzsimmons fight. On a side trip to Pyramid Lake he discovered his second vocation, Western landscape artist. Swinnerton's landscapes are directly observational, yet extraordinary for capturing the experience of immense spaces. Swinnerton had a reputation for generously mentoring young artists and illustrators, known collectively as "the Swinnerton boys." One day in a store Myrtle recognized the celebrity (then Las Vegas's only) and buttonholed him with "My son is an artist." Swinnerton looked at Walton's drawings, then took him for a hike to introduce him to the desert as a subject for art. More consequentially, he put in a good word for him at Chouinard Art Institute in Los Angeles. Myrtle persuaded Wilber to supplement the scholarship Walton was awarded, and in 1934 he joined "Swinnerton Boys" Thomas A. Dorgan, Carl Beetz and Pruitt Carter at Chouinard, where he would receive the bulk of his formal art education. As a student he had two small one-person exhibitions, at the Los Angeles Public Library and in a book store gallery.

When Walton left Las Vegas Florence went back to Reno, as did Myrtle after a visit to Indiana. Next, mother and daughter moved to Hollywood so Florence could try the movies – she was good-looking and had studied dance. When that didn't pan out they returned to Reno. Myrtle found another dress shop job and Florence took an office job with the WPA – it was she who alerted Walton in 1936 to the opening for artists on relief with the Federal Art Project after Wilber reneged on Walton's art school support. He enrolled in the FAP in Reno with high ambitions along with a satirist's eye for the city (plate 3) – at Chouinard he and fellow students used to wander the streets caricaturing pedestrians in the manner of Daumier.

Almost at once he was discovered by Inez Cunningham Stark and got his exhibition in Chicago. Over the next couple of years he exhibited in half a dozen less important shows in Nevada and California. And following the Taubes oil painting seminar in Santa Barbara he proposed to Marijo. They eloped in October, 1938.

Papa was hysterical

She had told her mother, Louise Etcheberry, [who] said, "I'll tell Papa. Let me do it." Well, I found out later that Papa, when he heard, was hysterical. He went to his lawyer to see what could be done, and the lawyer said customarily an annulment can't be forced through. He said the judges typically won't annul. And he said the best thing for you is just to see how it works. So he gave up on that front.

And he had a very deep resentment of me, because he had had some place in his fantasy – he had in mind to take Marie Jeanne to Europe, he wanted to take her abroad back to the old country [to find a husband] at a certain point, fore-seeable – now this is all shot down, and he was bitter about that. He was always bitter about, uh, the situation. Because of these omissions in his personal life. He had been robbed.

In fact it was difficult [for me] to talk to John Etcheberry Sr. about the time of day or anything. I had no communication with him at all.

∎

Louise thought of an expedient to semi-legitimize "the situation" in the eyes of the Basque community, and in her husband's eyes. Louise's niece Mary Inda was about to get married. Mary's parents were Michel and Josephine Inda, Josephine being Louise's sister, maiden name Larralde. The plan was for Marijo and Walton to stand up with Mary and the groom, Ambrose Arla, at the wedding.

The first step was a state visit to the newlyweds. The Etcheberrys came out to the Mayberry ranch in Verdi where Walton and Marijo were living.

A joint celebration

And it was a very pleasant afternoon. John Etcheberry Sr., Louise Etcheberry, the former Marie Jeanne Etcheberry. Of course the hosts were my brother-in-law and sister.

Well, we were told that Ambrose, the bartender, was going to marry Marie Jeanne's cousin Mary [Inda]. Mary, whose mother operated a little [Basque] hotel up the street [from the Santa Fe, the Alturas]. Aunt Josephine. So Ambrose and Mary were to be married [on Christmas day, 1938] at the big church on Second Street, the Catholic church [Saint Thomas Aquinas Cathedral].

Now this was like a mafia funeral. Crowds were there from the Basque community from all over the state. And Marijo and I were the honored guests at this occasion. We stood up with them. I was the best man for Ambrose, and Marijo was late – late – late. She took her time, man, did she drag her feet. I think it was because – She was so late that I went down alone, because we were gonna be too late for the ceremony. She was so late – finally she came. She stood up with Mary, and arrived dreadfully late! Of course there were pressures on her that I don't know anything about. It had to do with the whole scene – many pressures. She didn't want to go *at all* I'd bet. I don't know it, but I would guess it. I guess she wanted to crawl away and go hide some place.

Well, there was a very, very big celebration of both marriages. It was a joint celebration, at the Santa Fe Hotel. Now, at the Santa Fe Hotel there was a dining room in back where they served the typical family style Basque table – a long, long thing. They served many, many people. It was a big affair, and lavish, lavish service. I mean, many, many dishes, the Basque prepare. The French regard them as country folk, which they are, but many of their dishes are better than the French dishes. Some aren't. But this was a mountainous cuisine, and much champagne. And the dancing. And with Ambrose dancing – he was an expert dancer. Ambrose Arla was just one fine dancer. And he did the hat dance. And still dancing pick up the liquor and drink the wine. And he was good at drinking from the zagi [bota], they would have certain contests with this.

It was my virginal experience with the Basque revelry. I was to become very familiar with it. One of the wondrous things of society is the Basque celebration. Well, we had a big one.

.

Humility is not a quality one associates with Richard Guy Walton: this "rough human article" figured he would "outdistance" the "presumptive social set"; his unpublished description of Pyramid Lake exceeded Walter Clark's in *The City of Trembling Leaves*; big names in the art world were his peers at best. Only two things in his adult life that I'm aware of seriously humbled Walton. One was an exhibition where, as he saw it, the youth culture of the Sixties rejected his art. The other was immersion in Nevada's Basque world as the husband of Marie Jeanne Etcheberry.

White man

When Marijo and I would go to the [Santa Fe] hotel, she was very flippant in her nervousness. And I couldn't interpret this. I felt just derelict. She was flippant about me – "Oh, him, you know, this is my spouse," she would say, which is a kind of a strange word to use for that occasion, but she didn't know what to do, she was so nervous about the damn thing, that I'm sure that she didn't know, and it was hurting me, to be treated – I was never treated so in my entire life. I'd been always a kind of protected individual, as I see it from here. But I felt looked at, without being stared at. I was surrounded by strange language. One didn't know if they were talking about the news of the day, or sheep, or was it me, was the question. Once in a while, I'm afraid, it was me. I'd see the glances, and you'd hear the laughter. Well, I don't know how deep I'll go into this. I don't know, but I guess there were some that felt they had good reason for the laughter.

I overcame this in the fullness of time. I was to become – as they said of Douglas Fairbanks, Jr. in England – I was to become almost one of them, but not quite. They had a running gag about white people. They would call the rank-and-file average American a white man, and they'd laugh like hell about it, because they make such merriment about their minority status. And I was well aware that I was a white man in this not hostile, but strange, environment.

And I was to have through the years some of the dearest friends, some of the warmest relationships, there at the Santa Fe.

·

To appreciate the merriment about white people, you have to know that the ethnic slur for a Basque was "black Basco."

Prior to the Arla wedding Walton had already made a fair start on a major undertaking in his Verdi studio. The Federal Art Project had assigned him to execute a set of four large panels for the children's reading room of the Washoe County Library. As his theme he chose Tom Sawyer. "Both my parents being Missourians," he said in his artist's statement for the 1993 retrospective, "I had the thought that I was paying an old debt to American History by selecting Tom Sawyer as a painting theme." Another reason for the choice: Samuel Clemens is all but a native son of Northern Nevada thanks to his two years writing for the *Territorial Enterprise* in Virginia City, where he adopted the pseudonym Mark Twain.

Two panels survive: *Tom, Huck and the Dead Cat* (plate 4) and *Aunt Polly's Sid* (plate 5). All four had been taken down and stored in the library basement by a new librarian when his elderly predecessor died , then returned to the artist. The new librarian's motive for removing the panels may perhaps be inferred from Walton's taped account of their installation in May, 1940.

"Why didn't you paint Brownies?"

A hundred people were crowded into the children's room, if you counted those spilling beyond the door. My associate, Pat O'Brien, had handled the publicity. Pat taught sculpture at the Reno Art Center, a WPA project under the Adult Education program, my employer in the completion of the Tom Sawyer murals that were underway when the Nevada wing of the Federal Art Project was terminated. The Adult Education Project inherited my mural assignment, which involved sponsorship by the Washoe County Commissioners. Pat O'Brien had the mayor of Reno there, who gave a speech on fair play and sportsmanship. The administrator of the WPA for the state of Nevada spoke to the gathering. I recall him saying "On these walls" – and if there was more I've forgotten it. When the ceremonies were over and the crowd was thinning, the administrator, Gilbert Ross, wedged up to me with a red face, hotly annoyed, saying, "Why didn't you paint Brownies?"

·

The two lost panels, *Whitewashing the Fence* and *The Funeral*, were both damaged beyond repair by heat and contact in Walton's attic as he and Marijo were on a long road trip to New York in 1946.

In addition to the four panels, Walton started and rejected one called *The Runaway*. Also he did a preliminary study of Becky Thatcher, Tom's love interest, which he gave to his sister. Much to his consternation Florence sold it at a moving sale for twenty dollars in 1974. When Walton found out, he arranged for a report of the mishap in her local newspaper, the *Santa Paula Daily Chronicle*, which quoted him declaring, "The present owner must be located in order that the full record of this major oil painting of the 'American Scene' era be determined."

American Scene Painting was the broadly nationalistic trend of representational art that flourished between the world wars as a counterforce to European abstract art. American Scene included both socially conscious urban realism and the more romantic rural regionalism to which Walton's Tom Sawyers belonged. In calling his study of Becky Thatcher "major," Walton was rating himself with the likes of Thomas Hart Benton, Edward Hopper and Grant Wood. In a 1961 letter to Vivian during their long engagement he speculated that he could get $30,000 or even $100,000 for *Tom, Huck and the Dead Cat*, "the best painting to happen under the American Scene days."

Walton wasn't entirely off base. Just two months before the Becky Thatcher study went for twenty dollars in Santa Paula, Walton had shipped the two extant Tom Sawyer panels to Washington, D.C. for the Smithsonian American Art Museum's bicentennial exhibition that ran from 1976 into 1979. Though not currently on view, the two panels remain in the national museum, gifts of the artist at their request. On a visit to D.C. in 1979 after the exhibition had come down, Walton was "given a tour of the galleries by the curator of 20th century painting, Harry Rand." The curator's receptionist told him, "They are the most popular paintings in the entire museum."

The coincidence of Santa Paula and D.C. is only one of several ironies touching the Tom Sawyer panels. Another is, they would not have been available for display in D.C. had they not been rejected on Walton's home ground of Nevada when the library took them down. And another, Walton the "dedicated abstractionist" for almost the entirety of a long career received his greatest recognition in his sixties for these realistic panels produced at age twenty-five. Twice *Life* magazine scheduled articles on them, only to cancel for "fluke" reasons: once, when they realized the Tom Sawyers came out of the WPA so were off their subject, and again, when they canceled all art coverage after Hitler annexed Austria. As Walton mused in a different connection, "I'm a man of near misses." How would he have handled it, I wonder, had he received publicity in *Life*? Would he still have turned away so resolutely from realism?

Curiously, when interviewed for an article about the 1993 retrospective, Walton traced his turn to abstraction back to *Aunt Polly's Sid* (plate 5), specifically the

"stylized hand." "With *Aunt Polly's Sid*, nobody influenced me. I was free," he told the reporter.

A further irony of the Tom Sawyer panels is Walton's ambivalence about Mark Twain, whose writings in one vein validated Walton's American identity, but in another typified an American mindset Walton despised.

Could I explain?

I found Huck's reality in the look of my cousins, a branch whose father had been an Ozark celebrity [Jesse Foose]. He could shit in a dandy's saddle standing upright in the stirrups during a church meeting – could I explain that to Harry Rand [the curator]?

They lost me

I believed in Tom Sawyer, I believed in America, I believed the American cause. I was – I believed, I believed through my grandfather! Through all my people! I believed America! I lived America! I breathed America! I was America! When I was a young painter. And then they lost me. And I realized I had to be responsible to the world. But through a region, through your place and your people.

.

Vivian has Walton's explanation of the riff about "a dandy's saddle": practical jokers did that to self-important dandies, who would sit in shit when they swung into the saddle after the service. "Then they lost me" means his disillusionment from McCarthyism, from Vietnam, from Wounded Knee and more – Nixon resigned while Walton was dealing with the Smithsonian about his panels honoring Twain.

And in that same time horizon he wrote and recorded "Nexus," a long poem juxtaposing quotes of Mark Twain's prose to verses of his own. The Twain is from chapters 15 and 19 of *Roughing It*, chiefly 19, where Twain holds forth about his encounters in Utah with "the wretchedest type of mankind I have ever seen," the Gosiute ("Goshoot") Indians. Twain exhibits a vile Eurocentric, imperialistic racism toward Gosiutes in particular and indigenous peoples in general. An excerpt from "Nexus" will serve to show how he repudiated Twain by lambasting white civilization.

Nexus

Mark Twain: ... *inferior to all races of savages on our continent; inferior to even the Terra del Fuegans; inferior to the Hottentots, and actually inferior in some respects to the Kytches of Africa.*

Inflation, nations, expansions, mansions, freeways and halls, curves, gutters, things that one mutters, flyways, byways and balls, long vacant scrotums, Teutonic totems, oil slicks and rusting beer cans, dead ducks, God's will, and Bob Dylan, and hordes of black chillun continue to carry the calls of the peoples, rich peoples, poor peoples, peoples political, all. Say it: Give me five, brother.

Mark Twain: ... *a silent, sneaking, treacherous looking race; taking note of*
everything, covertly, like all the other "Noble Red Men" that we (do not)
read about, and betraying no sign in their countenances ...

> They came in wagons, came without tents, blasted the Indian, his
> government, lied about passage, lied about trade, lied about Jesus,
> lied unafraid, diseases in blankets, syphilis in bed, do you want
> gonorrhea or chancroid instead? Would you like my consumption?
> Would you take typhoid, too? Don't answer my question, don't
> look annoyed, you!

Mark Twain: *The Bushmen and our Goshoots are manifestly descended from*
the self-same gorilla, or kangaroo, or Norway rat, whichever animal-Adam
the Darwinians trace them to.

Walton's relationship to Twain has another wrinkle. In 1961 he had prepared a
35-page typescript, *The Sandwich Islands of Mark Twain,* for the centennial of
Twain's arrival in Carson City. The intended pamphlet would consist of Walton's
introduction followed by Twain excerpts culled again from *Roughing It,* passages
recounting his adventures among the islanders. Twain's condescension in this
case is relatively mild, and he even admires what was in fairness a richer, more
complex society than the Gosiutes. I have no information that *Sandwich Islands*
was adopted for the Twain centennial in Carson. It happens, though, that just such
a book was published in 1990 – so another near miss for the "man of near misses."

❖

Walton hadn't yet finished the Tom Sawyer panels in Verdi when he and Marijo
had to leave for Reno. In January or February, 1939, Florence had been diagnosed
with early stage tuberculosis. For her well-being the Mayberrys abandoned the
rigors of the Verdi ranch, requiring the Waltons to take an apartment in town.
He "had the WPA truck move out those masonite panels to the new residence" on
Sixth Street. The panels remained there until transferred to the Reno Art Center
in the California Building in Idlewild Park, where Walton completed them. He
was director and taught classes there.

Walton and Marijo lived in the apartment only until the Etcheberrys built a house
for them on the home ranch in Fairfield Heights. Louise Etcheberry meant to keep
her teenage daughter close. That summer of 1939 Louise set her plan in motion.

I should talk to Papa

Marie Jeanne's mother told Marijo to have me talk to Papa, about a house. She said that Papa wanted to build a house for us, and that I should talk to Papa. Now I don't know what Louise told Marijo, the conversations were in Basque right before me, and I never knew what the exchange was, I would get the translation. I would wander off and do something else while they were talking, [or] the conversation would have occurred down at the [Santa Fe] hotel, back in the kitchen while I was at the bar with a cold beer. Well, Marijo made it clear to me that what I was to do was to bring the subject up with Papa.

Well, it was a warm summer evening. I saw John Etcheberry Senior standing by himself in front of the hotel, and I broached the subject as best I could, and I dare say he'd never heard of it. I thought that I was talking into his desire, that he had brought the matter up himself. But it appears to have been some kind of a strategy on the part of the well-meaning Louise. I was utterly confused, didn't know what I was talking about. Well, then it went into process. I never mentioned it again, and regretted it at once – I was utterly humiliated.

Well, Louise, I was to find out, would have her way in all things. He maintained the hotel, [and] took care of the bar affairs and the sheep business, and she managed the kitchen and the hotel proper. But for those who understood about the Basque traditions, they're fairly matriarchal. And the men seem to front things, but the women get their way and they engineer things. Louise was a master at this. She did just about what she pleased, and she was a generous, kind and gentle and well-meaning person, but things happened according to Louise's schedule. And Louise had in mind that the house should be built. Of course, I felt like an appendage all the way in these things, and knew I was.

It's my judgment from long witnessing that the women are the managers. And the men have the tail feathers. They front things. But the women are the doers. So a house was built.

∙

The builder was Johnny Etcheberry, their eldest. He and Paul, the middle child, both learned building skills at Reno High. Neither graduated. They started Etcheberry Bros. Housing Constructors after Johnny returned from World War II service in the Seabees. By then John P. had died and Paul had quit a job with Sears to run the family sheep business, and Johnny, who was married with a child, didn't want to be away from home more than he had to be moving the herds or in sheep camp (figure 13). He earning his living as a welder, and mostly contributed to the sheep business as all-around mechanic. He could fix any kind of machinery or vehicle.

Together the brothers became successful builders of residential and commercial properties. In 1948 when the old wooden Santa Fe was condemned after a fire swept Lake Street they rebuilt and enlarged the hotel as the brick structure that stands today. Also standing are the numerous brick houses they built when they developed the home ranch into the Etcheberry Addition.

Figure 13.
Paul (foreground)
and Johnny
Etcheberry at
marking time in
Secret Valley

In younger days the brothers learned to fly together and they raced speedboats, Paul the daredevil driver, Johnny the engineer. Together they set a world speed record on Lake Tahoe "that stood for half an hour," Paul Etcheberry, Jr. told me, with pride and mirth. As adults in business their differences of personality somewhat came between them. Johnny was easygoing and fun-loving, Paul a workaholic. "Johnny wasn't too warm to some of Paul's attitudes in business," observed Walton, "Paul being very aggressive." They had joint and separate careers as builders. Paul also held the Overhead Door Company franchise for Reno and had a mini-warehouse business in Sparks. He finally closed out the family sheep business in 1956 when prices fell with the end of the Korean War and due to Australian competition.

After their sister eloped in 1938, the brothers followed their parents' lead by paying a brief Sunday call of their own on Marie Jeanne and her new husband in Verdi, to establish amicable and proper relations. Then in 1939 Johnny built their house. Walton assisted, and was forever grateful for the experience, as he explained decades on to Johnny's son, Johnny-Pete. Johnny was dead by then. He died in 1966 at age forty-eight in a plane crash. Some ten years after that his bushy-bearded son with wife and young daughter dropped by Walton's second house, the house in Virginia City Walton had largely built himself after he and Marijo separated.

So many things

A car drove up, and I went outside. And standing in the gravel yard was a husky young man with a flaming red beard. He said, "I'll bet you don't remember me." I said, "Through all that hair, how could I?" He said, "I'm Johnny Etcheberry." I said, "Johnny-Pete," and we fell into each other's arms, two of us huskies.

[Erasure. This tape and some others have staticky blank stretches where Walton erased material he evidently deemed too intimate or otherwise unsuitable to let stand for posterity.]

I told Johnny-Pete, who had accompanied me up to the water main, en route, I said, "You know, you and I and so many others are better men for having known your father." I said, "So many things I could not have resolved." And I said, "I built the house only because he taught me."

And I know his father loved me.

•

The home ranch was headquarters of the family sheep business, but not a place where the Etcheberrys pastured flocks. They kept a horse or two, a donkey perhaps, some goats, pigs, turkeys, and Louise raised chickens for the hotel as well as for their table. Johnny repaired the outfit's trucks and equipment there in a garage beside the outbuilding he'd remodeled as a home for his young family. A grassy meadow with a rough fieldstone wall where cottontails lived sloped to the bluff. "A very charming place," Walton found it. The only sheep were under care, some old ewes and the "bummer lambs," those whose mothers rejected them or died birthing in the hills. If another ewe couldn't be induced to adopt them they were brought to the home ranch for bottle feeding.

It was before Walton's day – at least he doesn't mention it – that John P. held a saloon license for a rooming house on the home ranch. It might have been the ranch house itself. When Walton arrived, an eighth of a mile separated that house from the next until his and Marijo's new home went up beside it, rather spoiling the landscape in his opinion. After the war the brothers developed a whole neighborhood around them.

To build the Walton house Johnny had two other assistants besides Walton.

Not for this society

And her brother John, who was an enormously talented young man, Johnny built the house. He had a young friend of his, Shorty Hadlock, was his assistant. And there was another gentleman who was to help in the construction of this new house. That was Biscaya. Biscaya dug the hole for the oil tank. He removed a rock of enormity. He had been a miner in Montana and knew how to handle big rocks.

Biscaya was not housebroke. He was a fearsome person. As his name implies, he came from Biscay. He lived on a chicken ranch, in the tiniest little shed like a wood shed. But he would grunt at you, and he was fierce, and he might hit you with something. He was a caution. Shorty Hadlock had been up in the rafters

somewhere, doing something, and he had asked Biscaya to hand him a board or tool, and Biscaya hadn't been communicated with properly and the tool was not forthcoming, and Hadlock cussed him. Well, when Hadlock came down, Biscaya got after Shorty with an axe, and chased him around and around the house. And Shorty quit the job, he wouldn't go back, until they got rid of Biscaya. Well, they sorted them out, and Biscaya would do something and then they'd take him away.

Louise would go pick up Biscaya in his little hovel, up by Sun Valley on this ranch, where Biscaya had a canvas erected as a sort of a tree, to give him shade. And the big airplanes would groan over on their way to the airport, with that crawling cast shadow sweeping over in and out of the hills and vales. And Biscaya could not stand aircraft. I have seen him, in later years, when he was assigned by Louise to mow the lawn – he would do it with a sheep shears, he wouldn't do it with a lawn mower. He'd cut it with a sheep shears, and I've seen him drop his sheep shears, and shake his fist at the airplane overhead, yelling at the top of his voice, "Christo! Christo!" shaking his fist. Marijo once asked him about the airplanes, and he told her in Basque that they had devils. That they were chickens. In his sense, the chickens meant that they were crazy, they were devils: they had chickens in their heads. When he would shake his hands, and the airplane didn't go away, he ran – he would run to his left, and run to his right, and run back again and back, like he was going to be pounced upon by this airplane. Oh, how he hated airplanes. He regarded them as objects of the devil, and the pilots insane. Well, I've seen him clip an entire lawn with sheep shears. I have Biscaya's sheep shears with me yet.

He was tall and skinny, with a hatchet face and a black moustache, and wore a leather cap, an old one. He also wore tennis shoes, and the tops of the tennis shoes he'd cut with a knife, cut them down sort of halfway between shoes and Oxfords. He couldn't stand the confinement, the restriction of those uppers of the tennis shoes. He also tore off or scissored off the bottoms of his pants. He always wore overalls, bib overalls. And sometimes a jacket.

Sometimes he would walk to that property [six or seven miles], through the years to come. Other times, Louise brought him in the car. Now he would talk to Louise – no one else, he wouldn't communicate, he would "Ruh! Ruh!" to anybody, but he would talk to Louise. Not much, but they had a community. He had a high regard for her, and she for him, an enormous sympathy for him, and understanding of him. Biscaya was not crazy. Biscaya was just not for this society. There are animals like that, too. I once had a dog named Cuddly Puppy, who was a cross between a German Shepherd and a Great Dane, and he had to be put away. He couldn't adapt.

·

I spell the nickname Biscaya following the English spelling of the Bay of Biscay and the province of Spain Biscaya came from, in Basque spelled Bizkaia, in Spanish Viscaya, the 'V' pronounced 'B'. Johnny-Pete didn't recognize the name. He knew the man as Bishkabooba, an invention of his father Johnny's, as Walton explained to Johnny-Pete. Bishkabooba sounds derisory, but so is Biscaya, an epithet with

pejorative overtones coming from a French Basque, or so I'm told by someone of that descent.

Enamored young Walton was open and raw from everything surrounding Marijo when his path crossed Biscaya's. The "white man," the "rough human article" identified with this archetypical outsider. "I have Biscaya's sheep shears with me yet."

On October 20, 1939, patrons of art in Northern Nevada along with artists including Walton and Marijo formed the Nevada Art Association. Walton's mother Mrs. Myrtle Robinette was a vice-president, and Florence Mayberry another charter member. But this was no family vanity project. Officers and members included Charles Cutts, who in 1931 had founded the Nevada Art Gallery which evolved into the Nevada Museum of Art, Mel Vhay the wife of architect David Vhay, and arts patrons Samuel and Edda Houghton, among others. Dorothy Bartlett, Judge Bartlett's middle daughter, whom Walton would in future escort home from the Corner Bar in the Riverside Hotel, was secretary. In newspaper archives I find articles about the association through 1944, but no further mention of the Walton family after 1939.

While the Tom Sawyer panels were in progress Walton showed them to Margaret Bartlett – the judge's eldest daughter, Monte Bartlett, she whose name Walter Van Tilburg Clark would accuse Walton of dropping. In 1939 she was married to Richard Millar, a banker. Walton ran into her and invited her to see the paintings at his apartment on Sixth Street. They will have spoken about Robert Caples as they perused the Tom Sawyers laid out on the apartment floor. Shortly before receiving the assignment, Walton had attended the week-long seminar in Santa Barbara with Frederic Taubes hosted by Caples, the love of Monte's life. There Walton learned the techniques of the Flemish masters.

I'm indebted to Taubes

That's where I started from, in my oil painting. He gave me a lot of mistakes, too, to make. Especially that retouching varnish. A boo-boo, that stuff. However, I'm indebted to Frederic Taubes, because Tom Sawyer couldn't have happened if I hadn't had a seminar with Frederic Taubes. There is no question about that. So I give my thanks to Robert Caples and Shirley – Shirley Behr Caples – and to Frederic Taubes.

·

Several mural commissions came to Walton because of the Tom Sawyers. In addition to the one he did with Marijo for the 1940 State Fair in Fallon, he executed a pair of mural panels that year on the theme of historical Virginia City for the Nevada State Museum (briefly named the Nevada Museum and Art Institute) occupying the old Carson City Mint building in the state capitol. One of the panels, Virginia City's busy main drag C Street with St. Mary's in the Mountains visible between buildings (figure 14), hangs today in the Secretary of State's outer office. Also in 1940, the Treasury Section of Fine Arts commissioned him to paint a mural for

Figure 14. Walton's panel of C Street, Virginia City (1940) (center left). Walton's mother Myrtle Robinette on couch, his sister Florence Mayberry at desk, Walton standing between Dr. William Rowley (left) Rev. Henry Thomas

the Buhl, Idaho post office. He spent a week in Buhl with Marijo choosing his subject. Installed in 1941, this 5' x 12' canvas done in egg tempera depicts the old *Snake River Ferry* (figure 15). The style is again American Scene.

From 1939 through 1942 when he took a wartime job, Walton had almost two dozen exhibitions, some one-person, some group. These included, in San Francisco, the M. H. de Young Museum of Art, a department store, and the San Francisco Museum of Art thrice (twice one-person shows); in Los Angeles and Sacramento, a gallery each; in Chicago, the Chicago Athletic Club; and in Nevada, mostly Reno, fourteen shows, everything from a high school to an art museum.

He continued teaching for the Federal Art Project until it terminated, then taught as its director at the Reno Art Center, an asset to the city which he had suggested to the WPA's Education Project. From his new house he gave classes in drawing and painting from the model as well as plein air landscape, first for the WPA, then privately. But he was strapped for money. At the 1940 state fair he set up as a quick portrait artist. He had to send an urgent letter to Caples to borrow twenty dollars for repairs when his car threw a rod as he and Marijo were on the way to Buhl to install *Snake River Ferry*. "Andrew screamed when I opened your

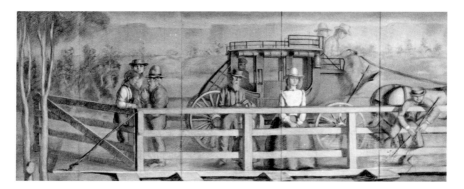

Figure 15. *Snake River Ferry* (1941), Buhl, Idaho post office mural

letter," answered droll Caples from his and Shirley's Indian Springs artists' colony. Walton found "Andrew looking up at me from the twenty dollar bill."

Before 1940 ended, Walton left the WPA. On the way out he displayed his versatility at a WPA-assisted event by conducting a Christmas Cantata at the Civic Auditorium for the Gems of the Antilles Club. Then he became a janitor at the post office, thanks to his brother-in-law David Mayberry, secretary to the postmaster. The job left him time to paint, but he found it "humiliating." He said it gave him shingles.

Money problems, and an awkward position in the Basque world to compound his chronic irritability about social standing, and the difficult marriage itself – all this brought on a sort of spiritual crisis, or shift.

We were both hungering

Before the war, we had a profound religious experience. Speaking for myself – I know Marijo had been a traditional Catholic. Although not identified with the church as a member, she'd been raised in a Catholic environment. And I had no formal connection with organized religion. And we were both hungering for a connection with society.

.

Walton's "profound religious experience" wasn't a Road to Damascus moment. The key to his seeking – moreso than Marijo's I imagine, although he didn't say it – was his "hungering for a connection with society." He wrote in *Pyramid*, "My tendency

toward anarchy made me a lonely man and the church, being at the appropriate pole from anarchy was attractive. If I just bent a little perhaps society would come to me."

He grew up having "no formal connection with organized religion." Nothing in his materials indicates any such inclination on his father's side, the Waltons. Wilber's expletive *Hey, Jesus* came from "a Missouri expression" he used if he hit his finger with a hammer or when hauling himself out of bed, "with no religious bearing." Nor had the name of his grocery, The Golden Rule. Myrtle his mother had in her background her great-grandfather John Taylor, the circuit rider with the venerable Bible, and Becky, Myrtle's mother, whose faith-based moralizing hadn't deterred flighty Myrtle until she finally married Wilber Walton – a bigger mistake, she estimated, than her two earlier marriages for passion. Four times divorced, Myrtle too hungered for a connection. The whole family in Reno, Florence and David Mayberry, Walton and Marijo, and Myrtle, signed onto the Bahá'í religion more or less simultaneously. That happened in May, 1941. But before that, Walton had been exploring spiritual options.

The Episcopal Reverend Henry B. Thomas – Father Radford in *Pyramid*, "an informal sport with a quick comeback" – was chaplain at St. Stephens Chapel on Eighth Street, since demolished for the interstate. Rev. Thomas played some role in WPA art matters, and had established an annual fall art show at St. Stephens which Walton joined in October, 1939. Thomas was also one of the charter members of the Nevada Art Association with Walton and family.

He was a liberal

I had entered an exhibition at the St. Stephens Church, the headquarters of Father Thomas, a rather young, vital, busy Episcopal minister, who was active in community affairs, and involved himself in the Reno Art Center, and was a very close personal friend of mine. It was in his office that I found the pint of whisky behind a copy of *Jesus the Unknown* by Merezhkovsky by accident. He was a liberal, and his wife was a great hand at making stewed kidneys and Maryland eggnog [with rum and brandy or bourbon].

But I was more responsive to a more vigorous approach to spiritual matters, and I found the answer in Emmer Booker.

.

Reverend Emmer Booker, a trained concert pianist, was minister of the Bethel African Methodist Episcopal Church, with a mostly but not entirely Black congregation. Walton and Florence told different versions of how the family found its way there. Florence's version brought in their grandparents from Jim Crow Missouri. The Fooses had moved to a house adjacent to a poor Black neighborhood. When word got around that Becky welcomed Black neighbors into their home, a delegation of good citizens came to object. Fighting Jesse Foose advised them that he kept a loaded shotgun under the bed ready for anyone who made trouble about it, and that was that.

Florence brought this up to demonstrate the anti-racist pedigree of the Fooses' daughter, her mother Myrtle, who in Nevada – then known as the Mississippi of the West – befriended "an attractive young black woman," a stock clerk in the dress shop where Myrtle worked. Readers with sensitive detectors may pick up in Florence's superfluous adjective "attractive" a taint of the subtle racism that afflicts even we white Americans with good hearts like Florence, less now than eighty years ago, but to the present. That said, one day the young woman broke down as she told Myrtle how the police had awakened her and her husband in the middle of the night to arrest him on a spurious charge. Both were hauled to the police station, questioned with standard racial abuse, and he was jailed. Next morning after the husband's white employer vouched for his character he was released, but remained a suspect. That evening Myrtle "in a tempest of indignation" told Florence what had happened. Next day Florence called the mayor and the chief of police to reprimand the city, whereupon the couple received "an unexpected apology from the police." Myrtle told the young woman about Florence's intervention, she told their minister, Emmer Booker, and he responded through the young woman to Myrtle to Florence, inviting her to give a speech before the congregation.

Florence, I learned from an old Reno Bahá'í, was a prodigious talker. "Yes, like her brother," confirmed Vivian Walton with a laugh. But in 1940 Florence was petrified to stand in front of the AME Church audience. Once there, however, she discovered the vocation that carried her to the top of the Bahá'í structure as a public speaker, "a quiet, very specific kind of powerful presence," I'm told, who "hardly ever used notes."

Walton's version of the family's initiation to the AME had nothing to do with Florence, Myrtle or the police.

The possibility of becoming a minister

It just happened that the Education Project had sent me down to the African Methodist Episcopal Church to see Reverend Emmer Booker, who had appealed to them for assistance for a Halloween program that the church was to put on. I contacted Dr. Booker, who was a young minister – a beautiful man! A most handsome man. We became very dear friends. I helped him with that – in fact, Marijo, when she heard about it, threw herself into it, delighted to assist in this pageant. And we did a crepe paper display, sort of stage back-up for their tableau, which was a very charming production, with this rich native talent. They had some men from Peavine Alley come down and sang a most engaging bit. And various performances. Rich in talent. I mean, just off the tips of their fingers, just talented. It was tremendous. Well, I was delighted to be associated with them.

And I was to see a great deal of Emmer. And we would have long talks, heart-to-heart talks. And I explained my concern for spiritual existence in society, and we could concur on – our social views were very close, and he was prone to socialism

and so was I. We didn't call it anything. Well, there seemed to be no end of the Depression, which only was ended incidentally when they invented war for that era.

I came to be known by that entire congregation personally. In fact, I was to meet the bishop and inquire about the possibility of becoming a minister in their church. These conversations occurred. Emmer couldn't see any reason why not.

.

Walton didn't pursue the ministry because of what he regarded as establishment Black rejection "of their anarchist half who could take the church or leave it alone."

If Walton's adjective "native" may raise eyebrows, he had a definite reason for mentioning that Booker was "beautiful" and "handsome." The reason had to do with Florence and Myrtle.

Screaming and squealing

My mother and my sister and my brother-in-law David – we'd all go over there, Marijo and myself, the whole family, every Sunday we'd go to the AME Church to hear Emmer Booker. We just loved them. Became very fond of them – of him personally. And later I found out that was to be a disturbance in his home life, because his wife didn't understand that, that my mother and my sister were very outpouring – it wasn't easy to interpret their ideas, they were so frankly friendly that it could make you nervous. Screaming and squealing and yelling and cheering when – so excited and happy and pleased to see their friends. And this could be misunderstood.

.

Walton didn't directly blame Mrs. Booker's misunderstanding, if that's what it was, for their falling away from Rev. Booker's AME. "Well, in any case," the tape says next, "Helen Griffing came along into our life."

Helen Griffing was a Bahá'í "pioneer," or missionary, and another charter member of the Nevada Art Association. Griffing arrived in Reno with a lead to Florence, who had been dabbling with Bahá'í for many years – going back to her childhood, she claimed in her spiritual autobiography, as evidence of destiny. Through Florence's instigation the family began to attend Bahá'í speaker meetings at Griffing's apartment. In May, 1941 Florence had her moment of illumination and before long led the family all to sign their Bahá'í declaration cards: "I accept Baha'u'llah as the Bearer of God's Message" and so forth. Florence and Walton both credited Helen Griffing.

A Bahá'í lecturer

She made a very heavy project of our family. Ultimately, we were called to join the Bahá'í faith about that time, largely through the care and understanding of Helen Griffing. So I was to become a Bahá'í lecturer, my sister and I spelling one another on many occasions. Marijo threw herself into Bahá'í work fervently. Her best efforts were in the publicity department, which was her more natural medium. She was not much of a public speaker.

.

They all had a part in forming Reno's first "Spiritual Assembly" in 1943, and Myrtle may have presided. The local elected assemblies take the place of clergy in Bahá'í. Walton, already a practiced lecturer on art and photography, lectured for the assembly on such topics as "Divine Justice," "Unity of Religions," and "The Most Great Peace."

But inevitably he pulled back, as he had from Episcopalianism and the AME.

Nothing but trouble

Well, I just figured that I was the cause of difficulty, and in the faith, one of the main principles is if you're the causer of difficulty, you remove yourself. So I removed myself. I knew I was going to cause nothing but trouble. And went into a kind of limbo. Well, I knew that that wouldn't work, but what could I do? The group irritated me fitfully because of these inconsistencies with the letter of their law.

.

Walton would have had problems with the doctrines and policies of any organized religion. He didn't specify Bahá'í's irritating inconsistencies, and my inquiries discover no such principle as self-removal for causing difficulty. But remove himself he did. He told Vivian that when he and Marijo drove to New York, in 1946, they detoured to see the famous Bahá'í temple in the Chicago suburb of Wilmette. Although still under construction, the temple had long been in use. They came at an off hour. A caretaker refused to let them in. Whereupon Walton renounced his affiliation.

The family didn't follow him out. Florence built a life around Bahá'í. Myrtle in her seventies pioneered in Switzerland for two years, returning from there in 1961. That year Walton wrote to affianced Vivian of "the religion obsession which took over" his mother and sister "so wholly to the detriment of family values – even in their own relationships to one another – even to that of David and Florence." When Florence visited Walton and Vivian in the 1990s, her brother's lapse from Bahá'í values disappointed her – she knew, of course, that he had disaffiliated half a century before. Yet she couldn't keep off the topic. He provoked her by pouring red wine into his spaghetti sauce, against Bahá'í prohibition, then taunted her further by assuring her the alcohol would cook off.

Nor did Marijo follow him. "This further split us," remarked Walton laconically. She became an elected member of Reno's Spiritual Assembly, and continued to host Bahá'í meetings in their home well after Walton had quit. After they separated in 1958 she pioneered in the Basque Country, where today there are about 200 of the faithful. She remained a Bahá'í to the end of her life.

Walton's term as a Bahá'í overlapped World War II, the duration of which he spent as a civilian in Nevada. If he tried to volunteer for service, he didn't say so. The draft board classified him 4F due to a persistent fistula on his coccyx, which he lived with for another twenty-five years before having it surgically repaired.

Within days of Pearl Harbor, he and Marijo joined with other artists in forming the Co-Arts group, with the mission to "render free service in an art capacity to [civil] defense organizations." Robert and Shirley Caples joined from Indian Springs. Hans Meyer-Kassel was a member, along with *Gazette* arts columnist Lillian Borghi and others. Borghi's coverage didn't mention any practical outcome of their mission.

Walton exhibited at the Co-Arts gallery at 73 Sierra Street through July, 1942.

Venereal Disease Control

Along about this time Bob Caples came through. He had joined the Navy. And I was to find out that he had suggested to his father, Dr. Byron Caples, the chief of Venereal Disease Control with the State Department of Health, he had been urged to consider me for the job of investigator, that perhaps I could take care of some of that follow-up work and do some artwork for the advertising campaign of the program. Dr. Caples contacted me – either he or Bob did. I went over and talked with Dr. Caples, who I had known socially for many years. And I accepted that job.

.

Robert Caples hadn't quite yet joined the Navy when he stopped in Reno to visit and get his second divorce on his way to New York to enlist, which came to pass on September 11, 1942. That same month Walton left his janitorial job to be taken on by Byron Caples as a venereal disease investigator at $200 a month. Dr. Caples, a urologist, had headed the state's VD (STD) program for some years. His name appeared frequently in the papers, as lecturer on the topic, witness at the legislature, and advocate for destigmatized admission to county medical facilities for syphilis.

Dr. Caples performed these duties out of his medical office in the same Clay-Peters Building where Walton and Robert Caples once had studios, on the same fourth floor. Also with an office in Clay-Peters, on a lower floor, was Thomas C. Wilson, another Co-Arts member whom Walton had recently met there. Wilson had just opened his eponymous advertising agency, Reno's first. Until business picked up he paid his bills thanks to the VD program as Byron's administrative officer, a position I imagine that he, like Walton, obtained through the intercession of his old friend Robert Caples, whom Wilson "ran around with" and painted with at Pyramid Lake back in high school. Wilson would later invent the slogan "Harolds Club or Bust."

Wilson and Walton were "war emergency" employees of the Nevada VD program with salaries funded by the U. S. Public Health Service. Nevada with its open skies and spaces accommodated air fields such as Fallon and Stead, where pilots and navigators learned to fly, gunners and bombardiers to blast mountains and playas. They even torpedoed Pyramid Lake. The federal government had an interest in keeping these personnel VD-free and fit for duty.

"Sleuth," Dr. Caples nicknamed Walton . His job was mainly to hunt out military personnel as well as prostitutes with venereal disease. "I was empowered to detain anybody on either hearsay or reason to believe." He found his responsibilities demoralizing, soul crushing, and it took a toll on his marriage. His accounts of this employment, though mindful of the good story it made, are heavy with regret.

Erosion in my private life

So those were for Marijo peculiar years. Here her young husband the artist was a venereal disease investigator, who was obliged to go out every night to work on his cases, that's the only way he could find the people who had been reported.

So my regimen was to show up late in the morning, perhaps 10 o'clock, and I worked all night long. Well, Dr. Caples and I had a very flexible investigator and doctor-in-chief relationship. We worked it very smoothly. We were very close for just about four years.

Meanwhile, an erosion was occurring in my private life. Marijo never knew for sure where I was. I was gone night after night after night, and what was I after? I was after girls, wholesale. Also, I had a certain amount of education work, and there were occasions when I would have to go out of town on investigations. In the late term I had to be gone for a week or ten days at a time, promoting legislation.

Under the pressure of the environment of our marriage, and the fact that we had two separate worlds, Jo and I grew – tended to grow apart, as time went on.

∙

Walton once confided to his friend Jim Hulse – "in our chatter," Jim told me – that "their husband wife relations had not been normal and easy at first. 'She wouldn't let me touch her,' or words to that effect." Did they elope before having sex? She was sixteen. Yet if innocence is what attracted Walton to a teenager, he would learn that she wasn't virginal. "He thought Mj had been abused as a child," said Jim, "in the Basque sheep camps."

I might have reminded Jim Hulse – one of the few to whom Walton showed his novels – that without using the word 'abuse' (probably Jim's word), Walton had already written about what happened at the sheep camps in *Pyramid*, his first novel, finished in 1951. And told Jim that for one of his rewrites Walton had even taken a passage on the subject and fashioned it into a poem, which he used without title as the book's epigraph.

Sheep Camp

She spent eight thousand summers
 at as many thousand feet
 where herders sang to garlic
 . . . one song and another
 changing verses, often lines

Where herders made love to her
 in a canvas bedroll under the sky
 with a pine needle mattress nesting them
 . . . herons flew to the meadow
 and chi-chi-munks cried.

 ▪

Thanks to Vivian, it chanced, this poem was published. She saw a notice for a national poetry contest at the public library in Reno (where the Tom Sawyers had formerly hung) and insisted he enter. Walton, ever ready to repurpose his compositions, "lifted lines" from his "unpublished novel *Pyramid*" and "put them in verse form." He related this circumstance in yet another novel, *Beyond Holland House*, where he repeated the poem, with the title "Sheep Camp," without revealing that the acceptance letter requested a fee – so *Poets of America: 33 Poems* (1974) was a vanity publication.

"Not even ten," says Pandora in Walton's *Pyramid* novel, "and I was the wife of four herders that grandfather never suspected when he went for supplies saying, 'Jean Pierre, take care of Pandora.'" The "grandfather" was really Marijo's father John P. Etcheberry, whose Basque name Walton gave to the abusive sheepherder Jean Pierre, no coincidence if the hint is taken from *Pyramid* that Marijo was abused by her father: "I have always hated my father since a little girl and I will not tell you why."

It isn't obvious from these writings, nor his tapes, that Walton was "disgusted," as he told a confidant, when he first learned what had happened to Marijo.

Walton repurposed this material yet again, in a short untitled prose piece about incidents in a sheep camp and other sexual episodes in the life of an underage girl named Pandora. The detail about lipstick tracks with Marijo's dependency on makeup. A few other, irrelevant specifics have been omitted here.

"Keep an eye on Pandora!"

She spent eight thousand summers at as many thousand feet, where herders sang to garlic one song and another, changing verses, of ten lines. Pan said when herders made love to her in bed under the sky, with a pinyon mat below them, herons flew to the meadow, and chip-i-munks cried. "I was not yet ten, and the wife of four herders, Grandpa unsuspecting," she confessed. The old man headed for Reno, calling back from the truck, "Jean Pierre, keep an eye on Pandora!" Jean

Pierre would yell back to him, "Pandora, he I okay. I see you" – "You'll see" in his lingo. When the Ford left, he'd throw his hat on the ground, dancing on the brim, Pan bringing the wine sack Jean Pierre held with a fountain of burgundy from as far as he could reach. Then drawing the leather sack close, he'd snap it down carefully, not missing as he would that night sooner or later, squirting Pan, and embracing the child and the wine sack, roaring with mock surprise and merriment, "Son of a gun! Alor!"

She loved Simón, Jean Paul and Antonio, but Jean Pierre especially.

Pan said the boys teased her about her face until the time for lipstick came, and she showed them. At the home ranch, she had a girlfriend, Basque like many herders, who knew one hell of a lot about things unmentioned. "Gradually," Pandora said, "we discovered ourselves," establishing a weapon used well in school, ultimately in church.

As a social service, Pan drove a priest to Austin every week, until he said no. And when asked why, she knew why. He was young and handsome, and she was using the weapon. She told me, "We made love in the car until they saw the lipstick on his collar, and sent Father to Siberia or to Rome."

.

And there is a story Walton recorded without comment about young Marijo because of what it suggested about her exposure to sex in the Basque world of Reno at the Santa Fe Hotel.

Enlightening

I should index an additional anecdote. Marie Jeanne was always available to her mother as an assistant in an emergency. If her mother needed an extra hand at certain festive occasions at the Santa Fe Restaurant, Marijo would help her. Either there would be a special party, or perhaps someone had gotten ill, such things as that. In this case, her mother had asked her to help with the rooms. They were short-handed. So Marijo made herself available as chambermaid briefly, to assist her mother.

Now Jo, she gave me a report of the day, on one occasion, which was very enlightening. She said she knocked on the door of this room, and opened the door to go in and change the sheets, and she says, "My goodness," she said, "there was a couple in bed. The sheepherder was making love to this prostitute. And," she said, "without interruption" – the prostitute saw her come in, the sheepherder didn't know, – saw her at the door. And she said, "The prostitute looked up and wiggled her fingers hello, without interruption." Marijo closed the door and left.

.

Marijo's father John P. Etcheberry died halfway through World War II. The cause of death was congestive heart failure, but really alcoholism according to a grandson. In his last years John P. just "dabbled around on the [home] ranch" in Fairfield Heights. Louise ran the hotel, and son Paul left the tire department at Sears to

take over the Etcheberry sheep operation. War had made the sheep business a "strategic industry" and profitable. Paul sold his wool to Pendleton Mill in Oregon.

Because some Basque herders returned to Europe to fight while replacements from the Basque Country grew scarce, ranchers recruited new herders from Mexico, either Basques who had previously emigrated there, or else Latino herders. Nevertheless Paul was often "short-handed. So therefore," said Walton, "it left the door open [and] they asked me if I would go. This was the middle of the war," he would exclaim looking back, amazed by what life had brought, "and I'm a VD investigator!" Thanks to the flexibility of Dr. Caples, Walton was able to take weeks off at a stretch from his VD job for sheep camp – a unique pairing of occupations with nothing in common but the mammalian reproductive system.

He devoted hours of tape to his cherished sheepherding adventures. "One must appreciate," he said to begin, "the geographic scope of the sheep operation." Following a routine set by John P., Paul summered the Etcheberry flock in the High Sierra in the vicinity of Lake Almanor, a reservoir near the meadows of Westwood, California, where today you see Black Angus cattle. For the winter Paul came down to Nevada to camp by Nightingale Mine, near the east-facing base of the Nightingale Mountains. That range forms the east side of the basin of Lake Winnemucca, the ephemeral twin of Pyramid Lake. For spring lambing and shearing the herd was moved from there back to California, to the "middle ground" at Rye Patch or Secret Valley in Lassen County. For marking they moved on to the vicinity of Madeline Plains, then again to the "high ground" for summer. The total distance covered each way was well over 100 miles as the crow flies, considerably farther by a route Walton doesn't exactly trace except that it passed above the Needles at the north end of Pyramid Lake. He never made the whole trek himself, instead joining the camp at Nightingale Mine, Rye Patch, Secret Valley, Madeline Plains or Westwood. Twice or more Marijo went with, but that's all he had to say about that.

A mark of honor

I was always enchanted to go with Paul. Paul and I didn't have the cleanest communication, I had a little better rapport with Johnny for other reasons. Paul, it seemed to me, had potentials toward intellectualism, but Paul freely – there was no money in that kind of thinking, and so he wouldn't even begin. Johnny had none. Johnny was a different cut altogether. And I accepted both as my brothers-in-law at their declared levels. I never expected more than that which they entertained for themselves. And that's important in human relationships, it seems to me. So when we were together, we were always complete. What they expected of me, I do not know, I've no idea – to keep my chin up, I suppose. They were never critical. The Basque community doesn't seem to be a community that criticizes, like in the general American community. They play a tight game, holding their cards close to the chest, and I respect this – this is a thing of cultural achievement. You may feel a sodden unacceptance at certain points, but not specific criticism.

And it was pleasant to go with Paul to Nightingale Mine, and it was always pleasant to associate with the sheep camp life, and to become part of it. I enjoyed that very much. And to be accepted by a sheepherder was a mark of honor in my book. I felt wonderfully redeemed when I saw that one of the employees at the sheep camp would accept me, genuinely. And sometimes they could scarcely talk English.

•

There was Fermin, a tall Basque in his mid-fifties, proud of his high-priced Western boots. Fermin's boots smelled of garlic, because everything of Fermin's was rank with garlic, which he ate raw by the head and pureed as a soup.

There was an unnamed herder with "a very fatherly love for Marijo," who reminisced about the plump child they called Jeannette, or Jeannettine, or Patatine, Little Potato. Was this the same man who said "I see you" for "You'll see"?

And there was a herder whose name Walton pronounced Palani, a Frenchman, whom Walton singled out for his heavy drinking. Palani prefaced everything with "Alors" – "Alors, I lose-a my guts, you know."

And Onenti, to whom Paul brought Spanish language papers published in Los Angeles along with supplies when Onenti was watching over the summer herd alone on the high ground.

Intuitions of the sheepmen

The herder moves them around from area to area, letting the sheep graze. And Paul would go every so often, perhaps once a week or so – meet him in rendezvous, at a prescribed place. The sheepherder would tie a cloth on a bush to indicate that his camp was nearby, and the pickup truck would stop when you find the cloth – and [Paul would use] his country wit to find the tent.

The mountain people know how to handle themselves. And Paul was expert at this. He was a beautiful figure. He had inherited all of the great intuitions of the sheepmen. And Johnny, too, for that matter. Johnny could have handled it as well as Paul. He liked to stay at home – he was married and had little Johnny-Pete, so he didn't want to – he was not a natural for that assignment.

•

Johnny acted as "baseman" on the home ranch after service as a Seabee in World War II. Paul had tried to volunteer as a pilot, but was rejected for not having the high school diploma required of officers.

And there was Gaillardi, a "red-faced giant of a man," who became a cook at the rebuilt Santa Fe Hotel where he and Walton maintained a warm if superficial friendship until Gaillardi died of a heart attack.

And Trini, a Mexican who'd come over the border as a teen after both his parents died, a "very kind man" who never adjusted to American ways. He called Walton Nick. "'Neek,' he said, 'the Americanos, they are mean ones, Neek.'"

And Pete Artois [ar-TOE-ess], who told Walton stories about the coyotes he

shot at close range, with a stick, and the fish he dynamited. He didn't tell the one Walton did about the prostitutes Pete terrorized.

Totally uncivilized

Pete Artois looked like John the Baptist, unreformed. He was a handsome man with a black shock of hair, curly hair, and totally uncivilized. Artois was the terror of the prostitutes at Lake Almanor. There was a whorehouse outside of the community, at the edge of town – of the scattered resort area. But there was a whorehouse. And I was told that Pete Artois would crouch over in the bushes, come up – leave his sheep and go over to the edge of the property and peer at the prostitutes hanging up their laundry. They wanted nothing to do with the man, they were terrified of him. But he would like to look. Now, he was not a trouble man. He was a gentle man. But he was rough-looking – Oh! And he had a gruff voice. He was really a great poetic image.

.

In 1948, after his sheep camp days were over, Walton was briefly art editor without title for *Nevada Highways and Parks* (now *Nevada Magazine*) under Frank McCulloch, a Nevada ranch boy who gained fame as a Vietnam War correspondent and newspaper and magazine writer and editor. McCulloch published Walton's story about a comical rite of passage he underwent at Paul's sheep camp involving a runaway horse. "Ride 'Em Cowboy" had been rejected by *Harper's Magazine* only because they'd just published a story about a horse, Walton said they said. In *Beyond Holland House* he bemoaned yet another near miss. "This has been my fate from the beginning."

"Ride 'Em Cowboy" lacks the depth of his tapes, from an older age, where he dwelt with appreciation on the personalities met in sheep camp. Too bad he never wrote about the Basque herders the way he talked about them, especially the herder closest to his heart, the "fearsome," the never "house-broke" Biscaya, who chased Shorty Hadlock around the building site of Walton's house with an axe, and dreaded airplanes with chickens.

The true Biscaya

I was camp tender at Rye Patch, and I'd finished cleaning up at the camp, and took a walk, at random. All the hands had gone to the sheep. Biscaya was with us on that occasion. He didn't often go out to the sheep camp, and among the sheepherders he was strange. He was remote from all, not only the white people but from the Euskaldunak, which is the Basque name for the Landsmann. Biscaya stayed by himself all the time. Ate by himself. Joined in with no one. Well, he was night man. He was so incompatible with society that he only would accept the job of night man, the man who sits with the sheep all night long. But the sheep have difficulties in this lambing period, and they need help – sometimes the breech birth. And the herder will have to reach in with his arm, clear up into the sheep,

into the vagina, and twist the lamb so that it will emerge properly. It's the most pathetic thing in the world, to see a ewe down, with an impossible birth. So this will explain Biscaya's duties as night man.

Well, it was perhaps ten o'clock in the morning. Furthest from my mind was Biscaya. In fact, you'd only see him sitting on the edge of the campsite from time to time, totally to himself. Sometimes whittling. Well, my chores were done, and it was a clear, sunlit morning, and I took this random walk. And it was some distance from camp, mounting a little rounded hill, and I heard a song, faintly, I picked up this song, and I was attracted to this song, this familiar song. Stronger and stronger I heard it. And finally clearly, it began, "Mexicali Rose, I love you. I'll come back to you some sunny day." And peering over the knoll, it was Biscaya! By himself, overlooking the sheep. Crouched there, with his leather hat, his jacket, his overalls, and his severed tennis shoes. I backed down the way I'd come, without turning, and when my head was out of sight, I turned around and left, with Biscaya still singing, "Mexicali Rose, I love you. I'll come back to you some sunny day." And that's how I came to find the true Biscaya. Who knew English better than anybody suspected.

·

Was the great revelation of "the true Biscaya" really his command of English? One can learn a song in a second language, passively comprehending the words without commanding them. The twist of the story is plainly Biscaya's unfulfilled romantic urge – something Walton walked up to and seemed to back away from, as on that hill in the Sierra he did from the singing man. Had Walton actually ended a written story with the observation about Biscaya's language instead of saying it midstream on tape, I'd credit him with purposeful unreliable narration. As it is, he may or may not have recognized the story he had. When he told it on a different tape, he ended it the same way: "Who knew he spoke that much English?"

Walton said he was "camp tender" at Rye Patch when he came upon the singing Biscaya. The Etcheberrys, to go by Walton, used the title camp tender for two distinct job descriptions: the boss, in this case Paul, who assigns tasks and keeps the herders supplied – that's the customary usage; and Walton's job, "the camp tender who cooks the meals, and tends camp, keeps the fires going at these periods of emergency such as lambing time or marking time," that is, when several herders camp together.

Walton's tape dwells on his duties as cook: the morning "kafea," the coffee drunk from bowls with canned milk and lots of sugar into which the herders from Euskal Herria broke the "sheepherder loaf" baked by Paul, making "a veritable coffee stew"; and Paul's recipe for "sheep camp stew."

Yearling lamb

Now they butcher a yearling – that's the prime meat, of the yearling, not the lamb. Now you've got mutton, on the one hand, if they get too old. But the sheepmen that I have known do not prefer lamb at all. They prefer yearling lamb, which is a

full-bodied young sheep. It was male, of course. They never butcher the female. So I would prepare these stews in their tradition. Paul would show me how. It's a vegetable stew. You make squares of meat, about an inch square, let us say, loosely. You braise that in oil and seal it. And you pour off the excess oil and then you brown your vegetables: carrots and cooked potatoes and cabbage, et cetera. With a good deal of garlic, and onions. And tomato sauce and red wine and water. And this is in a Dutch oven. It's highly seasoned with California mild chili powder. And with a heavy lid, it steams on the top of the sheep camp stove.

I record the recipe for posterity and Basque studies.

Walton made art on sheep camp themes as late as 1980. A 1950 sketch (plate 6) for a "paper painting" shows the interior of the main tent: a coffee pot on the camp stove with the stove pipe exiting the side of the tent; near it, a box of foodstuff or pile of fuel; to the left, the camp tender's cot; the center pole with candle holder; and a sheepherder, ready for lamb marking. Marking was when the lambs were dabbed with tar, the equivalent of branding, and also when tails were docked for sanitary reasons, and the males castrated. These bloody tasks account for the sheepherder's peculiar garb, as described by Walton's notes: an inverted burlap sack for protective vest with neck- and armholes cut out with a stockman knife, and a cap fashioned by trimming the brim off a fedora.

❖

While serving his tour of duty as "investigator and epidemiologist," stated Walton in his 1993 artist's statement, "I dropped my painting career for the duration of the war." Epidemiologist was a stretch, but he did mostly suspend his public career as an artist. In 1943 and 1944 he exhibited only twice. Once was at the Reno Army Air Base in Stead, a group show alongside Marijo, Caples (in the Navy) and others. The second was also a group show, the annual watercolor exhibition at the San Francisco Museum of Art. And then "in 1945," says the artist's statement, "I arose from the ashes as a symbolist." That autumn he had three one-person exhibitions in succession where in all likelihood he unveiled his new style, "abstract symbolism."

"I arose from the ashes" – Walton left no explanation of his developmental leap during the hiatus of the VD years, only this figure of speech, adding the observation that "American Scene Painting was dead." And elsewhere, "I explored new ideas by the dozen." His ideas were expressed with paint, but not only that, he wrote a book: *The Mark of Man* was the first of Walton's roughly twenty books written or conceived. He dated the inception of the ideas it explored to 1938.

A shower of light

Part of my reasoning was based in the logic of Ouspensky, in *Tertium Organum*, a very complicated book, a hard book to read. Well, I read it in the days when I was with my sister and brother-in-law in Verdi. I read that, and was absolutely charmed with it. Those were the days when I would lie in my cot at night and see the moonlight in the panes – the window panes of the chicken coop studio that I had redone. Looking at the window, I would see the moon in every pane. That chicken studio, built of heavy materials salvaged from an old railroad ice-house, was just a shower of light, when the moon was coming up, because of these reflections in the panes. Apparently, the source can be amplified.

Now, thinking along that line, I was very fascinated with Ouspensky's concept of time: he held that there is no such thing as now, that time is an infinite thing, and that now is forever. That you have to see it in one sweep. So that sparked my young mind, and I began to apply, not the theories, but that type of reasoning to other matters, principally vision, and the shape of things.

•

He dated the actual composition of *The Mark of Man* to "1946 when Charlton Laird was working on a piece of shit called *Thunder on the River* – we sort of tumbled around about books one afternoon at the S Bar S ranch." The S Bar S, one of the last ranches in private hands within the Pyramid Lake Paiute Tribe Reservation – since restored to the tribe – belonged to Comstock heiress Helen Marye Thomas, who lived there with her partner Phyllis Walsh. I suspect that Caples, a regular at the S Bar S, made the introductions. Laird was a widely published University of Nevada linguist. His "piece of shit," a novel, came out from Little, Brown in 1949. *Thunder on the River* is quite a decent job of historical fiction along the lines of Guthrie's *The Big Sky*.

The Mark of Man

Now, at this very moment, the onion-skin carbon, the last remaining copy of the text of *The Mark of Man* is now burning in the fireplace. But it was a poorly written book. It was not a well-[inaudible] book. But the scientific material, or analysis of vision, was in that. And I have retrieved that material, and kept it clean.

One of my points being that what we saw was not the fact, that light rays constitute a symbol in the brain, and that you don't see the reality, there's no way to know a reality, and what you see is only a picture – which is a symbol. The thing the manuscript is shooting at is that man himself is a symbol, from a certain point of view. That life, existence is symbolic. This *Mark of Man* text gives credence to symbolism at a level heretofore unexplored, as far as I know. And I pursued the theory that all of it was symbolism if we would but understand it as such. And that even the most realistic painting was therefore a symbolic painting. And that we can find common ground on this if we could but assert the value. And I wanted to see a great coming together in the postwar world, with great art overtaking the nation.

.

Burn the last copy of the manuscript he may have, but not without first reading an hour of it onto tape with running commentary, for posterity. Someone else with different credentials from mine will need to evaluate Walton's esthetics, metaphysics and psychology of perception here, and will be in a position to say what exactly Walton carried over from *The Mark of Man* into decades of delving intensively, not to say obsessively into art and vision, culminating in a quasi-scholarly paper, "Elliptical Perspective and the Z-Axis." Obviously the proposition that we don't perceive reality as such is foundational to any theory or study of perception. More original to *The Mark of Man* was the project of "a great coming together" of realism and abstract art on the common ground of symbolism.

These speculations of his aside, three portraits illustrate the change of Walton's style from realism to abstract symbolism when he "arose from the ashes." His untitled lamb marker from 1944 (plate 7), emphasizing the herder's expressive eyes and brimless fedora, is already off realistic, no longer American Scene but not yet abstract. Walton did more than a dozen portraits of lamb markers that I know of, one of which (plate 8) looks to be an early abstract symbolic painting (the signature is of no use determining date, since Walton's signature changed little). The brimless fedora now stands above a face like an executioner's mask. Where a shading of red hinted at the herder's bloody occupation in 1944, here a neck entirely the color of blood arises from waves signifying the burlap sack and symbolizing the flow of blood.

The third portrait, from 1945, is fully abstract and fully symbolic. In *Self Portrait* (plate 9) we pick out Hitler's abbreviated moustache and the slanted bang he affected; otherwise the portrait is all Nazi colors, swastika and sieg heil salute, except for the single eye. Walton's friend Jim Hulse described the eye as "tyrannical," in keeping with the painting's theme, "the hatred and anxiety that nearly destroyed Western civilization." The schematic eye captures the person Hitler, no easy feat. Hitler is singularly difficult to see – you look at the face, the eyes, and ask, who is this person, but you can't see him. A human being who is all self is empty, is no self, symbolized by the schematic face with a vacant eye shot with fire and blood, the consequence of Hitler's world-consuming self-inflation. Hence the unexpected title, *Self Portrait*.

When first exhibited just after the war, *Self Portrait* caused outrage. Unthinking viewers misinterpreted the title as flaunting the artist's Nazi convictions. When exhibited in the 1980s, geopolitical realities were such that Walton covered it with unbreakable plastic, fearing "a Jewish zealot on the tender edge might hit it with a hammer." By then he had prudently changed the title to *Lest We Forget*.

But was there another layer to the original title? There's no question that the psychological portrait of Hitler is there in the painting. Beyond that, as with Biscaya's "Mexicali Rose," I ask myself how much Walton intended. Did he intentionally portray the artist's own egocentrism in *Self Portrait*? Or unconsciously project it?

Walton exhibited the painting many times over the decades. It never sold. A museum curator once offered $5,000 to buy it for her private collection. This was

during the 1980s. Walton asked Vivian what to do. She told him what he wanted to hear: $5,000 wasn't enough to buy a new car. So Walton turned it down. I have to admire Vivian, knowing how strapped they always were. She knew he didn't want it hidden from the world in someone else's living room. "It could be the painting of the century," he told his sister Florence, "Picasso's Guernica notwithstanding."

Walton's employment as VD investigator terminated early in 1946. Already he felt confident enough in his new abstract style to confront the New York art market. That July they rented out the house. He put the best of his recent paintings in the back seat, leaving the Tom Sawyers stored improperly in the attic, where two of them would perish in his absence. You can imagine there was some tension when he and Marijo set out: the incident when he made Marijo jealous by taking Dorothy Bartlett home from the Riverside bar happened "just before we went to New York."

It took them nearly a month to set their course. First to decompress they camped at Pyramid Lake for more than a week. That could be when he crossed lances with Charlton Laird at the nearby S Bar S ranch. Next, instead of heading east they backtracked to California, accompanying Marijo's brother Paul on a supply run to the herder Onenti on the high ground at Westwood, where they camped "for quite some extended time." This was Walton's valedictory sheep camp outing. From there they dropped down to Southern California to visit Walton's mother Myrtle in Santa Paula. She lived there on and off, and at the end of her life, on the lemon ranch of her married best friend from their Missouri childhood, Gertrude Harpold, a craftsperson with some "regional reputation." In Santa Paula Walton exhibited *Self Portrait* in a group show at Santa Paula High School sponsored by the Chamber of Commerce. The local paper covered the public's hostile reaction and Walton's defense, with a photo of Marijo looking at the painting. "She doesn't care for it," states the reporter, "although she can see the point of view. 'I think it's horribly ugly,' Mrs. Walton said." We can infer they hadn't completely decompressed.

Their route to New York as retraced by Walton – through the Southwest to Texas and the Louisiana bayous, then up through Mississippi and Tennessee and over into Washington, D.C. – omits the detour he and Marijo made to Chicago to visit the Bahá'í temple in Wilmette, where he renounced his affiliation in a fit of pique.

Walton's best contact in New York was Robert Caples. After Navy service marked by repeated hospitalizations for chronic conditions, Caples had returned to Reno for life-saving medical treatment overseen by his doctor father, and for a divorce from his Navy wife, his third. Walton didn't know he was in town. The next Walton heard from Caples was a May, 1946 postcard from his old friend, who by then had returned East to art school to remediate a yearslong layoff from painting. Walton took the postcard as a sign to come to New York. It resonated with the 1937 Christmas gift of *Moby-Dick* which Caples had inscribed in pencil, "For Moby-Dick Walton, the Sparks whale, from the Bell Street Ahab," below a sketched whale (see figure 5).

A fish and a mountain range

Now, nine years later I have a skeletal fish on a desert plain, from Robert. It shows a little mountain range, and it is signed by his usual "R." And there is no message, except that fish, which has been a symbol between us, for curious reasons, all through the friendship. On the photo side of this postcard is a broad view of downtown – midtown Manhattan. Bob was about to enter the Art Students League and be there for a while, on the GI Bill. Poor Bob had been in the hospital before he severed his relationship with the Navy. He'd had a prolonged stay at Bethesda. But Bob was never very strong. He had some insistent illness. But that didn't trouble his spirit. He was still the same wry and wonderful guy that I had known years before.

·

Caples had recommended the Great Northern Hotel a block from where he roomed. The Great Northern, in the heart of the gallery district, had literary associations. Walton planned to stay there for a month. But Caples had neglected to make the reservation. When they arrived no rooms were available, so they spent their first night in a less ideal hotel.

The vibrating room

Well, we went from that hotel to the rooming house [at 101 W. 56th Street, on the corner of Sixth Avenue] where Robert lived. And he had spoken with the landlady, who proved to be a very interesting woman. He had made all the arrangements for our stay there. And we finalized them with her. Bob had recommended it not as a very sumptuous place but as right in the heart of the action for an artist who was concerned with gallery hunting.

Well, that room was motorized. It was jumping from the moment we arrived till the time we left. Never stopped vibrating. It vibrated less in the late hours of night and the hours of the early morning. But as soon as you awoke, that room was vibrating.

·

Next day they visited with Caples, and the next met up with him at the Art Students League. Caples "was very concerned about Marijo"; he warned Walton to "be very careful in New York with strangers." Walton doesn't say if she went out by herself or anything about what she did. As for himself, with or without her he fell in with old and new friends, and above all made the rounds of museums and galleries. The highlight of the trip was the connection he made with the Betty Parsons Gallery.

Betty Parsons, known as the "den mother" of Abstract Expressionism, was a well-born painter and sculptor who repatriated from France after losing her wealth in the Great Depression. She taught and practiced art in California before returning to her birthplace New York, where she exhibited and worked in art galleries. Walton hit New York just when she was opening her own gallery, which became the art world nursery of Jackson Pollock, Mark Rothko and Theodoros

Stamos, among others of the first generation of Abstract Expressionists. He sat down with Parsons in her new office.

Never returned

From what Betty Parsons had said, when she first showed me a small Pollock painting she drew out from under her desk, I thought he was an Easterner. No, Colorado, with an LA hitch.

Three paintings we left at her newly opened gallery and were never returned to me. One of the three was *The Saint*, a second was a symbolic abstraction called *Lady Dealer* (a comment on Reno gambling), the third she had to have shown to Ad Reinhardt – it was called *Black On Black*. [Reinhardt] later did my blacks.

•

Nearly half a century after the fact Walton was claiming credit for inspiring Ad Reinhardt's signature "black" paintings. And that wasn't the only case of influence, borrowing, theft or however he regarded his effects on the New York scene in 1946. At the Parsons Gallery's debut opening he met Barnett Newman, the self-described "spokesman for the School of New York." Walton, full of himself now that his paintings had been accepted into this company, "lectured" (Walton's word) Newman and Theodoros Stamos "on symbolism in modern art" – only to read in the future "of Newman as a Symbolist." In a Newman sculpture acquired by the Museum of Modern Art Walton detected his own "cross like an hour glass."

Walton says the three paintings he left with Betty Parsons "were never returned," so presumably they never sold and he never sought to retrieve them – to do so would have placed him in an embarrassing position. So another near miss. In truth he wasn't ready for New York, and Parsons may well have accepted the paintings to placate this overconfident incessant talker from the West.

Also while in New York Walton tried to find a publisher for *The Mark of Man*. Through Paul Fanning, an old Chouinard friend whom Walton bumped into on the street, he got to the home of prolific poet and anthologist Selden Rodman, who would later buy a small Walton painting. Indeed it was Rodman who steered Walton to Betty Parsons. He also imparted advice, when asked, on publishing *The Mark of Man*.

Not responsive

He suggested, without seeing the manuscript – suggested from the overtone of my remarks – that it might be for New Directions, who were very advanced publishers. So I went to their office subsequently, left the manuscript, and picked it up before returning West. They were not responsive to it, and for good cause. It was not well written; it didn't know what it was.

•

Walton hadn't attained this critical perspective on the spot from comments by New Directions, if any, for he turned around and submitted the manuscript to another

publisher, one recommended by the New York family of a good friend in Reno, Eddie Star. It was the editor at Dorrance & Co. who "suggested that I rewrite it, and stay with the theory, take out the other stuff" – Walton didn't say what "other stuff," probably a first attempt at cross-genre literary autobiography. Walton remembered Dorrance & Co. as a publisher of "esoteric books on obscure spiritual matters, and theoretic matters." In point of fact, Dorrance was and is a vanity press, and *The Mark of Man* was spiritual, theoretical and obscure. Even so, the Dorrance editor advised revisions, but Walton "just wasn't up to it. Frankly, I wasn't author enough to do it."

One last New York episode. The record of it comes from the 1980s and Walton's last self-referential effort, *Harry*. In a stand-alone prose piece in *Harry* sweetly titled "Elephant Graveyard," Harry reminisces about his – Walton's – women, not the women important in his life but those briefly encountered.

The School of New York

Harry fell in love with an octoroon in a praline shop across from the Monteleone in New Orleans. He bought some pralines and never forgot her.

Harry wasn't hung up on memories but he had a high regard for them.

There was the girl from Ohio he met in the elevator coming down from an exhibition at a Manhattan gallery. She was a large beauty, a heroic brunette who told him she was a Hans Hoffman student, inviting him to come down and have a look around but Harry walked away headed for the automat, had lunch and never forgot. He said, had he gone down, he would have joined the School of New York in its infancy because of the student.

.

What if thirty-two-year-old Walton had possessed the discretion not to "lecture" the notables of Abstract Expressionism, the midcentury's most significant art movement, but instead had stayed in New York to learn and grow in the presence of Jackson Pollock, Mark Rothko, Hans Hoffman and the rest? His story would have been different, and that of American art might have been. His not possessing that character is the flip side of "refusing to compromise his lifestyle for the opportunities of the big city," the interpretation of Walton's choice to abide in Nevada by curator Spencer in the retrospective catalog.

Walton and Marijo returned from their long road trip on good terms and "so happy to be back in Nevada and home, we decided to build a sort of patio at the Marsh Avenue place."

The Virginia City Gasworks

And we came to the Comstock, to Virginia City, to find old brick. We inquired about, and were told there were bricks down below the power house. When we found them, we made other inquiries as to who owned them. We were told that a person called Nicky Hinch owned them. What the bricks were, were bricks from the old gas plant that was here, the historic gas plant.

Well, we negotiated with Nicky Hinch, who was a character in his own right. We paid him twenty-five dollars for brick, as many as we wanted. Ultimately, he said, "Well," he said, "I'll sell you the whole property for another twenty-five dollars." And we were so pleased to be back from New York City, and so joyous over the opportunity of acquiring a piece of property on the Comstock for fifty dollars that we went up to the courthouse and negotiated the transaction and bought this property – this property from which I am taping at this moment.

And when I had the survey made, I found out I didn't own what Nicky had sold me. But the thing is that then I acquired it from the county, very cheap, for fifty dollars a lot. He had nine lots down here. I bought a parcel of six – actually I bought a parcel of three from Nicky, legitimately, which were just mining dumps, I mean the most barren earth, flatlands beside the mining dumps. So we had access to these bricks.

▪

Walton and Marijo had eloped and married in Virginia City in 1938. They bought the bricks and land there in 1946, in his name. When they separated in 1958, he had the survey made, bought the extra lots, and moved from their Marsh Avenue home into a small trailer on the empty Virginia City property to begin building his house. He was forty-four. He would live there for the next forty-four years, until his infirmities forced Vivian to remove him from the locale that had held him for the second half of his long life. It was in their new home down the hill closer to doctors and amenities that Vivian offered me the souvenir of a yellow brick from the gasworks, the day I asked instead for Walton's *Moby-Dick*.

In 1946 when he and Marijo bought the bricks Virginia City had ceased to be quite a ghost town, but land was still cheap. The crown jewel of Nevada's silver bonanza had yet to experience its rebirth under the stewardship of Lucius Beebe. Artists were already drawn to the town, however. Artist Zoray Andrus had pioneered in 1937 when she and her husband rehabbed the Nevada Brewery in Six Mile Canyon. Robert Caples would arrive there back from New York in 1948. He and his fourth wife opened an art and gift emporium targeted at the growing traffic on the boardwalk. Duncan Emrich, Roger Butterfield and other nationally known writers already lived there. Walter Van Tilburg Clark arrived in 1949.

During the mid-1970s Walton took several years off from painting to write a book about his adopted home town, which he continued to revise at least into 1980. *Virginia City* (unpublished) was a history and a contemporary portrait of the place, in text and photos. The photos became the subject of Walton's third, 1994

retrospective. The text included sketches of residents, both those with notoriety such as Beebe and hotel owner Florence Edwards, and obscure characters the likes of Nicky Hinch.

Sharp in a deal

Abe Kendall oddly told how Nicky Hinch got his nickname. When a small boy, Elmer Hinch would ask for nickels on the boardwalk. A wag saw him coming, and when asked for a nickel, the man held out coins of all sorts in both hands. As usual, Nicky took a nickel, and the bunch around them laughed at his simplicity. Asked why he didn't take a dollar, Nicky drawled back, "Then you wouldn't do it anymore."

His sister, Alice Hinch Byrne, told a story of how Nicky had asked a stranger for a nickel, with the man turning his pockets inside out, saying "I'd give you one, but I don't even have money to eat on." Nicky left, but later found the stranger again and gave him a handful of nickels, saying it wasn't right, not eating.

Slow-speaking, overweight Elmer Hinch, sharp in a deal, both in youth and maturity, suffered a heart attack on a deer hunt, to join the legendary figures of the Comstock, equal in his way to Old Virginny.

.

The story of the bricks wouldn't be complete without Biscaya.

Louise suggested they take Biscaya along for loading and unloading. It was a three day project. When they picked him up at his chicken ranch cabin in Sun Valley on the second day, Walton decided to check his oil and somehow cut his hand badly under the hood. "My god, the blood spurted. And Biscaya paled! He just paled, and he said, 'Zhu! Zhu! Zhu!' and he ran to the cabin, yelling, 'Yai! Yai!' – he beckoned me, he didn't speak, he just beckoned and he grunted." Biscaya insisted by gestures that Walton wrap his wound in a filthy sack that stank of rancid bacon, and though afraid of blood poisoning, Walton was more afraid of Biscaya. But then he drove straight to a drug store and replaced Biscaya's sack with a sanitary bandage. Biscaya was so "disgusted" with Walton he refused to go along for more bricks on the third day.

The fate of Biscaya

Louise reported that Biscaya said [in Basque], "Too many Americans." Well, I was the only American around, that was one too many for him.

But in any case, Biscaya had paled at my injury. His human mercy was just over-flowing. And that was the depths of Biscaya that should be on record. Now, here is the biggest brute that I ever met in society – just seemingly the most complete brute of my acquaintance, this brusque man. So he refused to go with us anymore.

[At a future date] Biscaya had been to the store and he was walking home with his slight provisions. And the boys would torment him, the small children would throw rocks at him and torment him with cat-calls. And Biscaya had chased them, waving his arms and shouting things.

Well now, the authorities gathered him up. Louise officiated at these negotiations, she being his only point of contact with society. And they committed him to the state mental hospital. Not because he was insane, but because there was nothing else to do with Biscaya.

Well, that's not altogether sad, because the last I heard was that Biscaya was very happy. That they let him garden with his hoe, and that he would work as he pleased in the state hospital garden, working with his crops, and he could sit and roll his cigarette, and sing, and be to himself to his contentment. He was happier at the state mental institution than he would have been in society. And Louise consistently went to visit with Biscaya, to communicate with him. He didn't mind it at all.

So I've never been sorry about the fate of Biscaya. And I always think of him as one of the dearest people.

·

So it "should be on record" that maybe Walton did really intend the true, poignant moral of the sheep camp story about Biscaya singing "Mexicali Rose, I love you. I'll come back to you some sunny day."

In 1947, Louise conveyed most of the Etcheberry home ranch on Fairfield Heights to her sons John and Paul with a view to their developing it, as they did. To her daughter and Walton she gave their house and lot (with its new brick patio). This was the only financial interest in the home ranch that Marijo received, a state of affairs which led to a schism with her brothers, but not with her mother. Marijo knew the conveyances to be the machination of her brother Paul.

Louise, widowed in 1943, was simplifying her life. The sale of her share of the Santa Fe Hotel came to completion after the Lake Street fire of 1948 when the hotel, quickly rebuilt by Paul and John, reopened under the sole ownership of Martin Esain. The Reno City Directory lists her next in 1955 as a "maid" at the Santa Fe! It can't have been for want of money. This woman who came to Reno from the Basque Country as a maid for the Giraud family just wanted to be occupied. "She was a real workaholic," said grandson Paul, Jr.

That's also how Walton remembered her from her years cooking at the Santa Fe.

She didn't know any other life

Louise worked like a slave in that kitchen. Oh, I never saw anybody work like Louise. Poor thing had the varicose veins in her legs, and she'd been a very pretty

young woman, one could see, but she was just beaten with the labors and didn't know any other life style. That was it. She was a most respected cook. Oh, she had a big reputation as a cook. She performed miracles at the oven.

.

Louise continued as maid at the Santa Fe until 1961, then went over to the Riverside Hotel, where in two years she was promoted to head housekeeper. In 1963 she finally retired at age sixty-seven – but at seventy she was back at it, now at the Windsor Hotel. In 1973 she returned to the Riverside, where she remained until 1980. Then finally she truly retired, age eighty-four. All these years she lived with one or another of her children, mostly Marijo. She died in 1989.

Louise hadn't yet sold the Santa Fe when Walton and Marijo drove to New York in 1946. Prior to the trip Marijo had been "doing show card work" – a form of advertising art – as an assistant to Reno artist Lyle Ball. Before and after New York she designed window displays at the Reno branch of I. Magnin, the upscale California department store, and over the next years had several jobs along the same lines of advertising and display, plus occasional modeling. It was the impression of the Waltons' friends, and largely the fact, that "Mariejeanne provided their income."

Walton once drew up a resume for his purposes as autobiographer on which he put VD Inspector 1942–46 as his last employment. That's not technically true, but the position under Dr. Caples was indeed his last regular, stable job. There was his stint in 1948 at Frank McCulloch's *Nevada Highways and Parks*, doing layout and contributing photos and drawings, as well as the articles on sketching with Caples and on sheep camp. Before and after that he tried to make a go of it with "Bonanzart," landscape and life art classes at his Fairfield Heights studio.

It was strange

Well, after my art classes in Reno dropped off, and my experience with the *Nevada* magazine had occurred, I tried to swing my affairs over to a more realistic area. The money I had made in those years with the art class on Marsh Avenue didn't amount to anything. Marijo and I weren't happy, but we had kind of a loving kindness situation, and lived together not as strangers, but – it was strange. And from this point, one can see that it was an impossible situation for both of us.

.

What "more realistic area" of money-making Walton swung over to isn't apparent. Sales of art weren't paying greatly. In 1947 he exhibited locally in a saloon (with Marijo), a church auxiliary group show, and a bookstore (with sittings available for Christmas portraits).

Abstraction from the following year (plate 10) is interesting primarily as an early instance of a technique that Walton would continue to employ through many permutations of style. "Paper painting" produces "a kind of monoprint," a one-off combination of printing, painting and drawing. Walton adopted the technique from Paul Klee, whose influence is distantly discernible in *Abstraction*. Klee drew

on, or incised, a painted piece of paper whose load of paint he then transferred by pressure to the painting's surface. The quote below comes from a 1970s audiotape synopsizing Walton's use of paper painting, also termed his "stamp-on technique."

Press down and peel off

[The artist] will use [the piece of paper] as a tool, like a brush or a palette knife. When he gets it full of paint, as needed and flat, thick enough but not so thick as to go where not wanted, he will press the paint edge down to the painting, and peel the printing paper off, transferring the paint to the painting. He will then load the printing paper again and repeat this method as he sees fit.

.

In 1948, the year of *Abstraction*, Walton exhibited once in Reno but thrice in San Francisco group shows: at the California Palace of the Legion of Honor and at Gump's and City of Paris department stores. Money didn't flow in from these endeavors, and Marijo carried them. Plus they had the house, and Louise supplied them with staples from the Santa Fe kitchen even after she demoted herself to maid.

A generous woman

Through the marriage she was so generous that she would give all manner of things – chickens and coffee and sugar and all kinds of things would materialize from the Santa Fe Hotel. Well, later I was to find out that it's a Basque tradition for the workers who work for the lord of the manor to go home with certain things from the kitchen. And that the owners of the house understand that that's traditional, in the Basque Country. Well, she continued the principle from the Santa Fe Hotel, and we didn't buy any coffee for years. (Marijo and I were married for almost 20 years.) Such a generous woman, and so sweet. But even continued when the hotel was taken over by Martin Esain.

Well, this didn't do my ego any good. There was no way to discuss this. Marijo wouldn't talk about it ever, anything that had to do with her family I could never even discuss. Couldn't even discuss it at all.

.

Walton wasn't earning, and they "weren't happy." Walton associated these two realities, but his and Marijo's problems went deeper than money. A hand-written, half-illegible chronology he drew up in 1978 hints that he had begun to stray during the war. Was there an Alidia in 1944? Someone Ju- or Fu- in 1945? In his tapes and writings for posterity Walton skirted the matter with vague allusions such as "weren't happy" and "impossible situation," but in a letter which he had no reason to suspect would ever see the light of day he reminded Robert Caples, as one man of the world to another, of the day in 1948 or so when he, Walton, was with a woman when Caples in his sly sardonic way introduced Walton to another man with a salacious insinuation. The man knew perfectly well who Walton was, but Caples, writes Walton, had said, "'This is Charles Strictland.......I mean, Dick

Walton.'" In W. Somerset Maugham's *The Moon and Sixpence*, Charles Strictland is a painter modeled on Gauguin who leaves his wife for art and has other women. The lady in Walton's company "didn't get it," Walton's letter informed Caples, who had never heard this detail of the story, "and when I explained she said, 'How dare he think that of me?'"

But perhaps what Caples implied by the comparison to Charles Strictland was what that character says of himself, "I've got to paint, I can't help myself." Or implied the rough manners of both. Or the mystery of the ineffable from the hand of someone so unmannerly. Perhaps the sexual angle was on Walton's mind, not on Caples' at all.

More explicit is a vignette from "Elephant Graveyard," Walton's fond catalog of lesser women in his novel *Harry*. Versions of *Harry* have different treatments of the episode which conflict, but only in details.

Myrna at the vegetable counter

Had he fallen for Myrna before he saw her Christmas window in 1948? Her apartment was on the upper floor of a two-story rooming house. They had met at the vegetable counter of a local market, and he had taken her home a few times.

Mirna in drawing class

Harry must have fallen for Mirna when he saw her window that Christmas when he was teaching. It was on the second floor of a rooming house beside the Truckee River. She came to him through his ad in the Reno Gazette [1947]. She was interested in the drawing class. One night he took her home and it was her window, all right. There was the palm tree, the donkey and the Wise Men without the Holy Family. He had a chance to see it from the other side. Mirna's family was circus. They had done a high wire act with Barnum and Bailey. Mirna set up a high swinging bar in back of the rooming house where people, headed for work, would see her do a routine for exercise. Harry said they built a hotel Casino on the property and three crap tables mark the site.

He once spoke to her of Symbolism. She said she understood. When she was broke she had taken a job in burlesque. "It was so embarrassing," said Mirna. "Standing before all those people, naked, holding a fur muff. I was Winter. Symbolism! I know what you mean."

She married the manager of an auto parts house and became one of the vanished souls. Harry held a glass of Jack Daniels when he said, "The lost ones go to the elephant graveyard. They never return."

▪

What of elusive Marijo, was she faithful? Opinions differ. Vivian Walton, generally a realist about her deceased husband, regards him as a great artist and no worse than a difficult man. He led her to believe that Marijo also had extramarital attachments, that they "lived separate lives." It could be, of course, that Walton

shaded the truth of Marijo to his second wife to appear less blameworthy. But Walton's younger friend Robert Debold, ninety-one and living in Guam with his wife when I contacted him, emailed: "Of the many of Walton's friends whom I knew I never once heard a word or tiniest hint of any affairs involving Mariejeanne." Debold regards Walton as a great artist and a scoundrel. He wrote that Marijo "had absolutely no reason to remain faithful to Walton," and that "the events left me with no respect for Walton's character."

I've come across no indication he was ever unfaithful to Vivian.

With Robert Debold it may be a case of deflated hero worship. He was one of a company of admiring undergraduates who took to gathering around Walton at the Marsh Avenue house. Initially they came for drawing classes which Walton advertised in the paper, with further recruits by word of mouth. A few were art students, most merely wished to widen their outlooks. Walton doesn't say what he charged for these lessons. It can't have been much, and became nothing as the gatherings evolved into an offbeat salon with Walton at its center, as always the incessant talker overflowing with ideas and observations. He called this coterie of students half his age "the Boys," seeing himself, and even describing himself to them, as in a mentoring role comparable to the one James Swinnerton had filled in his life when he was student age and one of "the Swinnerton boys," though Swinnerton's were never a group around him as were Walton's. The Boys called him "Walton" or "Uncle Richard," and to each other "the old man." This "old man," who when truly old would be described as the "'Grand Old Man' of abstract art in Nevada," was attracted to youth throughout his long life. He was only in his mid-thirties when these gatherings started up.

The Boys

My thoughts are concerned with Loring Chapman and "the Boys," that remarkable group of undergraduates from the University of Nevada which congregated at the house on Marsh Avenue in Reno, around 1948, intermittently, missing one here and one there, through the years until – through 1957.

And so I became "Uncle Richard," and those were to be some of the richest days of all my years, to be surrounded by these harum-scarum but brilliant young lads from the University of Nevada, who were attracted to the studio life on Marsh Avenue. Marijo was patient and indulgent of those wildcat visitations. They were welcomed by us both. And they used our studio room as kind of a club. It

was almost a public place. I've heard some of them remark on this in later years, with perspective.

.

The original cohort of Boys included Gunter Guigas and Pat Armand, who together brought along Loring Chapman in 1948. Other originals were Bob Glass, Sam Kafoury and Hank Cantlion. As this crew depleted, others came on board. Bob Glass introduced Debold in 1950 or 1951. Jim Hulse, although he knew Chapman in undergraduate days, didn't meet Walton until 1954 after service in the army. Of undetermined epoch are Bill Stone, Ross Campbell and George Bennett.

From what I gather, Marijo (twenty-six and up during those years) and any young females who came to the studio with the Boys were sidelined. As a progressive, Walton considered himself no sexist, to use the Sixties coinage for this pattern of behavior. He condemned such conduct in others without noticing the parallels. One of his tapes takes artists Hilaire Hiler and Jean Varda to task for something similar, in a passage worth quoting for its incidental revelations about Walton's relationships with artists. After Hiler he comes to Varda.

While the men talked

I've seen that same thing over at Varda's ferryboat by Sausolito, a young girl [in] that same role – not really a servant, but background person, you know. And these guys, these painters, they get the young girls from the art world, and they fix them on themselves, apparently. Varda always had a few, I guess, from what his reputation is. And I visited him one day at random, and we talked about our mutual friend Caples. Varda never liked me very much, I don't know why. I wasn't what he liked in society. He liked a very pleasant, sociable kind of a thing that – I'm too aggressive sometimes, I don't know. Varda never fully accepted me, as an artist. I don't know. He didn't allow any room for me. He was full of shit, Varda. Varda had plenty of it. But I respected him. I respected him as an artist and he had an enormous influence on me.

But both these guys, Hiler and Varda, had young girls there as attendants. They weren't quite people, they were just young girls, and they were there while the men talked. Ha! God damn.

.

Walton prided himself on forming independent friendships with the wives of male friends, something his history confirms. And as he once told Joanne de Longchamps, "You can't talk to men very well – at least I can't. But I can talk to women." This doesn't gainsay the male dominance of the gatherings on Marsh Avenue, nor that Walton's way was always to dominate conversation, so the line between sexism and egocentrism blurs. Thankfully the implication of sexual exploitation as by Hiler and Varda is absent from accounts of the doings on Marsh Avenue.

Walton, by then an experienced instructor of art, freely imparted his expertise. The gathering place was his and Marijo's studio. As the classes lost formality,

Walton would paint at his easel with one or more of the Boys taking in his lessons on technique or composition, or conversation ranged to other topics.

But it wasn't all art and conversation with these "harum-scarum" lads from the university. Walton himself was good for a joke, and some of his Boys were pranksters.

A brag

On one occasion, after a Nevada Day celebration in which they had celebrated their new homecoming queen, they had promised to bring her to the house, to deliver her on the porch. Well, they failed in that brag. Instead of that, they brought a post that they had dug up, a post with an enormous cable that they'd taken from the parking lot at the University of Nevada, wishing to bring me something. Well, in the morning I went out and there was that post, this great big 12 inch square post about 6 feet long, with this great cable.

And the Boys would go sledding, and they'd come up in – twelve, one o'clock at night with some car towing a sled. You could hear their voices before you even heard the car.

·

Of the originals, Bob Glass became a teacher, Gunter Guigas and Loring Chapman scientists, Sam Kafoury an engineer, Bill Stone a medical doctor, Hank Cantlion a Navy flier.

Commander Cantlion

I do think Henry is a better man than me; you could depend on Henry to set a plane down on a dime, 747 or Piper Cub – what did I know about flying? Henry is the only great flier I personally have. Nixon, Kissinger and Werner Von Braun might agree. The President was assigned Commander Cantlion as a NATO escort in Naples, and Von Braun got to be Hank's friend on flights to the Antarctic; Hank knew Von Braun as a gentleman and good company.

·

This passage from *Beyond Holland House* exemplifies how Walton stayed in contact with a number of the Boys, some as lifelong friends. Bob Glass, eccentric son of a Reno banker, became a science teacher. Walton befriended three generations of Glasses, receiving annual Christmas photos in perpetuity. Sam Kafoury was an engineer at Douglas Aircraft when he and his wife Emma Mae hosted Walton (as occasionally did Bob and Jean Glass) in the earlier stretch of years when the artist was making selling trips to Hollywood and environs. After the Kafourys moved to Coral Gables, Sam and Em hosted Walton on trips to the Keys and the Bahamas. In 1975 Walton depicted Sam as "my chief patron of these days." He bought Walton paintings at full price.

As the Kafourys were divorcing in the 1980s, Sam phoned Walton forlornly: "You're what's left." "No, Sammy," Walton answered, "there's Loring. When you're cut, he bleeds." Loring Chapman was "kingpin" of the Boys. A pioneer in the field

of behavioral neurobiology, Chapman published widely and was much honored. It was Loring whom Walton advised down the road how to seduce the single ladies in Loring's condo complex after his divorce.

Immediate friends

After his first class, I quizzed him about his purposes for taking the class. He was a pre-med student and simply wanted to extend his horizon. I was terribly drawn to him. And Loring always had a little quality of embarrassment, of not knowing what to do, and he always defaces himself. But this is a vanity, because he has an ego which is the equal of Napoleon's.

He was of slight build in those years, and he was not very tall. And a perceptive person. You could see that his intelligence was extensive. For that reason, we hit it off into channels of a certain depth from the beginning in our exchanges, and there was no pussyfooting in this relationship, we were immediate friends. Although he was so much younger than me. He was said to be the youngest student at the University of Nevada at that time, and was accustomed to being in the lead scholastically, in whatever arena. Loring had been a Quiz Kid. In the days of radio there was a very famous program called "The Quiz Kids." The Quiz Kids were the brightest children in the United States. Well, need I say, Loring was a Quiz Kid in his time.

Well, after the drawing classes, Loring would stay in there. And I understand that I tended to lose him some time at the University because of these conversations – would kind of screw him up. But he has no regret about it. He feels that there's something that we shared in those years that was invaluable to him. Our talks were extended along technicalities of life, and some of his problems, as well as ponderings into the world of art. We would get bored pretty fast talking about art.

Loring had no extreme talent as an art student. But he had a peculiar touch that came out in his self-portrait. If he had wished to, he undoubtedly could have made a plunge into the arts. He would have been one of those wild talents in left field. He had very little discipline as a draftsman. He had all his discipline in the academic world, however, at the university. There was a period in the summertime when Chapman would disappear. He'd say, "Well, I won't see you for a while," he said, "I've got to do some studying." He would go to the library, get all the books on his subject, and he had the ability to speed-read. He could look at a page like a sentence, and go to the next one. And he'd commit all this stuff to his memory bank. And he passed with the highest grades, and I was told he slept through most of the lectures. And was a phenomenal personage on the campus. Well, he always played in the band. Among his other accomplishments is his instrument, the clarinet. I owe Loring a good deal for opening my eyes to elements in Stravinsky and in William Walton, my namesake. Oh, and in Samuel Barber.

Well, today Loring has his gray hair as well as I do myself, with tenure and with the full professorship, which are conditions, I understand, in the academic world

that are significant. Of all the "Boys" that came along in that group, Chapman seemed to have gone the farthest.

·

Chapman opened Walton's eyes to several contemporary composers. In recalling this, Walton took his having a foundation in classical music as a given. Where did that come from?

Today when so-called serious or classical music has a niche audience and live concerts are largely attended by a geriatric demographic, you wouldn't guess that in midcentury America conductors like Arturo Toscanini and musicians like Jascha Heifetz were fixtures of popular culture, familiar across America through CBS and NBC radio broadcasts. When Walton elsewhere told of crossing paths with the wife of conductor Leopold Stokowski, he assumed the listener would know who he was talking about.

The introduction was another Robert Caples favor.

Off with Garbo

Bob asked me to meet him at Brundidge's, and I met him down there, and he said, "There's somebody I would like you to meet, that I'm to meet." And he said, "It might be worth your while." And along came this very large and very lovely woman. And she introduced herself as Evangeline Staples. She was actually Evangeline Stokowski. Stokowski was off touring Europe with Greta Garbo at the time, and they were lovers, and Evangeline Johnson came to Reno for a divorce and thought she would be pursued by newspaper people.

·

Evangeline Johnson Stokowski and her sister, heiresses of Johnson & Johnson the medical company, went with Walton to his Clay-Peters Building studio, where each made a purchase. This was during the Federal Art Project, in the days of radio and 78 rpm records. The milieu of Reno's "presumptive social set" through which Walton circulated, and before that the milieu of art school in Los Angeles, provided the young man from Stockton opportunity for self-education in classical music.

Among Walton's closest friends was Eddie Star, a cocktail pianist and singer with classical training (figure 16). Eddie socialized with the Boys, as evidenced by a single reference in a late Walton novel: "Hank [Cantlion] moonlit as drummer with his university gang: Glass on bass, Chapman – clarinet, Debold – piano, at times Eddie Star." But the friendship with Eddie, who had come to Reno about 1940, predated the Boys: in 1946 Dorrance & Co. had been recommended to Walton for *The Mark of Man* by Eddie's father on Long Island, Jules Starr. (For show business purposes Eddie dropped the terminal 'r' from the family's anglicized surname, which had been Staropolski in Russia.) Walton's novel *You Wouldn't Believe it* places Eddie in a different circle of Walton friends.

Figure 16. Eddie Star's business card

You Wouldn't Believe it was the third of Walton's three novels produced in as many months at the turn of 1950–51. This is his Reno novel, revealing the old-Reno side of this many-sided man who came in on a train at fifteen in 1929, an aspect of him as genuine as any other, and one he owned by writing the novel, even if *You Wouldn't Believe It* is by far Walton's least Walton-centric novel. He is there, if at all, in two minor characters. The major characters are real friends of Walton's, the plot a patchwork of their adventures and misadventures, culminating for no compelling reason other than drama in the great Reno flood of November, 1950. The author displays his familiarity with Reno's gambling/hotel/bar scene, today rebranded as "the gaming industry." An historian of that subject might well unearth fresh details here about the owners, owners' families, performers, gangsters, floozies, bartenders, maitre d's and doormen of the era. My interest lies in the immediate circle of Walton friends who gathered at Compton's Bookstore, John Spann proprietor – the John Spann who introduced Walton to Marijo. Spann had inherited Compton's from Mrs. Compton, a family friend.

The bookstore becomes a gift shop, its proprietor a crude sexist with a law degree named Wilmer Flyge. Spann really had the degree and went on to practice. If the one-dimensional representation of him as a committed male chauvinist pig is anywhere near accurate, he wouldn't have objected. Less comfortable with his character was Rae Steinheimer, Walton's senior by five years, whom Walton at

age sixteen first met at a party of sister Florence's friends. Walton leaves out Rae's colorful father, a Reno businessman who made his fortune trading high-graded (stolen) ore from Gold Hill. The Rae character, Robert Von Holst, is a cliche macho Hemingway wannabe who uses "Von Holst" in place of "I." All including a wife who disparages his sexual performance spend the second half of the novel trying to protect Von Holst and themselves from the alcoholic's three day bender. Rae took offense. Walton defended his methodology.

Most of your major writers

Rae Steinheimer was quite sensitive about – "Well, Walton," he says, "writes about his friends." Well as I understand it, a writer has to. Actually *You Wouldn't Believe It* was an excuse to set down a group of friends. These are not the exact people. I took an author's liberty in revising all circumstances and revising all names, as a novel should be done. And these are purely imaginary circumstances, done in a broad and sweeping hand.

You either write about your friends and your personal experience, or you're not writing at all. Hemingway said you better know something, or don't write about it. But it is fairly fictionized. Well of course most of your major writers have to drain from their personal experience.

.

The fictionalizations were superficial, for anyone with the key – and Reno is a small place. Craftwood Gifts and its lawyer proprietor were obviously Compton's Bookstore and John Spann, Von Holst the hunter obviously Rae Steinheimer the hunter. If anything *You Wouldn't Believe It* is flawed like Walton's other novels by what you might call the fallacy of the factual. Were such a roman à clef published today without permissions, the subjects could sue on the grounds of misappropriation of their lives, if not slander – not that Rae and the rest would have.

Walton was oblivious to the unflattering portrait of himself thereby created. The author doesn't rise above his characters by recording them. He must not have been aware that isolating his friends' foibles to the point of parody belied his warm regard for them, something that comes across in *Beyond Holland House*, a much later autobiographical novel, really a memoir, selective of facts but not fictionalized.

I loved him as a brother

Reserved more than shy, Rae said little but talked long, one on one – calling them "the good and the long talks" – we had a few. A booster of Hemingway, many of his friends endured Steinheimer as the writer's alter ego. In the end he drove his Porsche to a Vegas hospital when he had the heart attack, signed himself in and died. Germany and Scotland had given him a kind of guts I've never seen the word for; I loved him as a brother.

.

The last thing Rae said to Walton: "In the end it's the old friends."

Figure 17. Walton studio in 1948, with Marijo Walton, Rae Steinheimer, Roscoe (Ross) Campbell and Bernard (Bennie) Herrmann

Another Walton friend subjected to parodic exaggeration in *You Wouldn't Believe It* is Bernard (Bennie) Herrmann in the character of composer Berny Bernfeld, a morose, self-involved Jewish schlub with "an underlying handsomeness" who sits in a chair "like a wet sheet" (figure 17) reading Havelock Ellis on sex, as Herrmann did in Spann's bookstore where Walton met him in 1948 when Herrmann came to Reno for a divorce he didn't want. Walton knew Herrmann's music before he knew the man.

Concerto Macabre

I first came to Bennie through his piano concerto when I didn't know him at all, sitting in the Majestic Theater in Reno, alongside of Marijo [seeing] the film *Hangover Square* [1945], and had been amazed that such a piano concerto would be in a film, never to be heard again. Later I connected the composer, Herrmann, with his role on the Sunday CBS Symphony [radio] program I routinely preferred over the more familiar Toscanini broadcast on NBC. Bennie programmed more adventurous music.

•

Hangover Square, available on YouTube, is a dated psychological mystery of the amnesia genre. The murderous composer dies performing at the piano in a fire set by himself at the debut of his concerto. Rising above the noir melodrama is Herrmann's score, cited by Stephen Sondheim as "a major influence" on his *Sweeney Todd.*

Herrmann (1911–1975), an academy award winner, wrote the scores for *Citizen Kane* (*William the Great* in *You Wouldn't Believe It*), *Vertigo*, *Taxi Driver* (dedicated by Martin Scorsese to Herrmann) and many other notable films.

Rare musical experiences

I have had some rare musical experiences with Bennie Herrmann. When first visiting my Reno studio in 1948, I played my newly purchased recording of the Holst *[The] Perfect Fool* ballet for him. Bennie and I were diagonally across the large studio. After the introduction of the horn – [Walton sings the part] – with that strong beat that follows, Bennie began conducting me as though I were the full orchestra, nodding his head before my entries on all the instruments, then pointing his hand at me on cue. We finished the full score together, you know, in peculiar silence.

•

In coming years Herrmann would facilitate the commercial success Walton achieved as a painter selling his wares in Hollywood.

And then there's Eddie Star. His character Hymie Fink the unhinged cocktail pianist teeters on the brink of antisemitic stereotype, excused by Walton's deficiencies in narration of this sort and saved by his record of partiality to Jewish friends, his naming of the "wondrous Jew" Einstein as his role model, and his glad suspicion that his great-great-grandfather on the Walton side was a Jew. Assuredly Eddie's own expression, the title *You Wouldn't Believe It* comes from the habitual exclamation of serial liar and exaggerator Hymie Fink. The novel opens with Hymie in crisis because someone has gouged out the eyes of his dog – only nobody did, and nobody believes it. The real Eddie suffered from a brain deficit, as Walton explained in a letter three years after Eddie's death in 1979.

A hole in the head

He said, "You know, I have a hole in my head." I said, no, I didn't know and Eddie shoved my finger into a skull depression that could have caused him to wash his typewriter in the bathtub to clean up humanity.

Eddie said his brother Joe Star had struck him during a row over who'd use the skates. The wheel of one of the skates had made the dent in Eddie's skull. My friend Chapman (Dept. Head of Behavioral biology at UC Davis Med. School) told me no one was likely to escape brain damage with such a brain pressure and other complications. Chapman was a former student of mine and I respected his

view and forgave Eddie Star many dumb things which made no sense whatever in the human story. Brother Joe had performed a sort of lobotomy on Eddie using a roller skate.

.

I wonder if a reader can decipher Walton's idiosyncratic figure of speech about the typewriter and the bathtub – unless that's an implausible thing Eddie literally did?

How he and Eddie met, Walton didn't say in his books nor on the tapes I listened to. Remarkably, Eddie comes up on tape more than any other person with the exception of Vivian. Yet it's difficult to grasp where Eddie fit into Walton's life. John Spann was a casual acquaintance, I gather, Rae a boon companion, Bennie a fellow spirit in the arts and a patron. But Eddie? He's here, he's there, almost like a family member whose presence explains itself. Maybe he's like Biscaya, or like Uncle Lawrence for that matter, extreme types whose dynamism took ego-driven Walton out of himself. Or is it that, in these personalities, he unwittingly or wittingly saw aspects of himself: Biscaya the antisocial brute with tender mercy, high-spirited Uncle Lawrence possessed by appetite, Eddie Star the holy fool?

Eddie had six wives. In the novel he's on his fifth, a B girl he treats no better than she him. "Why do I always marry crazy tomatoes?" laments Hymie. Hymie/Eddie is a man of schemes (like Walton). In the novel, to make a few dollars Hymie cooks up a publicity photo for a casino hotel and its sexy diva with him playing a spinet for her on the diving board of the outdoor pool surrounded by showgirls in the water. The diving board photo shoot looks like a scheme Eddie hatched while Walton was writing *You Wouldn't Believe It*, for the following June the *Journal* carried a publicity photo something like it: Eddie Star and two other artists, one of them Walton, at poolside before their easels painting a starlet who stands on an oversize die on the Riverside Hotel diving board (figure 18). Eddie had ambitions to be a painter as well as musician. With financing from his father he tried to set up as an art dealer, unsuccessfully. As another source of income he dressed windows at Gray Reid's department store.

The tapes show Walton doing his best to look after a friend, without ever giving himself credit for it. Eddie is in trouble, or sick, or tries to kill himself with pills. Walton consoles or counsels him or visits him in the hospital. When Walton became enthusiastic about bow hunting, he included Eddie, no outdoorsman. Wouldn't you know, Eddie managed to shoot himself through the flesh between his thumb and first finger. When Walton and Marijo took on management of an art gallery in Newman Silver Shop on Second Street, they brought Eddie in. "Thoughts of Eddie and his state of depression still burden my thinking," he said in 1975. "I don't know what the hell to do about Eddie." When Eddie's hip and femur became necrotic he had replacement surgery. The bill came to thirty thousand, which Eddie didn't have. He hit the bottle, his liver was destroyed, his wife (the last of six) left him, the house was "a shambles," he had no furnace oil. Then in 1979 he was hospitalized for an exploratory operation.

Figure 18. The Riverside Hotel diving board photo, Walton left, Eddie Star center, 1951

May I say, I love you?

The man with the tubes is Edward A. Star who got the cards from Louis Armstrong, calls from the Lone Ranger, commiserations from Cat Ballou, he'd played Rachmaninoff's Piano Concerto for Leopold Stokowsky at the Christmas Tree, played breaks at the lake for Liberace. How to say he'd taken me backstage at the Riverside to meet Kay Starr in her dressing room, that she'd later sung for us, personally. What about Buddy Baer. Eddie fishing with David Raksin or playing 'chopsticks' with Herrmann?

[Eddie asked Walton to hold his hand. They sat nearly silent for half an hour.]

"Richard, do not get me wrong." There was a break, and when he got himself together, said, "You know I am not that way, but may I say, I love you?"

There was another day. Found him in the hall on a gurney, being rolled to surgery. The doctors and orderlies handling him stopped for me to have a word with Eddie. I forget what I said. Eddie's voice was faint. I bend close to get his words. He was saying, "When I go upstairs this time, I'm not coming back."

On the other visit he had asked God to let him die, had given up on family. His brother Joe called from Roslyn Heights, asked me if I'd take care of Eddie's ashes for them, to say a few words and scatter him over the land he loved best.

Knowing I couldn't speak on that occasion, I recorded a scrap from a Hebrew booklet Eddie had once given me, then retaped him singing the Coyote Song caught

at a party on the Big Robert. Sealed fast, the undertaker's box couldn't be opened, so I smashed it with a small ore pick, transferred Eddie's burnt crumble to a paper bag along with the Panasonic and the Star cassette. Ted and Helen Garland came up to be with me, and we climbed the hill west of Sugarloaf that's across from the grave known as Julia Bulette's. There I played the tape to the Flowery Range, and that was how Eddie Star sang at his own funeral.

·

Walton saved a "fragment of charred bone filched from Eddie's remains."

The 1951 diving board photo with Eddie and Walton at their easels gave publicity both to the Riverside Hotel and a nearby outdoor art fair of which Walton was chief organizer. The 1949 iteration of the fair, a project Walton conceived and realized, had Eddie as its titular chairman initially, but Eddie ceded the position to Walton for reasons that I imagine had to do with Eddie's compromised thought process. In that first fair, Walton exhibited a work which had already garnered press attention on account of the scandal it triggered in Reno.

1949 was the year when the Santa Fe reopened after the Lake Street Fire; when Charlton Laird's "piece of shit" novel was published; and when Walter Van Tilburg Clark's *The Track of the Cat* appeared and he moved to Virginia City, nearly a decade ahead of Walton. 1949 saw Walton exhibiting in the Francis Taylor Gallery of Elizabeth Taylor's father in Beverly Hills; in Carson City at an Admission Day group show; and at a show he mounted in his Marsh Avenue studio which included Caples and Craig Sheppard as well as Marijo. And his paintings continued on sale in the high end San Francisco department stores Gump's and City of Paris through 1949.

The scandal commenced the day after the opening of a Walton show in the gallery space of the Reno Little Theater in May. Some lady complained to the chairman of the theater's board of directors, Carl Shelly, who happened to be a county commissioner, about Walton's painting of a nude. The chairman "jerked the painting out of the exhibition." Another Walton nude from the same year (plate 11) resembles his description of the offending item, except that for the latter he used his recent paper painting (stamp-on) technique to convey the offensive body part.

A little shadow of red

It was a stylized torso and had a waist, just a line, and a triangular rib cage and a rather bulbous pelvis. Inspired somewhat by Minoan figures. An altogether

abstract creation. It had a shadow underneath the arm, and to turn the belly of the torso, I put a little shadow of red at the crotch underneath the tummy.

When I went back the next morning, after I'd hung the show, to see if the pictures had settled, to straighten them, which is practice, I missed the painting. I said, "Well now, there's a painting missing. Where is that?" Well, they didn't want to talk much about it, they said Mr. Shelly had it removed. So I called Mr. Shelly, who ran a hardware store in Sparks. And I asked him what was wrong, what the objection was, and he wouldn't discuss it. He said, "You know very well." I said, "But I don't. I don't know what your objection is." Now if he had some kind of a background thought that it was sexual, I didn't know – I really didn't know whether it was the time of the month in his mind, or if he thought red-hot flaming genitalia, or what. But he wouldn't discuss it, and he slammed the receiver down in his rage.

Well, Rae Steinheimer happened to be sitting there. And I said, "Well," I said, "I can't let this go, just without objection." I said, "It forces me to remove the paintings, all of them." So Rae went over and together we pulled down the exhibition, and brought it back to the Marsh Avenue studio.

·

In fairness to the commissioner and the offended lady, Walton's many nudes from this period unquestionably had an erotic quotient (plate 12). The question is, was that any reason to censor them?

Pulling down the exhibition was just the start. Through connections of Rae's an article aiming to embarrass the board chairman was published in a start-up newspaper, the *Reno Reporter*, under the title, "County Commissioner Bans Painting." Then Walton got the notion to organize an art fair to be held at Powning Park and Virginia Street, to stick a finger in Commissioner Shelly's eye by flaunting the censored nude in downtown Reno. With approval from the city council, Walton assembled a committee (chaired by Eddie to start) and sent out notices, with "a very heavy response" from artists around the state. He brought it off in less than a month.

An apology

I was to hang the offensive picture in the middle of the Virginia Street bridge, subsequently to be photographed with two little kids, two little boys, looking up at the painting, and I was sitting beside it by the lamppost with the small, inoffensive painting being viewed by these children.

Well, the Associated Press was to come along and run that story. And the result was that I got an apology, a letter of apology, from the Reno Little Theater board. At the top of the list of signers of this letter was the name of Carl Shelly. And then outstanding persons of the community, who supported the Little Theater, many of whom I knew personally. But in any case, we made up for the banning of the painting.

·

Someone in Reno for a divorce must have bought the controversial nude at the fair, for it shortly made its way to Riccardo's restaurant in Chicago, a turn of events that merited gossip column coverage in the *Chicago Tribune*.

The following year, 1950, Walton had two group shows in Reno, at the university and the Twentieth Century Club. And besides continuing at the department stores in San Francisco, he had his most important exhibition to date, at the de Young Museum in Golden Gate Park, the museum where sister Florence took him as a boy before he grew "obnoxious." He had already exhibited there in 1942, but only one or two pieces in a group show. Now the de Young gave him a gallery. A year before his nude had been censored at the Reno Little Theater. At the de Young he was censored again.

This wasn't shown

A pro-woman curator, Ninfa Valvo, declined to show my rendition of "Adam" because of his symbolic penis. After all, I had been a VD investigator, assigned to Nevada throughout the then recent WW II. I knew far better than the curator what a penis was and had a unique symbol of "the father of man's" genitalia. With conviction I made it a penis of a few inches long and perhaps six inches wide. It had been circumcised and was a remarkable tribute to Adam. But Ninfa Valvo did him in & this wasn't shown.

Another rejection was a better painting named "Red Nude" and I can think of no reason not to show it.

.

When he and Marijo separated, *Red Nude* was the only Walton she wanted.

This time he prudently didn't pull down the show. His twenty-nine paintings hung from October 24 through November 24, with an opening reception by invitation. The show received nearly a dozen notices and reviews in San Francisco and other California papers. Yet its most consequential outcome for Walton was a family matter: he came to accept his father, something touched on tangentially at the end of one review, where Nan White the reviewer took the human interest angle to report that Walton was "most pleased by the fact that his father shut his grocery store for the first time in 15 years to attend the opening."

Just weeks if not days after the de Young show closed, Walton dove into writing novels. By January he'd finished the first, *Pyramid*, and was on to the second, the story of his childhood and teens. The closing chapter of *The Delta Queen* leaps ahead almost twenty years to the de Young show and the matter of his father, whom he embraces by bringing to life the loving heart and paternal pride beneath the man's ignorance, avarice and bluster. The convergence of Walton's professional and personal lives in this conclusion makes it the most successful and also the most tender passage of the novel, arguably of any of his writings.

To appreciate the distance Walton traveled to write it, here is a letter he sent to his father as a boy going on ten. This was in 1924, before the family moved from

Fresno to Stockton. Wilber's grocery business was failing, so Walton and Florence were sent to live with their maternal grandparents Jesse Foose the fighter and Becky Foose in Indiana. Already at that age articulate on paper, Walton wrote with a country inflection demanding payment of money owed to him for some reason by his tightfisted father. The letter contrasts poignantly with the artist's vita for the de Young show, which states, uncorrected by the artist, "Walton's whole life has been spent in the art world and among artists."

What a difference in you and him

Dear Sir:

I am a little hard up and in need of a little money.

I'd like to have that money you owe me.

I would have sent the letter before but didn't have the money to send it with and didn't want to ask grandpa for any.

Send the money with intunst [interest]. You had it a good bit and that counts that much intrunts.

You smokin yir fine sigars and grandpa feedin yir kids, you get your $150 a month and nobody to keep but you and mother and you in debt and "grandpa" $50 dollars a month and he not in debt and ownes every thing in his house but our things. And he is old and can't work and you stout enuff too ern lots and lots of money and you in debt and grandpa not what a difference in you and him; you get 3 times as much money as him and "you" in debt.

Now the interest will be more and more. And give me your note.

You don't know whether I have a thing on my back or out in the streets, begging and suffering.

You mister W. G. Walton don't give yir kid a thing. And mother sending Florence and I $5 dollars every month grandpa feeding me clothing me whith one pair of pants "he" 50 dollars a month and you 150 dollars a month.

Well this is all answer soon and send me your first letter.

Yours Truly,

Richard Walton

·

Walton held back this letter from the many boxes of papers gifted to the Nevada Historical Society in 2000. It resides at the society now, among the equal volume of Walton papers gifted by Vivian Walton in 2019 with my assistance. On the envelope and again on an outer protective envelope, Walton explained how the letter returned to him: "When I was 10 at Newport, Indiana my grandma urged me to write to my father. Fortunately the letter was opened by my mother first in Fresno – dad never saw it. He was going through bankruptcy at that moment! Mom saved it & gave it to me before she died – Walton '77."

When Walton revised *The Delta Queen* as *Hey, Jesus*, among other changes he shortened it by a third and added a chapter with his father's illness and death,

which happened in 1963, thirteen years after the original ending at the de Young show. The new ending served Walton's purpose of tying things together in the record his life, but as literature the original makes a better finale. As for the two de Young chapters, the treatments are the same in essentials, and each has its points. (In both, he omitted the fact that sister Florence attended the reception, and so, I imagine, did Marijo.)

He set the scene by informing the lay reader that a large show makes financial demands on the artist, and he "didn't have a dime. He considered cancelling."

I've Gone to an Exhibition

He had not asked her to write Noah [Wilber] but his mother took matters into her own hands thinking it might help and she was right. Mark [Richard] was to get a rare letter from Stockton which said, "Dear son Mark: Your mother tells me there is something you want to do that you can't do and that you are blue. Come and see me." The letter was signed, "Your father, Noah."

Mark pulled up to the Delta Queen [the Golden Rule] and in ten minutes his old man tore off a sheet of wrapping paper and was putting down figures. "I have to frame the paintings, haul them down, stay two weeks, return in a month. The reception is also scheduled." When the list was finished Noah said, "It looks to me like you'll have to have five hundred dollars." And he produced the great checkbook, opening it on the counter. "Don't tell anyone. This is between us." He gave [the check] to Mark and changed the subject.

It was a year of floods. San Francisco had one of the worst storms on record, the night of the reception. An attendant ran out to him before he got to the museum. "Your father's inside. He's been waiting since morning." Noah had lost the invitation, had forgotten the time. Mark hurried through the galleries and came to his own. Eighty people were drinking highballs. There were two bartenders and six waitresses. Mark found his father in the midst of them all with a drink. They shook hands. Mark could see Noah was proud in a way he'd never known. Mark got him aside – then a press photographer wanted Mark's picture with some society matrons. When the shot was made Mark got his father and had the photographer shoot them. Mark knew they wouldn't use it, but Noah didn't.

It was hard keeping up with Noah, he'd get strangers by the arm and say, "That's my son."

"What do you think of the show Mr. Taylor?" someone said.

"Well, I don't understand it, but I like it."

"What is he trying to do?" asked one of Noah's guests, his [second] wife [Elizabeth Weisel] and two of their friends Mark had not seen before.

"I don't know. Except I understand it's kind of a mystic thing."

Mark had a last moment with him. "How did you come?"

Noah stood back and drew himself up, and said, "Why, I came in my Cadillac Car."

He had another drink and told a group of strangers, "I've got to get back to the store. This is the longest I've been away in years. I pasted those clippings, Mark sent me, on the windows, and I painted me a sign I'VE GONE TO AN EXHIBITION." Noah left......someone spoke. Mark didn't hear. *He was with his father. Noah was taking Mark back to the Delta Queen, at the wheel of his Cadillac Car.*

■

"As soon as I saved five hundred dollars," Walton later wrote, "I went to Stockton to give my father five one hundred dollar bills and he said, 'You owe me nothing, it was worth it.'"

"I understand," said Noah/Wilber, "it's kind of a mystic thing." Wilber picked that up from the clippings Walton sent him. Nan White in the *San Francisco News* covered Walton on the technical, social and spiritual aspects of his paintings. Walton explained his method of applying paint and the deliberate lack of perspective; he expressed outrage at the condition of the world, which he protested through "lyric pictures"; and as for the spiritual, "The spook, 'mamu,' a Basque word meaning little mite, spirit or apparition," said White, "is important to Mr. Walton. He attempts to work 'a good spook' into all his colorful varied canvases."

What to make of this? In the hundreds of tapes and many writings I've studied, Walton often enough addressed technique and deplored the state of the world, but never professed specific spiritual beliefs, much less anything about apparitions or spooks. Indeed he belittled Florence as an "expert on table tapping, ouija board and automatic writing. I leave it to my sister to figure out the spirits." Once he described himself as a "hierophantist" to a journalist interviewing him about *Self Portrait*, of all things. A hierophant is an interpreter of sacred mysteries, and a card in the Tarot deck. This spiritual persona presented to journalists is intriguing for an artist who elsewhere insisted his paintings were "of" nothing but "colors, space and form."

All as far as I can tell everything at the de Young was abstract and, by Walton's definition, a symbolic treatment of a figurative subject. *Duel of Laertes* indicates Walton had been reading Shakespeare (why not *Duel of Hamlet?*). *Godfrey's Back Porch* adverted to Caples' short-lived art and curio shop in Virginia City. *The Malefactors* anticipated the theme of a exhibition by Walton in Chicago three years hence. Of the remaining pieces, the largest block were torsos or nudes (plate 13), Walton's recurrent subject for a period of years. Six others referenced fish in their titles, three birds, and eight miscellaneous subjects.

The de Young show closed the day after Thanksgiving, 1950. Before the end of January Walton had completed his "sentimental tract by a greenhorn writer," his "Pyramid book" or "novel *Pyramid*," where Pyramid Lake is the entire scene of the action and, as in Walter Van Tilburg Clark's *The City of Trembling Leaves*, all but a character. *Pyramid* was Walton's "love piece for Pyramid Lake, one of the wonders of the world."

By 1975 there were five rewrites of the 1950–51 original. The five typescripts which exist, all undated, variously bear the titles *Pyramid*, *Pandora*, or *A Pyramid Called Pandora*. Four mention laser art, which came into being in the Sixties, and the fifth, titled *Pandora*, has Walton's "Sheep Camp" poem from 1974 as an epigraph, as does a sixth version, titled *Pandora, a Fable*, read by him on two undated tapes. Therefore none of these, unfortunately, can be the original version, in spite of the fact that two typescripts carry the misleading notation in Walton's hand, "1st Draft." In all these versions the female character is Pandora, a name taken from Loring Chapman's daughter Pandora, born in 1962. So at the very least a dozen years passed between Walton's first effort, which he destroyed, and any of the extant versions.

Pyramid was probably Walton's original title.

She said it's a poem

Pyramid was the first book that I began after my return from the big exhibition in San Francisco. I recall they were done in thirty days each. That was a real wrastle. But it was a pleasurable experience, to know you've written three books, I'll tell you that. Whether they were any good or not. And they in their ways stand up over a long haul.

As soon as I finished *Pyramid*, I started *Delta Queen*, to write a totally different kind of a thing. The romantic tract of *Pyramid* was completed, and so I tossed it aside, and now I wanted to write a very plain one. Now rereading this thing [*Pyramid*], one would think that I wrote the plain one first, but I did not. As Joanne de Longchamps, who was one of the few people who ever read it – Vivian and Mary VanderHoeven [Vivian's mother] have read it. But very few people have read *Pyramid*. I think Loring [Chapman] read it. But Joanne is a poet and I respected her opinion, and she called – she said it's a poem. Got what I meant, when I described entering Nevada in my teens: "the trees, the trees, the trees."

.

The chapter structure belongs to fiction, and most of the language to prose, with insertions of poetic passages. He hadn't conceived it as a poem, and called it "a novel."

Rex Kane arrives at Pyramid Lake before his lover. He target shoots with a 22 rifle. Pandora comes. He tells her he wants to marry her, she won't, for his sake and reasons of her own. They make love. They talk about their affair, she swims, they sun, drink wine, make love again, relish the place, walk, talk about her husband. He speaks of his childhood, his life, she of hers, he more about his, about art in America, the environment, diverse topics. They camp for the night, make love again. Next day they raft around the pyramid, talk, see a giant snake, prepare to leave. She confesses having another lover. He rapes her. She's glad. She leaves. He dies.

From their conversations we learn of Rex Kane's – Walton's – early boyhood in San Francisco; his coming to Reno; art school at Chouinard; Phil Paradise's letter and the WPA; the VD inspectorship; flirtation with the ministry; the university students he attracts; and more. We also get Walton's personality: his verbosity; his tirades on pet subjects ; his aversion to swimming; his self-image as a "genius." There are even candid moments of deeper introspection: "the crushing weight of error" borne by Walton from a boyhood with his father and uncles; and from his mother, he sometimes feels "like the lost little boy left alone on Market Street with the San Francisco traffic and the mother gone." Whether Walton had these insights in 1950–51 or they came to him for the rewrites in middle age can only be guessed.

If Rex Kane is Walton, who is Pandora? Vivian volunteered that Pandora was based on a woman named Aurora with whom Walton had an affair when things were going badly with "Richard's first wife." If that's what Walton told Vivian, he had in mind the revisions, not the original. I'd already heard something about Aurora from Jim Hulse, but not enough to know that Walton met her four or five years after writing *Pyramid*. I told Vivian what Walton said on tape in 1975, that the love affair in *Pyramid* was a total fantasy. All the same, Vivian was right in a different way than she realized about the bearing of "Richard's first wife" on the character Pandora.

So Lonesome

Pandora is a creature of pure fiction. Absolute invention. But based in real persons at the same time. However, I am impressed with the fantasy of the author. Myself. I'm beginning to understand a little more about myself, the man of those years, in this process of near-psychotherapy, the taping of one's recall.

Now this is a book of a clandestine meeting at Pyramid Lake between a painter and his lover, a married woman. Now, they have made love on the shores of the lake. And there is a bit of fantasy that occurs here, and is recurrent throughout the book. It describes the agony of the author, actually. An agony that was fulfilled by writing this fiction. And the author never intended the reader to ever have an idea that it was real. This was a lapse into pure fantasy. The author writes: "As Kane

finally dissolved into Pandora, she grasped his loins with hers, unwilling to have him leave her necessary last moment."

Now, if you balance that out with the author in [his actual] marriage where he reaches out toward his wife [Marijo], in the morning, as she passes, just to reach to touch her, and she twists away, and goes on into the dressing room, to sit there to put on the makeup, the armor for the day. And he is so lonesome, that he writes this god damn book, about a creature of utter fiction.

Well, that would seem to be a very lonely son of a bitch. Self-sorry guy, who is hungry for some kind of a creature that didn't exist. And he certainly never found a creature like that. And I don't know if [laughs] it would be desirable to find one.

·

"He certainly never found a creature like that." This session of "near-psychotherapy," taped in 1975, discloses the substance of the missing first draft from 1950–51 and its genesis in Walton's despair over Marijo.

The "real person" the "pure fiction" Pandora is "based in" is, in the first instance, Marijo. Before hitting on the name Pandora, he was going to call the woman Jo. It was Marijo who saw the giant snake with Walton when they camped once behind the Pyramid, as their friends knew. Pandora has Marijo's traumatic childhood, her sheep camp experiences, only lightly fictionalized – she brings a sheepherder grill to the tryst for their cooking fire! Did Walton imagine readers who knew Marie Jeanne Etcheberry would not draw the inference? The obsessive memoirist deceived himself, apparently, that the boundary between autobiography and fiction wasn't permeable when he didn't wish it to be.

Pandora is Walton's fantasy of who Marijo might have been, *Pyramid* his plaint of lost love. And this, I surmise, is why he told his second wife Vivian that Pandora was based on Aurora, as in large measure the character was in the revised typescript Vivian read.

Pandora leaves, Kane dies from a seizure. The death comes with scarcely any preparation, implausibly as far as realistic plotting goes. Walton had no wish to write conventional stories. Of his next book, *The Delta Queen*, he insisted he "didn't want any phony plot," a preference all the more marked in *Pyramid*, which advances by abrupt transitions from narrative to nuanced conversation to nature writing to lecture in the guise of dialogue and around. You could say the style is the counterpart of the painting style on exhibit at the de Young, the abstract symbolic treatment of figurative subjects, a trickier endeavor to succeed at in the time-art of literature.

Walton killing off his avatar at Pyramid Lake reminds me of what a dutiful reservation policeman once told me after spotting me on a hike there and tracking me down, that every year half a dozen outsiders kill themselves in that spiritual place. Kane's death symbolized for Walton letting go of any hope for happiness with Marijo.

The final resigning

Now, in the book, [Kane] describes to [Pandora] his experiences, and a lot of people would say, well, this is a talking down, a male chauvinist. But little by little, his position is totally destroyed! He's not the winner in the thing at all. I mean, he's the one that got left behind. She went on to conquer other fields. She was indestructible. And he was entirely destructible. Well, then you say that's a male sorry for himself. Of course – my God! – sorry for myself.

So, the author has to kill his man, because he knew he had to resign from life as he had known it. And that was the final resigning from the author's life, was in killing his principal character. And the Frankenstein monster called Pandora in this book gave vent to his hate, his fears, his mercy, his sense of pity, and to a fictional craving for a mythical love.

.

Their first day at the lake, Kane refused to look at the sunset, telling Pandora that sunsets had been spoiled for him. "He could only see the worst of Turner and the daubs of Arizona, Tintoretto's gaudy ceilings and the covers of magazines. He saw sentimental paintings in lobbies of hotels." Nevertheless, Kane's death at the end coincides with a Pyramid Lake sunset, painted in words by Walton, its splendor unseen by Kane. The description justifies as much as anything in the book Joanne de Longchamps' appraisal of *Pyramid* as a poem.

The water cup of the great palm

Gradually, inward, conewise and inverted, closing in and folding his own transparent fingers, and on the inner side, conewise and palmwise, gradually clenching without crushing, the unseen hand closed from the end of the sky to the brim of the earth bowl. The transparent fingers folded over the furthermost ridges, where sagebrush was dotted lace on lavender, then mauve, then brick-red or iron-red or Venetian red or English red or Indian red: earth red. And as the transparent fingers came to the closest inner hills of brown and ochre, and without it, the field of green, which was actually gray and called silver. And as the fingers came inward, the sage was intimately alive with communities and villages of small life, of ants and ticks, bugs uncountable, living the life in the lush and shaded and heavily perfumed world the hand knew better than they.

Bounding between the scented brush on crooked paths in the distant sage hills, the hearty jackrabbit remained. At the perimeter of the lake, near the monument, the land was dry and so dry. In the near-lying region, the transparent hand, while closing over the packrat, had left the hearty jackrabbit with the lavender and the mauve. The hand closed toward the water cup of the great palm, tapped the red rock of the elbow and the white-gray and granite-white flat stones as the only straight line, and the sentinels and waterlines one by one. And gradually, since the blue hills of unseen brushland, those of jackrabbits and moles, and since the pre-Stravinsky waterlines, which covered the land farther than the airplane

could see, and now which were in the cupped hand, and at the wake of one man.

<div align="center">•</div>

So culminates Walton's "love piece for Pyramid Lake." The "sentinels" are the needles, or pinnacles, an irregular file of tufa castles starting well onshore and reaching far into the north end of the lake many miles from the pyramid. They as well as the pyramid and the "waterlines," the stacked benches cut into the mountainsides, are all relics of Ice Age Lake Lahontan, as is Pyramid Lake itself, a recent development geologically speaking, notwithstanding the Triassic ambience of the place.

Walton asserted once that Walter Van Tilburg Clark "had something to do with kicking me off" in writing *Pyramid*, because Clark "had fallen short of doing his right job for Pyramid" in *The City of Trembling Leaves* – another book where lost love and the life of art meet Pyramid Lake. Walton also held his "greenhorn" effort above Hemingway's *Across the River and into the Trees*, the unstated basis of comparison with that semi-classic being, I suppose, memories of boyhood. Walton wasn't the first or last writer to oscillate between humility and grandiosity.

Although *Pyramid* may have had few readers, Walton would have welcomed many more, namely the public. In 1972, he sent a proposal for a book about Virginia City to Caxton Printers, a small publisher in Idaho. In the midst of exchanges on that project, businesslike on Caxton's side, ill-advisedly wordy on Walton's, he doubled down by offering *Pyramid*. Gordon Gipson the editor agreed to look at it, while making plain his doubt "it is one for the Caxton list." In a follow-up letter Walton volunteered unprompted to tone down *Pyramid*'s earthy language for Caxton. Gipson let the matter drop, and Walton took the hint. I find no evidence that he submitted the book elsewhere, although as late as 1989 he contemplated publication of excerpts in a newspaper or periodical.

Walton kept slides of his artworks in 3-ring binders with storage pages holding twenty slides each. Among the many hundreds of slides is one of *The Pink Pandora*, dated 1950 (plate 14). Energy flows from, and attention to, the woman's lower body. Here in symbolic abstraction is Walton's "fictional craving."

But not fictional for long. The novel enabled him to "resign from life as he had known it." He began an affair. Rae Miller was a tall, long-legged woman in an open marriage to a psychiatrist. Since there are paintings of nudes with the name "Rae" in their titles or in Walton's notes for them, she may well have modeled for him in the studio he shared with Marijo. If Rae wasn't Walton's first extramarital partner, she was the first he made no effort to keep secret.

Walton's only exhibition of record in 1951 is the June Reno Art Festival which the diving board photo dreamt up by Eddie Star publicized in the *Journal*. In 1952 he entered group shows in Virginia City, Las Vegas and Carson City. And he had two one-person shows in Reno, in spring at the university art department's gallery (he wasn't faculty), then in summer a one-man show, so to speak: a woman of means established a gallery on the river near the Mapes Hotel exclusively for Walton. Possessively she named the venue after herself, the Valerie Gallery. "Walton openly discussed the affair and her sexual abilities" with the Boys, Robert Debold told me, adding that the gallery soon closed, and he "would be surprised if even a single sale occurred."

Also in 1952 Walton became art director, writer and photographer for *Reno This Week*, an entertainment guide launched after the war by Ray Bohannan, whose voice was familiar to Reno listeners from radio commercials. Walton used Marijo once as the week's sexy woman on the cover, where she presents herself every inch as armored as his despairing description of her in her dressing room on Marsh Avenue. In only one photo I've seen of her is she smiling, but it's a good smile (figure 19). I imagine she wasn't as hard as she comes across, filtered through Walton's life. A cousin who knew her in old age liked her as a "fun" person.

Also Walton used artist Ed Kienholz as subject of a photo story. Robert Debold explained how that came about. "A young fellow showed up in a beat up car carrying a tombstone and Great Dane dog. Within a couple of days without spending a penny he traded the car up to a much newer one and got a salesman job at a local car dealer. He also was introduced to Walton because of his great desire to become an artist. He became a very enjoyable part of the Walton gang [of Boys] and also had great success attracting the ladies at the hotel where he was staying – he once divulged the reason for this with Walton and me, but I cannot reveal it. Anyway, after less than a year Ed left Reno and settled in Los Angeles where he focused upon the constructions that made him famous in the art world."

Walton dropped the famous name in artist's statements: "Edward Kienholz was in Reno in 1952, and became a familiar at the Nevadan's studio, later urging him to come to Los Angeles." And "Kienholz and I did have a beer at Barney's original Beanery" in Los Angeles, the inspiration for one of Kienholz's renowned assemblages.

Also in *Reno This Week* Walton published a story in two parts titled "Pyramid," with photos of tufa formations, Anaho Island and Marble Bluff. His accompanying text is another "love piece" for the place.

Figure 19. Marijo Walton smiling, ca. 1950?

Part 1

And the lizard skittered on the sand and the sun was west and time hung on a tumbleweed. The hot, loose sand of the high ground held the heat solid and the soul of Winnemucca was bisque in the flat oven. Jackrabbit was the stranger and Packrat shied. And beneath the white, rough, and random rock Rattlesnake remained. Cathedrals boiling from the watery floor were frozen and illimitable castings abandoned by the mother sea. The children of the lake, petrified on the shore-rim clung, deserted dolphins huddling in the monoliths. Yet the rock knew not fear, nor the sea, compassion.

Lizard froze! And Rock did not see – nor the soul of Winnemucca – nor the flat stones of sleeping Rattlesnake – nor did the perfect and the tiny shells of upper sand, see. Lizard froze in cataplexy. And Skitter did not see.

.

And so on. It gratified Walton that Joanne de Longchamps collected these and other issues of *Reno This Week* "for my photos and captions." Yet Ray Bohannan the publisher can't have found the uncommercial language suitable for the magazine's tourist readership. Such creativity contributed perhaps to Walton's lasting in the job for just the one year, 1952, as he had at *Nevada Highways and Parks* in 1948. Walton always said he made the magazine profitable for Bohannan, and that it went downhill after Bohannan deviated from his, Walton's, improvements.

Pyramid Lake is notoriously difficult to paint because of the ever changing colors and light. Moreover Walton wasn't by inclination a landscape painter. Among his slides are none with Pyramid in the title. Only because I happened to ask Vivian about an atypical painting titled *The Bats* (1953) (plate 15), did I discover that a set of four slides were of the lake, all similar in color scheme and perspective, and with similar distressed humans and crow-like flying mammals.

Immediately I flashed on my weeks camping and writing at Warrior Point nearly fifty years ago, and watching bats pick off moths around the light standards by the bathhouse. Today lights and bathhouse are gone. The lake has avoided development, thanks largely to the tribe and its allies. Old rail tracks have been pulled out and non-Native ranches mostly repossessed by the reservation. Only a few amenities for boaters have been added for the income from licensing, and the little community of Sutcliffe remains, where I honeymooned, more than fifty years ago, at Crosby Lodge.

In 1953 Walton had three exhibitions: one at the university in Reno again; one at The Little Studio Gallery in New York, about which I know nothing more; and one at the University of Chicago, where he'd exhibited on the invitation of Inez Cunningham Stark in 1936. Running for three weeks in March, this was a hybrid show: in one room, thirteen of Walton's watercolors, oils and mixed media; in a larger room, prints by a number of Chicago artists, two of whom had thirteen and fourteen entries apiece. Walton's segment was separately named "The Malefactors," for the series he produced from 1950 to 1952 under that title. Walton's stamped-on figures call to mind kachinas, the Pueblo immortals. Whether perceived as the size of kachina dolls, or as supernaturally large, or microscopic, Walton's Malefactors are bad actors on any scale, although a case could be made for their ambiguity (plate 16). One shows up again three decades later in a painting of the cosmos adverting to the big bang (plate 28).

The 1953 Renaissance Society show was arranged for Walton by Loring Chapman, "kingpin" of Walton's Boys, who had gone for his doctorate to Chicago. Walton was someone people did things for. Friends who responded to his talent and forceful personality in that way also recognized in him a type of helplessness, such that their acts on his behalf had a quality of aid or nurturance. When putting himself forward he would sabotage himself, witness his intemperate correspondence with Caxton about the novel *Pyramid*. And what sort of impractical ambition aims an article like "Pyramid" at the divorce and casino trade?

Walton was grateful to Loring for the show, just not sufficiently grateful to refrain from a tirade against his younger friend when recounting on tape in 1975 how Loring had gone out of his way to do him a good turn. To Walton's credit, or not, he said much the same to Loring's face on one occasion, tearing this successful protégé down for making compromises that failed his own obstinate standard of purity.

Absolutely housebroken!

Now, I pointed this out to Loring Chapman, and he was offended. I said, "Loring," I said, "this is a theory of mine," and I explained that he joined forces with a successful department, a famous man at Chicago [Dr. Halstead]. And then he transferred to Dr. [Harold G.] Wolff [at Cornell], who was even a bigger man. And Chapman came in as his associate, doing chores for Wolff, with a hyphenated authorship of some of these findings. And it was tailor-made. He couldn't have failed. He wouldn't touch a thing unless it was gonna promote his situation.

All these people [Chapman, Jim Hulse and filmmaker Laurence Mascott] think they're absolute individuals. I have never, ever known any of the three to get at odds with the system. Never do it! They're absolutely housebroken. No matter how big – Chapman's the big one among them, and he's absolutely housebroken! God, he would never put himself in a position that would sully the academic song. Never! Never!

Now, I have a note that says "It's a wise head that knows the tune." And I have not been wise in regard to tunemanship. I've had a hell of a time playing the group song. Unless the group fit me, I couldn't sing. And that's my failure. Now if the group ever sings my tune, it will be a different situation, perhaps. I do not know.

．

This is the same tape where Walton hoped that "posthumously" he and his "socialist people" would "find each other."

Three weeks after recording this scathing and self-righteous critique of Loring and without registering the contradiction, Walton on another tape illustrated his friend's "curious, almost juvenile sense of humor" with an anecdote establishing Dr. Chapman as anything but a craven careerist.

In the middle of this serious crowd

He was at a conference of medical doctors and scientists of various sorts, seeing a film, this technical film on the treating of certain animals with drugs, and the mating of odd species – cross over a chicken with a monkey or something. You know, they had it for each other. But anyway, this was a deviant chicken had been given this material, and I think the chicken was trying to hump a monkey or something. And Loring shouted out loud, "Go, Go, Go, Man!" in the middle of this serious crowd. Well, I doubt many joined with him in laughter. But he can't restrain himself. And he was to marry a girl [Toy Chapman] who played along with him in these things. And at Davis they were rather sportive, in some dimension.

•

Dr. Chapman founded the Department of Behavioral Biology at the Davis campus of the University of California. Loring the brilliant scholar had an undisciplined side of his personality which comes across in a letter he wrote to Walton about a 1969 show at Davis he arranged for Walton, with wild handwriting and interpolations in colored inks at odd angles and out of sequence wherever he found room on the page. Or else what I was looking at was an emergent, coherent network of ideation I can't make out. Vivian affirms Loring's brilliance and photographic memory, adding only that he had a drinking problem. He would go on binges. Possibly that explains the letter.

"The Malefactors" had been Chapman's first effort on Walton's behalf. The very next year he went to the trouble of carrying paintings with him on a plane to Mexico City for a conference. "He had an idea that my paintings should be seen down there. Well, it seemed to me an idea, maybe it would give a fellow a little international kick in the pants." Chapman made an appointment with the top man at the Palace of Fine Arts, who steered him to the home of Carlos Mérida. He found the Guatemalan artist "crouched over a table doing this fine, fine work."

"How'd he do this?"

Well, he said there's little doing in the abstract field, especially with outsiders, foreigners. And he had no hopes for any action along that line. But Loring said he was enormously concerned with the paintings. Carlos Mérida asked Loring endless questions about "How's he do this? How'd he get this effect? How'd he do this? How'd he do that?" And Loring said it appeared to him that Mérida was trying to do something at his table that I had achieved on a large scale in these paintings. And I was delighted and flattered that this great man, who I had been acquainted with by reputation for many years – that this man had this response to my product.

Well, in later years, it is my understanding, Mérida was to become a profound influence on Mexican painters, younger painters to come up, that drifted off from sociological painting into design. That the abstract arts became more important as time went on, and Mérida was their leader.

Well, Loring bundled those pictures under his arm and boarded an airplane and returned to the United States without incident, very unhappy that he was unable to secure an exhibition for me in Mexico. And then he found out that it's not easy to get paintings out of Mexico. So in a sense, he smuggled them out when he left. But this shows Chapman's adventurous interest in helping me down the road as time went on.

•

Chapman died in 2001, four years before Walton, as Emeritus Professor of Psychiatry and Human Physiology at Davis.

The year of "The Malefactors," 1953, Walton was publicity director for the Silver Arrows Field Archery Tournament at Galena Creek, in which he also competed. He became interested in archery through Robert Debold, who had taken up bow hunting. Marijo handcrafted quivers for them. She herself competed in the tournament, although it's hard to imagine her ever bow hunting, what with her profound sensitivity to animal suffering. "I loved her most," Walton said, "in such moods that she had with the animals," and twice he taped the same story to illustrate.

A breech birth

One twilight, Marijo and I were returning from town, and she said, "Stop! Stop!" She said, "Stop! There's a ewe in trouble." And we were all but home, with this ewe down in a ditch. The poor thing was just suffering – agonized, twisting and suffering and straining and straining. And Marijo was in tears, and in her town clothes kneeled down to the sheep's side in this muddy ground and reached inside the ewe's vagina up to her elbow. And she felt the lamb, and she tried, she tried to turn the lamb about so it would emerge properly. But the feet were already started out, and she could not. She struggled as she could to turn those feet, those legs – those long legs were twisted in there, a breech birth. And finally she had to give up, and we left the ewe to her doom. Marijo was in fitful tears, cried the whole night through. The lamb was killing the mother. And this was killing Marijo.

.

Walton and Debold used to try for deer in the pine hills above Washoe Valley – without success, the latter is now pleased to say. Walton developed qualms after he "heard a rabbit say 'ma-a-a' when hit by my arrow – I soon quit archery." Presumably that was the cadaver he dissected to produce *The Walton Rabbit*, "a thorough-going analysis of the anatomy of the rabbit." Walton's slides of the little book show watercolor sketches of muscle structure for artists.

"And that sits on my shelf. I never did do a thing with that."

The two men made a deer hunting trip in 1953 to the vicinity of Austin in the center of the state. Walton had received permission to hunt on John Laborde's Silver Creek Ranch. Ambrose and Mary Arla, the couple Walton and Marijo stood up for in 1938, were living there with Mary's mother, Louise Etcheberry's sister Josephine, who had remarried to John Laborde. Debold's foremost memory from the trip is of Basque ranch life. "The womenfolk worked from dawn to early evening at preparing meals for the men whose schedules seemed less rigorous."

Debold doesn't recall a little episode that made the trip memorable for Walton.

A record of romance

It has been my experience in life that no matter what corner you find yourself at, there's a record and continuum of romance beyond imagining. One could close his eyes and turn around and go a quarter of a mile and stand still, take the blindfold off and see what was before him, and there would be a record of romance at that given site.

It reminds me of when Debold and I were kidding about these things. We had seen a femme fatale with her cowboy in Austin, Nevada, when we were deer hunting. And she was a very petulant young woman. Apparently had been born and reared in Austin. And she stomped into this bar in a real peeve, in her high heels and gingham skirt, leading the way and this cowboy. And she had the little slave bracelets around her ankles. And she was giving him a very bad time. Later that night, I said, "Bob," I said, "You know, I believe you could strike out into the desert flat in any direction of your choice, continue for fifty miles, and stand still and wait for a while, and sooner or later there'd come some trouble in the shape of a woman."

.

Valerie of the Valerie Gallery may have been Walton's trouble of the moment. His trouble for 1954 became one Lois H., according to his hand-written chronology. The painting *Lois* is a typical nude of that period, a torso drawn over pink, with no head and attention drawn to the genital area. Another painting from 1954 had its title added retrospectively, *Remember Lois . . . 8-7-6-5*, suggesting the affair didn't last the year.

Of course Marijo was still his trouble and I dare say would trouble him even after they separated a few years hence. Also she was his main support. She had her ad and display jobs, found occasional modeling assignments, and taught adult education commercial art classes at Reno High , which she had left without graduating to get married. They lived on some kind of terms in the house her family provided. I imagine him sitting silently against a wall as she hosted a Bahá'í meeting when Florence came through town. And she continued to exhibit her art.

In 1954 Walton participated in a group show at the Nevada Art Gallery, and he exhibited at the Maxwell Gallery, then a San Francisco institution. At one or both he will have entered examples of a series of landscapes executed from 1952 into 1955. As in *American Flat XXIII* (1952) (plate 17), he arrayed a row of abstract figurations across the flat picture surface against a background that gains dimensionality only when you realize you're looking at desert vegetation. The image kaleidoscopes between flatness and depth. His title in this case refers to an area called American Flat west of Devil's Gate near Gold Hill and Silver City, indicating that before he moved there he frequented the Comstock where he and Marijo owned vacant ground in Virginia City.

Also in 1954 Walton's "noted friend Edward Kienholz" looked him up in Reno and urged him to move to Los Angeles. He didn't, but did drive down for the "memorable" forty-third birthday party of Bernard Herrmann – composer Berny Bernfeld of *You Wouldn't Believe It* – at his home in North Hollywood. Through Herrmann's good offices this party led to Walton's annual sales trips to Southern California, which lasted until 1968. At the party he first met several of his future customers from Hollywood's professional elite: composer Lyn Murray (*D-Day the Sixth of June* and TV's *Dragnet*, to name two credits), composer Jeff Alexander (*The Tender Trap*, TV's *Columbo*), and Herrmann's good friend, writer Norman Corwin (*Lust for Life*, radio's *A Note of Triumph*). The annual sales trips began in late winter or early spring, 1955.

That was the year Walton's mother-in-law Louise Etcheberry went back as a maid to the hotel she once owned, to keep busy. She lived then with son Johnny, who with Paul was in the thick of converting the home ranch into the Etcheberry Addition. And Walton exhibited at the Reno Little Theater again (one-person) in 1955, and at Gray Reid's department store (group), and he sold a news photo to the *Journal*. Also around 1955 he wrote and illustrated *The Grocer's Cat*, based on Wilber and The Golden Rule, a children's book rejected by Simon & Schuster as too adult. Also he and Marijo staged and performed the dance "Instruction in Art," starring him as the instructor, although Marijo was the one currently teaching art.

Also in 1955 he met Aurora, the woman on whose account he added layers to Pandora in the revised versions of *Pyramid*.

They were whole

With her body stretched long above the bedding Pandora loosened her belt and removed her slacks with the slender legs jack-knifed one by one. As her clothing was being removed Kane said, "Leave on the shirt. It gets cold before morning." And she did. He removed his unlaced boots and undressed, leaving his own shirt on, then swinging about Kane faced the girl who was squirming into the covers until only the face and her wavy hair showed. Braced on an elbow he considered the tip of her nose then the brow and chose to kiss her widow's peak – it was a dry kiss, perhaps that of a relative and with this accomplished he snaked under the covers with Pandora's smooth warm thigh against his own hairy leg. He settled beside her with his hands beneath his head and she put her right arm across his chest. Looking into the night sky with its stars and full moon, a sky of scattered light clouds that absorbed the moonlight, his sight was aligned with the deep sky dome with her at forty-five degrees.

Between the man and girl no words were said and neither moved; held fast by the deep dome and their own silence, they were whole. The creatures of the night of which they were both aware remained unseen and unheard, there was no breeze. Consuming space, the lake below, the sky above, and the sage hill rising east – he kept silent until slow words escaped from his dry lips, words neither considered nor desired.

"And how is my son?"

•

With the question their bodies meld as in a dream, not sexually yet sexually; tears fall "while a hard knot clutched his throat." Pandora sighs a rippling laugh.

"He's so funny – so much you. He's exactly you."

There follow pages of intimacy about their son, their affair, and the understanding Pandora has with Harold Manley, her husband, the father of her twins. Manley knows who fathered the boy – we aren't told the toddler's name. The Manleys keep a home and a bond, she tells Kane, but no longer share a bed. Kane and Pandora make love.

"Yes," said Kendall Scott, Aurora's daughter, in answer to my query, "her hair was about waist length at that time, wavy, and her widow's peak was stunning." These traits, the wavy hair and widow's peak, establish Aurora as the model for Pandora's overlayers in the rewrites of *Pyramid*. And as for Kane and Pandora's son, Walton had by Aurora not a son but a daughter, Kendall Scott, as I would learn.

When Vivian and I first discussed the novel, she insisted that the inspiration for Pandora was Walton's mistress and model Aurora. And although no such incident occurs in the book, as if in evidence she regaled me with the story of Aurora causing near collisions by undressing in traffic to cool her big breasts like a dog enjoying the wind. I pictured Aurora going around in city traffic, until I came across an untitled Walton poem suggesting that breast-baring was a single impulse of exuberance on the open highway.

Breasts in the breeze

He was doing a soft eighty near Indian Springs
at the wheel of her topless Ferrari when
the girl from Las Vegas unbuttoned her blouse,
unhooked her brassiere – breasts in the breeze,
laughing at the desert, and causing a near head-on
when motorists saw her coming their way
but he drove on to the dunes
where fingertip flowers bud flat to the sand
and they made love in the skinny

 not waiting for July.

•

Vivian talked up Aurora's hazardous breasts with ostensible enthusiasm, almost pride, the way she implicitly half-claimed all the women who came before her in her artist-husband's life almost as her own life story (all but "Richard's first wife").

However, Vivian didn't on that occasion betray the existence of his daughter, out of respect for Kendall's privacy. But on a different occasion when I brought up the question whether there could there be anything to "And how is my son?" then Vivian told me. Thereafter she got Kendall's permission for me to email her.

"My mother was a beauty," said Kendall, "standing 5' 10" hair as long as her torso. She was vivacious, playful, sensual, quick witted and engaging. He loved her forever." Beyond that, Kendall was initially reluctant to say much at all about her mother. "How do you wish to portray her?" the daughter asked. "She was private; I am fairly sure that she would find being mentioned in a public forum in too much detail, not to her liking." And "this is a tender and special area of our lives for all of us who are her family." But I earned her trust, for she opened up with some of the facts, and others I pieced together.

Aurora was married to Kenneth Krantz, a Las Vegas casino pit boss. She and Walton met in 1955 as a consequence of his commission to paint murals for the El Cortez Hotel in Las Vegas. Krantz came from a Jewish family with the custom of having family portraits painted. He met Walton and hired him to paint Aurora's. For the sittings she flew to Reno and Walton's studio. Kendall inherited the portrait along with a "nude beach ball painting" of Aurora, dated 1955, which Krantz may also have commissioned.

"It was a long distance affair," said Kendall. That surprised me, for I had the idea Aurora modeled regularly at Marsh Avenue, an impression I took from something Walton said about the visit from Johnny Etcheberry's son Johnny-Pete.

That must have been Aurora

Johnny-Pete loves me dearly. And little did I ever guess. And he has so many memories. And he said, one, he said, he used to go in our house. And I remember he'd take my arrows, and I'd find them in the field. He said one time he went in there and there was a naked woman. Well, that must have been Aurora, when she was posing. And he said, "Wow-ee, naked not a stitch on." And, well, he was a growing boy.

.

But it may have been a different model. Aurora, says Kendall, "lived in Las Vegas for the duration of the affair," so could seldom have modeled in the studio. And as a matter of fact Walton wrote a short story, "Flight into Vegas," where the protagonist from Reno has an affair in Las Vegas with the knowledge of the woman's husband. As in Walton's novel, which Kendall hasn't read, Aurora's husband did know, Kendall told me, adding that Krantz himself had outside love interests. Kendall may not be aware – I didn't mention it – that to go by the novel, Krantz forced or induced Aurora into regular spouse-swapping while (because?) the affair with Walton was ongoing. But is that so? Pandora's gratuitous confession, which precedes Kane's fatal seizure, may be Walton's invention, as were the twins he gave the Manleys , and the symbolic seizure.

"She became a muse to him," says Kendall. Walton and Aurora independently confided to her that "the more intimate nature of their relationship evolved slowly over a two year timeline, which then did become a full-on love affair." In that case, Aurora may really have been no more than a muse when Robert Debold lost "respect for Walton's character" due to the "totally open" nature of the attachment as he witnessed it in Reno. He does recall "Walton once boasting of their child, but by then it all seemed tiresome."

If they met in 1955, and the sexual side of the relationship developed over two years, and Kendall was conceived in 1957, and "during her pregnancy she [Aurora] retreated to Las Vegas," it adds up to a brief but intense sexual liaison.

In April, 1958, when Kendall was two months old, Aurora divorced Krantz and moved them from Las Vegas to Reno. Nevertheless she terminated the affair with Walton, who lost Marijo in 1958 as well. The ex-lovers maintained some contact, however: Kendall has a receipt in Walton's handwriting for a painting sold to Aurora for sixty dollars on November 10, 1959. By then or soon after, Aurora met her next partner. They married and remained together. The newlyweds decided Kendall's legal status should be regularized for her sake, given the mores of the 1950s: "I was formally adopted and my birth certificate altered to reflect the new agreements." Kendall grew up in Reno as Kendall Sarah Scott. She attended Reno High and the University of Nevada, where she studied art under my late friend Jim McCormick.

In June, 1976 – just before Robert Caples showed up at Walton's house on his last visit to Nevada – Aurora brought eighteen-year-old Kendall up the Geiger grade to meet her biological father. "Everyone knew he was my father," says Kendall. Everyone on her side. Vivian didn't. She was angry at Walton for withholding the fact from her, and angry about the fact, I surmise. During their three-year courtship they foresaw having many children. From Walton's self-reports he liked children and got along well with them. I asked Vivian a leading question, "Was Richard good with children?" She frowned skeptically and chose her words: "He was not interested." In the beginning she had wanted children, she said, and that was the plan. But when it came down to it, he told her, "You'd have to take care of them, I can't be interrupted." And that was that.

"We bonded immediately," says Kendall of her first meeting with her father in 1976. She found him "warmhearted, kind, charming, wry and talkative," and she observed "a sparkle between" her parents, "forever teasing and witty." The three never met together again. Aurora introduced them, then stepped away. Kendall went on visiting Walton until she moved to San Francisco in 1984.

"Everyone knew," but no one knew for sure. Aurora wasn't sure, according to Vivian's information, nor was Kendall when she contacted Vivian after Walton died. Kendall, then over fifty, told Vivian, in her sixties, that when she was younger she liked the idea of having an artist father. Now she was tempted to look into it. They discussed genetic testing. Two years passed before Kendall let Vivian know

she'd decided to leave it alone. Then in 2019 she contacted Vivian again to let her know she had recently done the test: "The results did reveal that Richard is my father. Delighted with the information yet bittersweetly sad that circumstances (social etc.) were so strained and convoluted."

"Their love story, held in my heart," Kendall told me, "has laid the path of my life's story." She finally pursued testing when "the inner drumbeat" became compelling. Having begun to paint seriously herself, she noticed that her brush strokes and signature resembled Walton's. That was the trigger. I can relate, having gone through something comparable in my own history.

The chance that set in train Kendall's life and its story was Walton's commission to decorate the El Cortez Hotel in Las Vegas with murals. The Reno artist was recommended by his previous murals, which included the four Tom Sawyers for the Washoe County library (plates 4, 5), the two Virginia City panels for the Nevada State Museum (see figure 14), and the *Snake River Ferry* for the post office in Buhl, Idaho (see figure 15). These projects for public institutions were done on panels or canvas. A commercial job in 1955 or shortly after, an Italian scene for Festina's Pizzeria on South Virginia Street in Reno, was probably painted directly on the wall. So were some or all of the six El Cortez murals, totaling 178 lateral feet. They adorned the casino mezzanine and the Cirque Room, renamed for Walton's circus theme. "Artists Rout Pirates From Las Vegas Den," reported the *Las Vegas Review-Journal* on the Cirque Room opening in August, 1956. The artists were Robert Loden, the overall designer, and Walton, who executed the murals.

Unfortunately Walton's murals for the El Cortez ultimately went the way of the pirates. They can be glimpsed now as the faint background for a showgirl on the cover of an October, 1956 Las Vegas entertainment publication (figure 20). And on an inside page we see the sort of act booked in the Cirque Room (figure 21).

Unbeknownst to admirers of Miss Po-Po, Walton used the Cirque Room to apply his ongoing investigations of vision as it pertains to art, begun in the late 1930s and tentatively systematized in his manuscript *The Mark of Man* of 1946. His relatively unambiguous remarks about it on tape in 1975 are easier to follow than the remnants he recited of that burned manuscript.

The reader might first google "Michael William Harnett art."

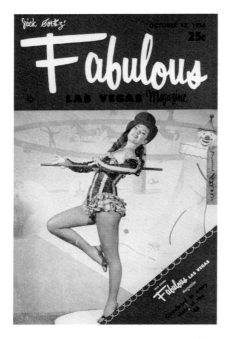

Figure 20. *Fabulous Las Vegas Magazine*, October 13, 1956, cover

Figure 21. Miss Po-Po in the Cirque Room, *Fabulous Las Vegas Magazine*, October 13, 1956, p. 20

Fake realism

I was very involved with Harnett at one time, and fake realism [trompe l'œil]. Not with the idea of becoming such a painter myself, but interested in why it looks so real. More real than anything, even than reality. And it was determined the reason that the Harnett type painting, or fake realism, looks real is because Harnett painted a limited [shallow] field, and that the mind, the eye, sees from point to point. You focus on one thing at a time. And [Loring] Chapman told me that your seeing reality is a matter of scattering your point of focus. So if you look at a man's nose, you don't see his necktie. But you're aware of it in the penumbra, or the side vision, which is the penumbra.

I have found that Harnett failed the minute he opened a window and painted the scene outside, because the mind rejects the focus of the thing hung on the wall. Should he paint an open window, as the Flemish realists did, and you show somebody two miles away, hard real, the mind rejects that.

Now one of my aims was to see if I could maintain this impact of realism in free space; if it could be done. The only time I used this theory in the outer world was in the Cirque Room. And that ball just came off the wall into the room. A very strange thing to see in a Cabaret.

I have only painted one pure one, an egg against a broken sky, a triangular piece in the right corner with an egg with a cast shadow [(plate 18)]. And Bob McChesney came on one of his visits, he saw that and he couldn't believe it. He just stood there and looked at it! And he's not one that's easily impressed. He has no idea where I've been. The largest one I ever did was the one Norman Corwin bought, his bird and egg. But I object to the bird being there. The bird was too humorous. I was successful with just the egg and just the piece of India red and the broken sky, the Monet-type sky in the background. I have a very high regard for Monet. Monet would know what I'm talking about. He knew it. He knew it very well. And the cast shadow on the flat is apparently my own contribution. You may not make the flat a table, because it fails then. Because then the egg and the table become a unit. You have to separate these into three steps: broken, the flat, and the round. With the shadow. The shadow does it. Or else the round joins the flat, oddly enough. You have to have the shadow.

·

The spacial effect in the Cirque room was achieved by "a 3 feet diameter circus ball casting its shadow on a flat area with other effects rendered in broken paint suggesting space."

Bob McChesney is California artist Robert McChesney. He, and then I, both became attached to Pyramid Lake, and thus indirectly came to Walton, through reading Walter Van Tilburg Clark's *The City of Trembling Leaves*. Mac and his wife, sculptor Mary Fuller, were friends of Walton's since 1962, when the McChesneys came through Virginia City on a trip to the lake. Thenceforth they overnighted with Walton annually on their way to or from Pyramid, every year bringing with them another couple, never the same, Vivian says, because the McChesneys were so difficult. Mac and Walton had great talks as artists and as ornery lefties.

The *Las Vegas Review-Journal* article about the routed pirates used Walton's language to describe the Cirque Room murals as "executed by Artist Walton in a manner which projects its central figures toward the viewer." In addition to the egg that astounded McChesney and the egg with bird bought by Hollywood friend Norman Corwin, both conjurations of eggs "in free space," Walton executed a number of straight "fake real" paintings on a shallow field in the manner of Harnett, including a rifle on a wall, which along with a portrait of Johnny-Pete he traded to Johnny Etcheberry in return for instruction in auto mechanics.

Between the El Cortez commission and the affair with Aurora, from 1955 to 1957 Walton spent weeks in Las Vegas, resulting in many paintings and drawings on Las Vegas themes (plate 19). Reno historian Phillip Earl described "Las Vegas Nights," Walton's two-week show in 1956 sponsored by the Las Vegas Art League at the city library, as a "surreal" treatment of the strip.

1956 was also the year Paul Etcheberry sold off the family sheep business for good. And Walton created a set of watercolor illustrations for his Reno novel *You Wouldn't Believe It*. And Bernard Herrmann commissioned him to sketch set

designs for *Wuthering Heights*, an opera composed between 1943 and 1951, with libretto by film writer Lucille Fletcher (*Sorry, Wrong Number*), Herrmann's wife. Known afterwards as Lucy I, she forced a divorce in 1948, the year Walton met Bennie in Reno (as told in *You Wouldn't Believe It*). The cause was Bennie's affair with Lucy I's cousin Lucille Anderson, Lucy II, whom Bennie then married. The opera *Wuthering Heights* would not be staged in full until 2011, the centennial of Herrmann's birth, with different set designs.

By 1956 Walton had begun his annual two- or three-week sales trips to Los Angeles. That year Herrmann introduced him to Alfred Hitchcock. Bennie was doing the score for *The Wrong Man*, one of eight films on which he collaborated with Hitchcock. Walton recounted the meeting in several places, including a poem which, like the one he made of Bennett Cerf's rejection letter, merely broke prose (his own in this case) into quasi-poetic lines, and like that poem clothed name-dropping in irony. One prose version occurs at the end of a 1982 letter to friends and collectors William and Anita Rowley, whom he wove into the tale (to exactly what effect was between him and the Rowleys). This very long letter is a typical ricochet of the Walton persona from one anecdote to the next, meant to convey by their very disconnection the brilliant texture of the life and mind of the raconteur. To illustrate the style – abstract figuration in prose? – here first is the paragraph preceding the Hitchcock story.

"The Walton boys all were talented"

Eddie [Star], Lord love him, I put his ashes on the mountain overlooking the grave of the Comstock hooker, Julia Bulette's own.......Eddie is bragging about that in the place my and Eddie's good and well dead friend, Rae Steinheimer identified. It was in my dream. Rae had been gone a year or so. I was in a guest room of another friend in Miami [Sam Kafoury] after having flown back from San Salvador Island where I'd snorkeled about trying to see the visual value underwater as free from earth forms in the ordinary atmosphere. Seemed the right thing. In my dream I had asked Rae where I would get more wine for a party – we'd run dry. He was about to tell me when he stopped short and said (in his manner of self interruption in life), "........You know, they always said there was Heaven and Hell and Purgatory – but you know, there's this other place." And while my ghost-friend was impressed with this news he wasn't displeased. And for that reason I think all the Walton fans will some day join together in that unholy terrain....... Yours, for this 'other place'!.......

Which brings to mind the day my close friend the great composer and symphony conductor, Bernard Herrmann introduced me to Alfred Hitchcock at the Republic Studios in North Hollywood—was it Studio City (the same)? William Walton [the English composer] had been feted by the film colony that summer so Bennie's "Hitch" said with a twinkle and very slowly," A-any relation to Willy?"

"No," snapped Bennie, "but he's got as much talent."

"W-ell," said Hitchcock," "the Walton boys all were talented."

Like any good William I can think of [i.e., Rowley], William Walton had been playing with the ladies' knees under the tablecloths at receptions in his honor. He was a scandal. He would have screwed the pilot's wife among the gas cans over China instead of mincing around for dinner. Peking Duck! Bah!......I forget nothing.

"Ach!" cried Anita thinking of the airplane banking between the hospital smoke-stacks, "Ach! It was William."

God love us all as one, R

∙

As for the poem, which omitted the gossip about scandalous William Walton, he titled it "The Complete Angle," possibly because by then it had occurred to him that Hitchcock's comeback was dismissive at his expense.

In Las Vegas in 1956 Walton somehow wangled a place on "a red carpet tour" of the Nevada Test Site's Yucca and Frenchman Flats, the former said to be "the most irradiated, nuclear-blasted spot on the face of the earth." Out of the experience came a series including *Yucca Flat at Twelve . . . 11-10-9-8* (1956) and *Ground Zero . . . 3-2-1* (1956), the latter to provide the title of his second retrospective at the Nevada Museum of Art in 1993, featuring works on paper mostly from the 1940s and 1950s. His artist's statement for the catalog talks about the tour, among other things.

Ground Zero

Albert Einstein might have said, "It is simply a matter of clocks."

Approaching my 80th year I begin to get it. People-time and bomb-time march to different drummers employed by the same deity for the operation of separate calendars in the Twentieth Century space-time collision. This came to me in preparation of the exhibition to be called **GROUND ZERO**, a show which could be dedicated to Joe Sanders and Oliver Placack, my hosts on a red-carpet tour (in the mid-1950s) of the Atomic Test Site just north of Las Vegas. Placack was our science guide and Sanders was boss of the scene who would soon be promoted to Chief of Pacific Operations...How could I ever thank them for their warm human attention to an artist's needs. I didn't understand why I felt as though I had come home when I saw the forty mile Yucca scene. In my press account of the tour I believe I did say to my hosts, "Gentlemen, we are in the same business . . . fantasy."

[Walton transitions by way of Ouspensky, Cezanne and sheepherding:]

The artist is subjected to his times. I was not without the wind, the sun, and the space-movement thrust upon me by my fellow student at Chouinard, Gene Fleury. It was Fleury who described Cezanne's space-movement to me as a cosmic reality. But my destiny was keyed to Nevada, which I think of as my personal **GROUND ZERO**.

Reviewing the "paper-paintings" of mainly the 1950s I considered the matter of clocks and decided there was a people-clock and a different clock with a separate time-scale that was not to be confused. I have called it a bomb-clock. My bomb-clock is involved not with minutes but rather it tick-tocks in decades.

[Walton continues by way of Prophet Wovoka, a Cherokee great-grandmother Susan Kelly Walton, the great-grandfather who abandoned her, modernity, Joseph Campbell, Eastman Kodak, his mother Myrtle, and Wounded Knee:]

So I have a tender regard for the abandoned Cherokee wife called Susan Kelley Walton, my great grandmother. And I take seriously the events of Wounded Knee which happened only a few years before my San Francisco birth calculated in people-time. In a hundred years people-time the American West has become a disaster area in the Indian view which reads best as bomb-time for weren't the women and children bombed as they huddled together in their tepees at Wounded Knee? Sure, you bet your life Susan Kelly was born in Kentucky.

.

Walton was 68 when he wrote his rambling letter to the Rowleys. He was 79 when he composed this artist's statement for the "Ground Zero" retrospective, interweaving cultural observation with reminiscence, genealogy, obscure aphorism and intriguing non sequitur. If the statement, which curator Spencer may have edited, has more overall form than the letter, it also evidences some deterioration; dementia began a slow progression beginning around 1990, says Vivian.

Until Vivian began accompanying Walton's Hollywood sales trips in 1964, he would stay with former Walton Boys who had relocated to Southern California and who tolerated his dog, usually with Sam Kafoury, then a Douglas Aircraft engineer, and his wife Emma Mae in the San Fernando Valley, and less often with Bob and Jeanne Glass, Bob a teacher.

In 1957, Walton had a one-person show and a group show, both in Reno at the new Cooperative Arts Gallery on the mezzanine of Newman Silver Shop on Second Street. Walton himself together with Marijo and Eddie Star managed the gallery for shop owner Nick Jackson in the beginning. Friends Robert Debold and Rae Steinheimer were other exhibitors, as were Craig Sheppard and Robert Caples. Walton continued to exhibit there off and on until the mid-1960s, when he got fed up with Nick Jackson's habit of not paying. After two attempts to extract money due, recollected Vivian with relish, they stormed the shop, extracted a payment, took everything of his off the wall and left, "never to do any business with Nick again. Several people later alleged that Nick never paid anyone who didn't lean on him heavily."

For 1958 traces remain of only one Walton show, at the Petite Gallery in New York City. It's strange that he didn't make more of this show, to which he consigned forty-four paintings, a large exhibition anywhere, let alone the art capitol.

And in 1958 Marijo decided she'd had enough. One day in downtown Reno she saw Walton drive past with a redhead in *her* MG. It could have been Aurora, who had reddish auburn hair. Marijo may not have known that Aurora broke off the affair with Walton when she moved to Reno. Or at least so Aurora would tell Kendall, reviewing the past. Perhaps she didn't break it off right away. Or it could have been a different redhead. Regardless, what made this the last straw for Marijo was the defilement of her beloved MG TD. She not only demanded an end to the marriage, she sold the tainted vehicle and bought herself an identical one to replace it, black with red leather interior, which she still owned when she died.

A terrible omission

In reviewing my tapes, I found a terrible omission. Something I apparently tried to avoid saying. That is, in 1958, Mariejeanne and I separated. She went to Spain, and I stayed in Nevada and built a studio home.

There's some detailed omissions of the personal interplay that I am just not getting into, where the subject for the divorce – on the other hand, for cause, when I got it, I would not give any details. I just said it was for our mutual advantage. And the separation had been for sufficient time that under Nevada law, that if you applied for divorce, it was automatic. Because of the separation.

.

"The separation had been for sufficient time" as technical grounds for divorce because Walton delayed taking care of the formalities until August, 1961. By then both he and Marijo were contemplating second marriages. Vivian was unaware he was still legally married when he proposed to her.

The tape where Walton made halting remarks about the divorce carries two dates, August 7, 1975 and January 5, 1983, the latter the very last date he attached to any of the tapes he deeded to the Nevada Historical Society in 2000. His comment about the supposed "terrible omission" of any mention of the separation must have been added at that late date, for only months before the 1975 date he had twice spoken about the matter. He discovered the omission "in reviewing my tapes," he said. He reviewed his notes written on or in the cassettes, which never use the words separation or divorce.

He said little enough about it on any occasion, never laying out the critical facts nor disclosing much about his emotions. The lingering wound must have been what caused his sense of "a terrible omission."

Upon deciding to separate, Marijo made plans to go abroad. Before leaving and while they were both still in the house on Marsh Avenue, Marijo sought the advice of Robert Laxalt in preparation for life in the Basque Country. Laxalt's memoir about his Basque father Dominique, old friend of her father John P. Etcheberry, had been published the year before, and Laxalt was a cousin by marriage: Marijo's brother Paul's first wife was the daughter of Dominique's brother Peter. That Laxalt family had once lived next door to Walton and Marijo, renting the Etcheberry ranch house. (Dominique had two brothers Peter, whom the Laxalts called "Nice Uncle Pete" and "Mean Uncle Pete." Paul's wife Lucille (Lu), who committed suicide, was daughter of Mean Uncle Pete, the neighbor, whom Walton found "a very warm person.")

The whole scene was wrecked

There was one occasion when Marijo and I were about to leave the house, having negotiated its sale – she was not communicating. Robert Laxalt, the writer, who is currently the head of the University of Nevada publishing instrument, had invited her to cocktails at the Riverside Hotel, as I remember it, and he'd come by to pick her up, and also invited me. Well, he was abashed when she said, "No! No! No! You can't go!" He didn't understand it. He was flatfooted. She didn't want me there, and he didn't know that the whole scene was wrecked. And he was rather paled by it. Taken aback and confused, because he didn't know but that everything was normal. He had had experience in Spain, and she was about to go to Spain, and wanted to talk with him about it. That was the occasion.

•

Walton was mixed up about Marijo's destination and Laxalt's advice: she was headed for Itxassou in French Basque Country not Spanish, whether to fulfill her father's wish of finding a Basque husband (she didn't), or to pioneer for Bahá'í (she did), or just to get away.

On another tape, this from 1977, he ruminated on the ruptures in their mutual friendships, how the Kafourys and Glasses and others who "adored" Marijo and were adored by her gravitated to him, although they may really have preferred her. "And so, life changes," he reflected. "Metamorphosis."

The only pain he came right out and owned had to do with the loss of his in-law family, the Etcheberrys.

I was a son

In separating myself from the life at Marsh Avenue, it was not easy to walk off from Johnny and Louise. I knew that it was the end of all that closeness and love. At the end, Louise spoke to me for the first and last time, personally. Except for that remark on the occasion of the funeral, the remark about Papa [?]. But this was a direct communication to me and for me, from Louise. She explained to me how I was a son just as Johnny and Paul were her sons. That she regarded me as her son.

•

In 1979 Walton ran into the Etcheberrys at the Reno airport. He was going to New York, and they were about to board the same flight. Louise, her son Paul, his wife Lucille (Lu) and a cousin were on their way to a family wedding in the Basque Country, with Marijo seeing them off.

Shot out of the sky

Lu Etcheberry had a surprise for me when our eastbound plane was announced; with her goodbye she gently kiss my cheek saying how much I had meant to her and that I was missed. I never heard what the problem was, later, and never asked: she took her own life for unclear reasons. Somebody said Paul had remarried.

My beard was white when Louise faced me at the airport, did she even know me? Was it my mistake? I'd so cherished what she'd told me when I left Marsh Avenue. Didn't I say [at the airport], "I'm your son, Richard." Jo shot me out of the sky with, "Hardly."

.

In 1960, when Walton was courting Vivian, he told her in a letter that Marijo had returned to Reno "but might as well be back in France, we seldom see each other unless I make a special effort." In a 1962 letter, he said he'd just learned from Emma Mae Kafoury of Marijo's second marriage, and told Emma Mae they hadn't been in touch for a year or more – probably an exaggeration, since ten months earlier he had finally gone to court for the divorce. He also told Em he was delighted about Marijo's new marriage, and hoped the husband "never finds out. And Emma Mae didn't ask, what?" And when I asked Vivian, she no longer knew, if she ever did.

Relations between Walton and Marijo became amicable if distant: in 1965, when he and Vivian were two years married, Marijo gave them complimentary tickets to the Reno Little Theater where Marijo was art chairman for some productions; and in 1976 Marijo called Walton representing the new Moana Nursery as their advertising agent to offer an exhibition in their gallery space, which came to pass.

Marijo had landed in her mother's apartment on Berrum Lane when she returned from France in the winter of 1959–60. That's when she began at the ad department of the Reno newspapers. In 1961 she moved to a house in the Etcheberry Addition. The following year her new husband moved in, Harold Morton, a real estate and insurance man. Then Louise joined them. In 1980 the Mortons moved to the house he built for her in Verdi. After finally retiring as a hotel maid, Louise again joined them. Around 1986–87 Louise began to fail and her two surviving children placed her in a facility in Reno. "By the time she died in 1989 at age ninety-three," her grandson Paul, Jr. told me, "she only spoke Euskara and my father was the only person who could talk to her."

In 1947, Louise had divided most of the Etcheberry home ranch between her sons Paul and Johnny as they set about developing it. The day before, February 3, 1947, she conveyed to the Waltons the house that had been built for them. It was the only portion of the Etcheberry property Marijo ever received. Walton said

she and he "negotiated its sale" when they split up, but between his bad conduct and the fact that the home was a gift of the Etcheberrys, he can't have received much of its value. Then there were the lots in Virginia City they had bought on their return from New York in 1946, where he soon took up residence. He settled up with Marijo from money he inherited from Wilber in 1963.

Why did he leave Reno? Mostly he wanted a fresh beginning. Besides, he didn't like big cities, and Reno was heading that way. "The town was changing into a tourist Mecca," he would remember. "The affectations of grace, and grace itself, had gone into decline. The town was diversifying into shopping-centerism, and my own life was shattering." He did come to "accept Reno on its own terms. It's a hell of a lot more interesting small area than anything I know of in California." But in the aftermath of separation, Reno was "that awful place."

Why Virginia City? The environs had "the trees, the trees, the trees" that first bonded him to Nevada. The town drew creative types. And he owned property there on which to undertake the distracting adventure of building a home.

A Butler Building

The studio home was purchased in modules, nothing over ten feet long, a Butler Building. It had been a former Navy hospital in the Bay Area. A flier had been sent to the rural service of the Bud Tuttles, stating that these buildings were available in ten foot modules. You could buy ten feet from here to Siam. So my dad and I went down to South San Francisco, and examined those buildings. And having built the roadster with Johnny Etcheberry's help, I knew I could build a Butler Building. Johnny would be my advisor.

We had bought three lots from Nicky Hinch. He had waved his arms rather broadly and included the whole valley. Well, I found that I didn't own but a little small part of the land I thought I owned when it was surveyed, and I had a truck-load of house parts, this Butler Building, coming in from the Cleveland Wrecking Company in South San Francisco imminently. Substantially we owned this little section between the C & C shaft and Union Street, about 300 feet deep and 100 feet wide. Fortunately, I did get six more lots from the county.

Now, when I found myself facing Christmas on the first year here – I lived in a tent and a trailer, slept in the trailer, cooked in the tent. Had provisions there. The trailer was the Etcheberry family trailer John Etcheberry, Sr. had used in sheep camp before he died. I bought it for a very small sum.

But when we came in, Sammy [his dog] and myself, I got out with an axe and chopped my way through sagebrush and rubble. This was a dump. I refused to let a bulldozer on the place and I chopped out the sagebrush and leveled the ground myself, and built the building largely singlehanded. Had help once in a while from Johnny Etcheberry on the strategy, how to handle this and that. Other friends helping hold impossible timbers – timbers, no: members – this is all steel, the building. Lyle Hardin helped me erect some of the front, Eric Shastal helped

me dig the sewer, and Eric was to stay with me for a long time, too. He was my taxi-driving friend who would return to the military.

So the dump has been cleaned up and has been graded a bit, and planted. And it still looks a bit wild [in 1976]. But I swear, it will have its manager before Christmas. We'll put in its final posts, and do the final pruning. The final edit, of the brush. And such brush – sagebrush and bunny-brush – as remains will be permanent. And I mean to encourage samples of each native plant.

■

So in spite of his fear of losing the Etcheberrys, Johnny Etcheberry remained a friend and advisor in practical matters.

Other friends pitched in, among them Bill Stone (figure 22) and Bud Tuttle. Tuttle was an atypical ex-Walton Boy in that he had a blue-collar job. Drafted out of the university in 1944, he attended the University of Iowa after discharge, graduated in 1949, then returned to Reno, where as a Walton Boy he began a career as a Sears service technician. Marijo bought her first MG from Bud, who declared, "If a car makes me do things I really don't want to do, I don't want it." Besides alerting Walton about the Butler Buildings, Bud and Nadine Tuttle helped him in another way.

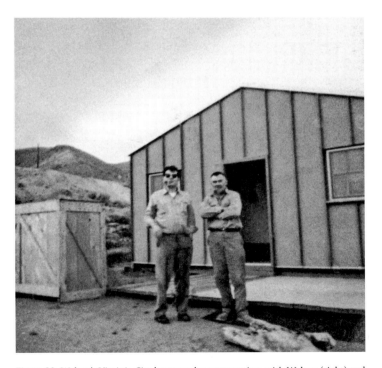

Figure 22. Walton's Virginia City home under construction, with Walton (right) and Dr. William (Bill) Stone, 1959

That was a gift

When I built the house, increasingly I was having difficulty seeing the nails, when I was doing the carpenter work. I built this thing – the interior, altogether – by myself, and put it together as a tinker toy of metal. But the interior is all my handiwork. Now, absolutely. The outside, too, for that matter. But I did have help. Once in a while somebody'd come by and help me lift something. But basically, it's my deal.

Now, I couldn't see the nails. Well, Bud told our friends, they made a contribution – made a pot – and sent me off to have an eye examination, and to get glasses. That was a gift, of my friends, the Tuttles – are of that stripe. And I never forgot it.

•

Eddie Star it was who came up with "Tinker Toy house." Nominally at 320 Union Street, the 20' by 60' modular structure went up on a property of about two acres. To completely finish home, studio and grounds lasted well into Walton's marriage to Vivian.

Walton first met Vivian Diane Washburn (1945–) in 1953 when she was eight years old. Her mother was a former art student of his. In 1939 Mary VanderHoeven (1909–1980), a woman a few years older than he, joined his class at the Reno Art Center in Idlewild Park, steered there by Walton's brother-in-law David Mayberry, who learned of her art background while processing her naturalization papers at the Reno post office. Born Margaret Mary van der Hoeven, she left Europe at the outbreak of war. She had been in Berlin, studying to become a sculptor and practicing as a physical therapist, a skill acquired at the prudent insistence of her Boston-born Dutch-American mother, a musician, and well-to-do native Dutch father, in import/export. After three years of training and a diploma from the Hague, Mary had built a good practice. In *Beyond Holland House*, Walton solemnly transcribed the affidavits her parents and the American consul in Rotterdam, Mary's birthplace, attested in 1938 for Nazi authorities to enable her move to Berlin, certifying that Mary's parents and grandparents "were of pure Aryan stock." In telling her story, Walton dwelt on two dimensions of Mary's European past, the situation she escaped, and her attachment to her wealthy and lecherous Dutch grandfather – Walton deploring the former, and just as obviously delighting in the latter.

In Berlin she married a German poet, Kurt Meissner – "ran off and married" said Vivian, most likely paraphrasing her mother, whose three marriages were all brief. They had a child, Vivian's older brother Titus, who remained behind with her parents until well after the war. Walton met Mary as a student in his art class

after she had emigrated to San Francisco, moved to Reno and acquired an "Electro and Hydro Therapy" business with an office in the Title Insurance Building at 29 E. First Street.

A handsome figure in the Reno swirl

Not realizing physical therapy at that time in America hadn't the status it did abroad, she'd taken over the Reno Health Baths with financial support from generous Eastern relatives. Patrons sometimes blundered into her health baths expecting a brothel and were sent packing, as Mary put it.

Independent and outspoken she was a handsome figure in the Reno swirl and I'd not forget her from that first day at Idlewild. Later, I'd see her at the Mayberrys', who were actively holding Bahá'í Firesides. She was easy to get on with but innocent in odd ways; it would take me forty years to get some things straight. Without a natural funny-bone she was still a lively wit and fun to be with. Her sharp mind thirsted for select information and her self-improvement regimen seemed boundless. Words mis-used, mis-spelled [sic], or spoken incorrectly would be attacked on the spot. She was the first wholly liberated woman I'd known, private, fastidious, and resentful of forward clerks. The mere presence of a woman in Reno suggested divorce; she was no exception.

．

Mary lost contact with Meissner her husband in Germany, then with her parents and baby when Holland was overrun in May, 1940. "I had intended to come here first and get settled and send for them both," Mary told Walton. "But now I can't." Instead she moved to Reno and got a divorce. "I was never comfortable asking Mary personal questions," commented Walton in another connection. She wouldn't be reunited with her son for another seven years.

The therapy business soon went under, and Mary began attending the university with the support of the Eastern relatives with whom she had once lived for a year as she attend art school in Boston. The details become sketchy. "Mary was so private I don't know much," explains Vivian. In August, 1941 she remarried, to Luther Dugan Washburn, a fellow student who grew up on a ranch near Wadsworth thirty miles east of Reno. They both dropped out and moved to Vallejo, California when Dugan got war work as a welder at the Mare Island Naval Shipyard. The marriage lasted three years. No more than two months pregnant, Mary left without telling Dugan he would be a father, or even that she wanted a divorce, which she obtained in Carson City in November, 1944. Only then did Dugan learn she was expecting his child; Mary felt she "wouldn't have the heart" to divorce him once he knew. Vivian was born on May 21, 1945, in Reno, whereupon Mary moved them back to California.

In March, 1947 she gave birth to another child, James Personett, by her next and last husband, a Santa Rosa real estate developer, Eugene Personett. "They loathed each other shortly after marriage," Mary told Vivian. Divorce followed

Jimmy's birth. With the settlement Mary established the Holland House restau-
rant in Kenwood, where Vivian grew up until high school. "Mom ran it by herself
with me as an assistant child server. Dugan tried to help in the beginning but it
wasn't a fit." Dugan was a kind man who tried to be a good father and thoughtful
ex-husband all along. "She and Dugan were friends without benefits. And he
was a responsible father without benefit of court orders." After the restaurant
failed he paid their bills, and continued to do so after he bought them a house
near a high school for Vivian in Fairfield where he had moved for subcontracting
opportunities grading new housing developments. Mary sold a painting now and
then and took odd jobs – sales, housekeeping, waitressing, stacking kilns, even
truck driving – without Dugan knowing.

This about Vivian's mother is by way of background to the unusual way Walton
was introduced to his future wife by his future mother-in-law, who had been in
sporadic contact with her former art teacher in the interim.

She was yet a child

[Mary] had dropped by my Reno studio with their daughter, Vivian, who was
about eight; there were questions I didn't ask, I doubt if she'd have said much about
the divorce – her marriage to a Santa Rosa contractor, their son. I did know Mary
had operated a failing roadside cafe called Holland House; she had mentioned it
on our chance meeting at the Raymond and Raymond Gallery in San Francisco,
one year. The Mayberrys had kept up with her better than I had. On the Reno
visit she urged me to paint her daughter while she was yet a child and I did what
I could to avoid it. Vivian had taken a strong dislike of the idea and of me.

.

Vivian's fond memory of the day is of sheep in the field outside the Marsh Avenue
house. She told me the reason she didn't like Walton then was that he wanted
to paint her portrait. Another time she acknowledged the full reason for her
reluctance and dislike, something Walton also skirted: the year before, when
Vivian was seven, Mary had written to Walton offering her daughter as a studio
model. "I have been talking with Vivian and I think she might consent to do a
little nude posing for you. I hope she will, because I know it would delight you.
The lovely texture of course, and what fascinates me above all is that though still
undeveloped, the whole little body is yet so definitely feminine. Particularly in
the soft line of the hips." Vivian refused.

Through many years of marriage Walton never asked Vivian to pose, not because
she would have refused, but rather, she says, because he had her body in "the file
case of memory."

Walton next met Vivian in Virginia City, after his unfinished Butler Building
had become habitable and the sheep camp trailer was available for guests.

A fascinating ponytail

Well, that Christmas, '58–'59, facing the new year, I sent cards to friends I didn't want to lose touch with to let them know where I was now. I was no longer in Reno. The house had been sold there. Marijo was in Spain and I was building a studio on the Comstock, and I urged them all to come by.

Well, the first one to take me up on that was Mary VanderHoeven, who had been my former student and a firm friend of the Mayberrys and my mother. So Mary showed up with her daughter Vivian. She had showed up before with Vivian in Reno. Vivian was about eight years old and she hated me. And now that she was pressing on fourteen and had a fascinating ponytail and a straw hat, she didn't hate me that much. Here I was in my forties and Vivian was thirteen, and five years later, when she graduated from high school, we were to be married.

·

In some manner the courtship commenced on that occasion, and continued during further visits. I had to ask, "What in the world did your mother think?" "It never occurred to her," replied Vivian. "My mom thought he was interested in her."

"But at some point she had to understand the true state of affairs?" Vivian answered by excusing her mother as an artistic free spirit.

As for artistic, Mary both taught painting and exhibited successfully in the towns of Central California, earned extra money making jewelry and pottery, attended poetry readings, and took her daughter to art films and museums. Vivian, herself once a painter and potter and currently a jewelry maker, and a constant and eclectic reader, got her inclinations from her mother. As for Mary's free spirit, if it doesn't speak for itself, she once offered a workshop titled "Being Truly Alive."

"I don't think for a minute she would have condoned it if Richard had a gas station or drove a truck," continued Vivian. "She regarded herself as open minded," and she "held him in high regard artistically. Male artists can come off as very romantic," Vivian added, with the slightest smirk. Then, "Looking back at the situation, all I can say of Mary is, 'What were you thinking?'"

The idea was floated to me by someone who knew the players that Mary may have had an affair with Walton back in the day. When I approached the delicate issue with Vivian, she denied it, not defensively, as if it were a thing she had long since fully weighed and rejected.

"Sixteen is when he started asking me to marry him" – sixteen, Marijo's age when they eloped in 1938. He had been twenty-four; now he was forty-six. Along the way she accepted, but insisted on finishing high school first, to prepare for college. He argued they could try marriage for a year and see how it went, but she wouldn't give in. So began their engagement.

Dirty old man

When I'd sold my quota at the Hollywood dinner parties I'd head back to Nevada the same way, a few days in Santa Paula [with his mother], a stop in Stockton

[with his father], a swing by Fairfield. I had a guest room at 716 Maryland; Dugan might drop by to pay some bills for the house he owned and maintained for Mary and Vivian. Armijo High was a few blocks off, a short walk but I'd drive Vivian to school like a dirty old man.

·

"I read a good part of *Lolita* and it scared me," he confessed in a letter. "Of course you are a lot older than Lolita and have the benefit of experience." "A lot older" was fifteen, almost sixteen when he wrote that. I could think of more than one reason Vivian wouldn't want to divulge to me her prior sexual experience, if that was Walton's implication. She deflected my approach to the question, but for which reason?

Qualms about *Lolita* and dirty old men didn't inhibit him from painting *Moonlight Lolita*, nor from writing such endearments as "My sweet child," "tender child," "Dear Child Bride" and "I love you, child." In one letter he addressed her as his "tiny doll," with the saving grace, to call it that, of making fun of both of them by signing below a cartoon lampooning their age difference (figure 23). This was in no way behind the back of Vivian's mother. A letter to Mary following a visit by Vivian to Virginia City gives the measure of the situation (figure 24). "Tell Vivian I love her – little doll. I kissed every one of her toes, one by one while I watched her pretty face. She didn't even say thank you sir. An all-time first, I thought I should be congratulated. They were clean, thank God. What toes! Oh, I love your daughter." What *was* Mary thinking?

"We have decided that we haven't got it any more and I am a dedicated monk," wrote Walton in the *Lolita* letter of May, 1960, implying for Vivian's benefit that he and Marijo tried sleeping together. But monkdom got old, as he made sure mother and daughter both knew in this composite courtship. Rosamond Hathaway, a child psychiatrist and war widow from Boulder, Colorado, "chanced into an exhibition of mine last summer and she was wiped out on the spot. Insisted I marry her immediately if not sooner." There was also Sandra, a Welsh heiress. "You know, of course, that both these ladies are important clients, too. I can't chase off $500 per year per head without some hesitation."

Figure 23. Walton's signature of a courtship letter to Vivian, with cartoon, June 28, 1962

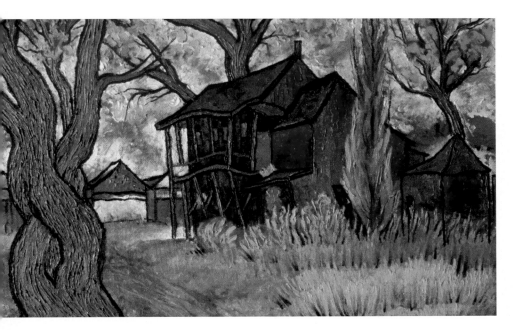

Plate 1. *Chinatown II* (1937)

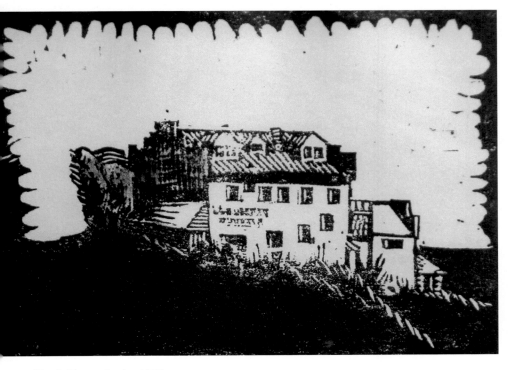

Plate 2. *Montara Inn* (ca. 1933)

Plate 3. *Riverhouse* (ca. 1936)

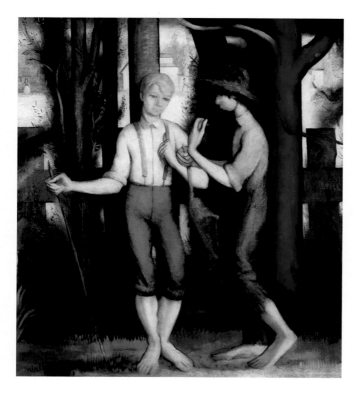

Plate 4. *Tom, Huck and the Dead Cat* (1939)

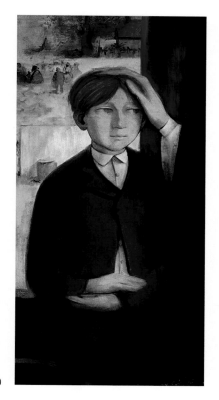

Plate 5. *Aunt Polly's Sid* (detail) (1939)

Plate 6. Main tent in sheep camp,
sketch, 1950

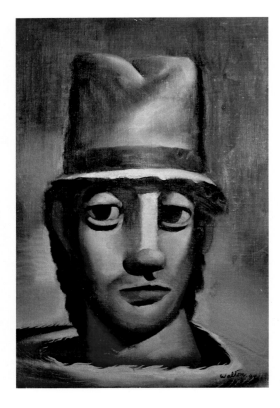

Plate 7. Lamb marker, title unknown, 1944

Plate 8. Lamb marker, title unknown, undated

Plate 9. *Self Portrait* (1945)

Plate 10. *Abstraction* (1948)

Plate 11. Figure, title unknown, 1949

Plate 12. *Vine Torso* (1950)

Plate 13. *Nude "X"* (ca. 1950)

Plate 14. *The Pink Pandora* (1950)

Plate 15. *The Bats* (1953)

Plate 16. *Malefactors* (detail) (1950)

Plate 17. *American Flat XXIII* (1952)

Plate 18. *Egg* (1959)

Plate 19. *Casino* (1956)

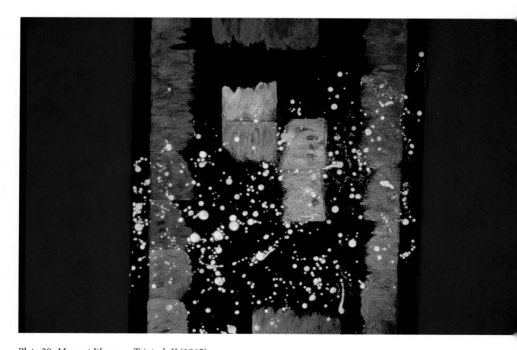

Plate 20. *Maze at Ithaca* or *Triptych II* (1965)

Plate 21. *Odysseus Rex* (1967)

Plate 22. *Pax Americana II* (1968)

Plate 23. Letterist, untitled, 1968

Plate 24. *Paleozoic II, "Trilobite"* (1972)

Plate 25. *Virginia City II* (1973)

Plate 26. *Malalo Ka Kai* [Under the Sea] (1976)

Plate 27. *Off Riding Rock* (1977)

Plate 28. *Homage to George Riemann* (1981)

Plate 29. *Call 1-800-1860* (1992)

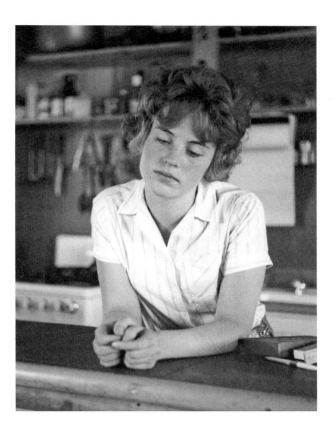

Figure 24. Vivian Walton in Walton's kitchen, ca. 1962

The plan was to marry after Vivian graduated in June, 1963. They were formally engaged the summer before. Nevertheless he continued to urge her, and Mary, to let the ceremony happen sooner, right away. In the meantime, his letters also instructed Vivian in both painting and writing, a stance of a piece with the rest from a "Me too" perspective. She didn't tell friends anything about Walton until about to graduate.

The wedding took place on June 23, 1963 in the front room of Vivian's new home. Virginia City Justice of the Peace Eddie Colletti presided. Mary and Dugan were there, and Vivian's half-brother Titus. Vivian thinks the Paskows, craftsmen friends of Walton's, may have attended, but no one else from Walton's side. Wilber had died that February, leaving Walton $7,000. He bought his only ever new vehicle, a GMC truck which he outfitted for sales trips to Hollywood. Myrtle was alive. She had been pioneering for Bahá'í 1959–61 but was back in Santa Paula. Florence may have been out of the country on Bahá'í business. "Talk about a small wedding," recollects Vivian. "Ceremony, cake, champagne. Everybody left and we washed the rented glasses. Looking back it seems very depressing."

Who took the wedding photos? In one, Vivian in gown and veil has Walton by the ear as a man behind him with a long gun holds him captive by the suit collar (figure 25). Behind Vivian stands an older man with the proverbial shotgun. The armed men are Vivian's male relatives. No one is quite in character, except for Walton, the desperate prisoner bound for the altar. Ty's grin gives him away as no natural when it came to make-believe; Dugan the shotgun toting father smiles sadly, reluctantly.

"I was so pissed off," says Vivian. The comic vignette was all Walton's idea.

The other photos, conventionally staged, show an eager groom, a sultry bride. Both look their ages. "We were 'a scandalous pair' for a short while," said Vivian with a nostalgic hint of mischief. On their wedding day she believed he was going on thirty-nine. "I didn't dare tell her any different," admitted Walton on tape in 1980, deceiving himself at that remove that he'd been only forty-five – really he'd been going on forty-nine. And yet, his people saw him as the vulnerable one. Bernard Herrmann "would tell Vivian to take care of me. In his kind way. Well, my father said the same thing exactly. He said to her, this young girl, eighteen years old, 'Take care of Dick.'" She would have been seventeen when Wilber saw her before the wedding.

Figure 25. Walton and Vivian's wedding photo, posed as shotgun wedding, June 23, 1963

Here I wish to insert a story illustrating the hazards of biography. This happened five months after the marriage.

Vivian was looking at her drawing board

Dugan and I were talking over a bottle of brandy with stories traded through a full afternoon, giving the one about Vivian and John Kennedy: the marriage was new and I had explained that when I was painting I mustn't be disturbed. I know I'd done it badly but she often spent time in the back of the house drawing – I couldn't hear her from the studio. Marshall Heuer, my insurance agent, dropped by that afternoon and as he left he said, "That was a terrible thing that happened in Dallas, wasn't it?"

I said, "I've been working. What happened?"

"President Kennedy was assassinated in Dallas." Marshall gave such facts as he had and took off with me running through the house to Vivian, shouting, "Kennedy's been killed!"

I told Dugan his daughter was looking at her drawing board when she said, "Oh yes, it was on the radio this morning."

.

I drew the conclusion Walton evidently wanted readers of *Beyond Holland House* to draw, that there was something amiss with Vivian.

When Vivian had come to trust me enough to say I could ask anything and she wouldn't be offended, I began to recount the Kennedy story. She stopped me with a quiet laugh. Walton told that story for years, she said, always leaving out the fact that the news came right on the heels of an angry argument over Walton's demand, "I need absolute silence! Don't interrupt me!" And so she didn't.

"I loved Kennedy," she told me. "I was horrified."

Vivian wrote regularly to her mother, newsy letters embellished with sketches in the margins, often discussing books, movies and other arts, but never revealing anything about the marriage. Mother and daughter also phoned once or twice a week. Were the conversations any more confidential than the letters? Vivian says no. The closest thing to a confidence I encountered in scanning 175 or so of Vivian's letters was penned the evening after a July Fourth visit from Mary to Virginia City in 1965: "Sorry you left in such a tizzy. There were misunderstandings all around that don't bear examination. Too complicated."

Walton counted himself "lucky to have had two mothers-in-law I cared for." He, Vivian and Mary would travel together to Holland and England in 1980. The only other clue to their relations as mother- and son-in-law comes from Vivian, repeating the refrain of all Walton's acquaintance: "We both felt his monologues could be overpowering."

During the courtship years and early marriage Walton got by almost entirely on sales at Hollywood dinner parties. "In two weeks I could sell enough to live all year on the Comstock," he boasted in *Beyond Holland House*. "Show fifty paintings quickly and you'll always sell something." He was able to haul fifty paintings and show them in someone's living room by painting on the cardboard backings of a hoard of scrapped outboard motor ads. With the paper ad peeled off he would prepare the cardboard with fine sandpaper followed by a titanium ground. His system was to produce what Vivian termed "a run of paintings," up to twenty or thirty together, which could take months because of how long it took for each layer of paint to be ready for the next layer, using the old master techniques Walton learned from Taubes.

A few months before the wedding he wrote to Vivian from Hollywood.

A "winning" aura

This area is very good for sales for me. It's hard to believe that so many people want so many paintings, and so easily sold. There is a "winning" aura about my case wherever I touch. So different than the patterns of jealousy up north. So many are used to success here they accept the other fellow's case with grace and respect.

·

But by the end of the tour, he conceded elsewhere, "I was running on my nerves. It was emotional for me, a process I could not bear up under." Moreover, in crude dollar terms Walton's success was modest. "In ten days I would sell ten paintings," he stated. "At $300 each I made my nut of $3,000, which was what I had to have in 1960 for my life on the Comstock." Among his papers are bank books for the years 1960–64. Excluding the inheritance from his father in 1963, total annual deposits actually ranged between $2,068 and $2,777, those amounts including income from exhibitions and other sources. For the ten years 1959–68 he averaged two exhibitions a year, all in Nevada (Reno, Virginia City, Las Vegas) except three in California (Bay Area, Los Angeles, Santa Paula). Half were group shows, none were major, most quite minor. In 1965 he received a total of $3,836, over two-thirds of it from sources other than Hollywood sales.

Vivian began in 1964 to accompany the annual sales forays. Sam Kafoury's wife Emma Mae didn't take to Vivian, so they put up instead at decent motels that had seen better days, and economized further with peanut butter and jelly sandwiches for breakfast and lunch, expecting a good dinner at the home of that evening's patron before guests arrived for cocktails and the art show.

Walton said fairly that he "moved in circles that few would have been able to follow." Vivian was a very young woman introduced to some of Hollywood's elite. Besides those already mentioned such as Norman Corwin, Walton's clients included Corwin's wife actress Katherine Locke; actress Marsha Hunt and her husband, writer Robert Presnell; Gregory Peck's wife Greta; actor Harry Carey; director Andrew McLaglen; producer Norman Herman; filmmaker Laurence Mascott and his romance novelist wife Trina; and composers David Raksin and John Williams. I had to press Vivian for any recollections, and asked what accounted for her nonchalance. She explained that she was raised among adults, and surrounded by the arts, and that she read a book a day, and that she didn't like most of the Hollywood types she met. Only David Raksin was "very nice." Her fullest anecdote involved a party at the home of John Williams which had a white-carpeted living room "with the square footage of an average house." Dress was supposed to be "casual," so Vivian came in t-shirt and jeans, only to find that casual meant women wore "$1,000 Palazzo pants." On another occasion Williams bought two Walton paintings but refused to allow his wife Barbara to commission a portrait of her and their children.

As for Bennie Herrmann himself, Walton's dear friend, she found him "boorish," with "no social graces at all," and Walton couldn't have disagreed.

An ugly soul

Boy, he had a baleful eye, God love him. He was an ugly soul about half of the time anyhow, and he was self-sorry. I don't think he quite understood how ugly he could be. Oh, he was a bastard to help. To people, people waiting on him. Vivian and I drove down to that hotel where he was staying. He met us at the door. We went in and had dinner with him as his guest. And he was unforgivably miserable to the waitress. He could be mean and small and petty. And he complained in a whining, growling way to the waitress, and made her just miserable, oh, about some small thing, like the water was late or some fool thing – inconsequential matter.

Oscar Levant, who was a pianist of credit, especially on the Gershwin material – Oscar Levant had written a book called *A Smattering of Ignorance*, and in it he referred to Herrmann as the most disliked man in Hollywood. He was viewed with suspicion, because no one knew when he'd jump down their throat.

 ▪

Herrmann said "Take care of Dick" to Vivian as they were leaving the restaurant that time. "We would never see him again." Walton credited what Vivian and many others didn't, Herrmann's "warm love" and "abiding concern for his close ones," his generosity and "care for his friends," and his capacity to relax when not "so damned nervous. Sometimes we'd go out, the three of us, Lucy, Bennie and myself. Hell, we had good times together." Not that he wasn't "a ponderous, insufferable bastard to live with," supposed Walton, who witnessed them "barking at each other like dogs."

Herrmann, who died at only sixty-four, used to tell Walton that "in his declining years he wanted to come to Nevada." Norman Corwin was Herrmann's closest friend, Walton his "Nevada brother. We saw eye to eye as artists." Yet not quite. During and after the war, Corwin famously created radio scripts supporting Roosevelt and the war effort. Herrmann criticized him "for allowing himself to be used as a spokesman for the New Deal." An artist, he insisted, "should keep himself clear of political events." Whereas Walton was ever grateful to the New Deal for the Federal Art Project, and on top of that created explicitly political art at intervals his whole career: *Self Portrait* (1945) (plate 9), sardonic portraits of presidential candidates Hubert Humphrey and Barry Goldwater in 1964, *Hanoi No Kleenex Si* (figure 26) and many more. But he wouldn't contradict Herrmann.

Figure 26. *Hanoi No Kleenex Si* (ca. 1964–68)

I always deferred to Bennie

I didn't argue with Bennie about it, as I didn't about – I didn't argue with Bennie at all, because I was there so briefly. It was not my position to row with this irascible man, who was my dearly beloved friend. Otherwise, I would be no better than any of his other friends, if I lived there and had to suffer his continuum. But fortunately I was only there for a spell in the winter.

I did so revel in our relationship, and I always deferred to Bennie because he was the great man in my life, one of the great composers of the world in his days, and I shouldn't argue with him. Although I didn't agree with him on a lot of things, I just let things pass. When he brutalized me, I'd just take my blows. But I valued his company and I loved him as a close, dear friend.

Certainly I never saw him as anything but an equal myself, and he treated me as an equal. And I didn't have any big reputation, just a little special one. He would tell people, he said, "Well, he's the only man I know who does exactly as he pleases." That's far from the truth. But anyway, Bennie told all sorts of people that. Among them was Alfred Hitchcock. But that's a bunch of crap, because I wanted a personal studio as big as a Warner Brothers sound stage, and I didn't have that, and so therefore I wasn't doing what I wanted. He always wondered why I didn't go abroad. Well, I knew why. God damn it, I didn't have the means, and I wasn't gonna be strapped abroad. And my back was to the wall here in my studio in Nevada.

·

Walton's deference to Herrmann bespeaks a relationship other than equality. Yet he did challenge the great man on one thing, and of all things on his conduct as an artist, a shot every bit as hard as Herrmann took at Corwin on politics and art.

"Bennie, why fuck around with the movies?"

I questioned his right to compose music for films. I said, "Bennie," I said, "why the hell do you fuck around with the movies? A man with your talent." And he would give these lame excuses. "Where else can I get an orchestra?" And I can understand that. And I understood, too, that Bennie liked the good life.

·

So Walton came on holier than thou with Herrmann the composer as he had with Loring Chapman the scientist for being a housebroken careerist, and as he did with another of his Boys, Jim Hulse the historian, for not risking his academic standing by going full radical in his political positions. They all compromised their talents, he judged, whereas poverty certified his own integrity. He, like the terrible Biscaya, was not housebroke.

Manifestly there was a large element of choice in Walton's frugality up in Virginia City with his "back against the wall." But who can say just where choice leaves off and constraints of personality begin? Integrity can entail both. As to integrity, however, a smudge of carbon can be found on the pot who called the kettles black. Vivian discloses that when he was preparing a run of paintings for sale at Hollywood cocktail parties, he went by the dictum, red sells, blue's okay, can't move a green. He would glaze a few paintings red ahead of the annual sortie.

Herrmann accumulated a Walton collection at his home in North Hollywood. The place went to Lucy II in their divorce settlement, but he rented it back from her, he was that attached to it. "It was the love of his life," said Walton, whose paintings hung in the cabana by the swimming pool.

A strange display of Walton paintings

His art tastes were peculiar. He had, perhaps, the worst collection of my paintings of any of the people who gathered them together. None of them went together.

None of them. And, with his heavy-handed way, he'd be the insistent designator of which painting was gonna be in the expanding collection. Oh, that had at least six or eight. Many of them were all right, if they were hung apart from each other. But he'd hang them right together. And that cabana was a strange display of Walton paintings.

•

Whatever his opinion of Herrmann's discernment in the visual arts, Walton held dear the sharing of music with his patron (my word, not Walton's). Once Herrmann kept him at the house till after midnight for the rare experience of watching a rerun of *Citizen Kane* on TV with the composer. Sitting on the bed with Herrmann's original score on their laps, "he would quickly brief me before each scene, then follow the score with his finger.

Besides music, Walton talked on tape about something else they had in common.

Their young wives

I myself had been recently remarried to a much younger person. Bennie had always been bemused by that circumstance. He was pleased – I mean, in his own wife, he was so pleased that Lucy II was young. [He] would often speak in light heart of dining with the Charles Chaplins, and made light talk about there they were with their young wives. And Stokowski, Leopold Stokowski, would often be a house guest at the Herrmann house on Bluebell Avenue, and stay at the Cabana, which was filled with my paintings. And Herrmann had joked with Stokowski about his marriage to Gloria Vanderbilt, she being younger than Leopold by a good deal [forty-two years].

•

When Walton made this tape in 1980, he reported the conversations between dead luminaries with neither overt amusement nor explicit censure, though you can sense some discomfort. To his credit, he referred to his own young wife Vivian as a "person."

Walton last saw Herrmann in 1965, a year in which he and Vivian stayed on in Southern California longer than usual, from March into late April. Once before, in 1963, he had varied the pattern by spending fully three months there doing various small jobs on films, which he hoped would lead to something larger. A letter to Vivian months before their marriage predicted that by the time she was in college – her plan that never came to pass – he "should be up to my neck in film work and would be making good money during the school months." That also didn't come to pass, but in 1965 he was kept in Hollywood from March into late April by several jobs, most if not all thanks to filmmaker Laurence Mascott.

At his elbow

Many times he would make a place for me in his productions – always talking films, always sending me to films of others, showing me rushes. Parading "the

artist" to his crew at headquarters [Mascott Productions] with near glee which he hid well. Then there were the lunches – how many lunches with Laurie, conferences, usually. I would know production through Laurie. The filmmaking community became familiar to me – and I don't mean my celebrated friends – I mean the back lots of the scene, the bones of the business. I'd wait for him at Pathe, we'd go on to a title house – I'd be at his elbow.

·

Mascott's main client was Litton Industries, a defense contractor and conglomerate. He made industrial films for them, and in 1965 was starting on a documentary for wider release, *The Battle of the Bulge... The Brave Rifles*. Walton's designs for the credits were cut except for a single image, so he got none of the glory when *The Brave Rifles* was nominated for an Academy Award as Best Documentary Feature of 1965. Nevertheless he was paid $600.

Laurie Mascott was another friend whom Walton regarded as "absolutely housebroken" and "afraid to get at odds with the system" – this pal whom he knew originally from Reno and who opened doors for him in Hollywood. I don't know that he confronted Mascott as he did the others. How could he? Walton opposed the expanding Vietnam War, and produced protest graphics in a style that some would called Conceptual Art, images of language such as *E Pluribus Unum, LBJ, CIA Lives!* and *Hanoi No Kleenex Si* (see figure 26). Meanwhile, with Mascott he was in the pay of an arms manufacturer collaborating on *Brave Rifles* to glorify the military.

Offsetting otherwise thin sales that season, Walton installed a large mural in Laurie and Trina Mascott's new home in Hidden Hills. The panels, totaling 35 lateral feet, spanned several rooms.

They leave me free

The Iliad and the Odyssey would run a thin line from room to room and over their fireplace. When installed a guest said, "But it doesn't resemble the sketch I saw last year." I said, "That is the closeness of the Mascotts and myself, they leave me free and I do a better job than hoped; they know it will happen."

·

Walton's mural for the Mascotts came near the beginning of an enthusiasm that lasted into 1969, what Vivian terms his "Greek black pottery period." Back home in Virginia City, he even applied unsuccessfully for a Guggenheim grant to study ancient pottery in Greece. *Maze at Ithaka*, or *Triptych II* (1965) (plate 20), my favorite in the series, presents as completely nonrepresentational, although given the geometric subject it's hard to say. Walton's favorite, *Odysseus Rex* (1967) (plate 21), "one of the best paintings of my long career," is an abstract figuration. Betty Parsons singled it out when she looked at a page of his slides in 1979. That was the trip East when he ran into the Etcheberrys at the Reno airport.

Making do from Nevada

Without turning to see who was there she said she wasn't seeing anyone that day. Ignoring that, I said, you won't believe who this is. She turned and said, "It's been forty years since I saw you. You look the same." Betty Parsons had been publicly described as a ferret. Energetic, she had a sharp answer, made quick, agitated decisions. Fidgeting over her clutter, she said, "You must have photos. Let me see them." She ran down them with a stiletto finger, stopped on *Odysseus Rex* tapping it five times. Somehow an apology, she said, "It looks good, but who can tell from slides. I'd have to see it." Not easy making do from Nevada.

.

Vivian explained Walton's technique for the Greek black pottery series. He began with a ground of black enamel paint. Next the over-colors, often brick red or pink, were applied by paper-painting (stamp-on) while the black ground was still tacky. After the enamel layers dried, a clear medium was applied overall, onto which before it dried he used small brushes to paint figuratively and/or drop white spots of oil paint (he called this "pointillism"). Variations include the solid red wings of *Triptych II* (plate 20), obviously brush-painted.

In 1966 Walton had to skip the annual sales trip south to complete a mural for the C. Clifton Young Federal Building and Courthouse in Reno, a commission for which he beat out Craig Sheppard, whom the architect would have preferred. Not long after installation the mural featured in the book *Art in Architecture* by Louis G. Redstone, McGraw-Hill (1968). Twice restored in the 2010s, for a tear and then for steam damage from a burst pipe, it can be viewed today dominating the lobby.

The project, initiated in 1964, was delayed by objections to Walton's proposed design – that's what kept him from Hollywood. In *Beyond Holland House* he complained about the matter as an aside to discussing his WPA days and the fiasco of Ben Cunningham's overpainted ceiling at the Reno post office.

It was always administrators

I would relive Cunningham's problem, myself, when an outgoing administrator refused to allow me to use my customary color in the Reno Federal Court mural on Booth Street. Unsuitable for a federal building was the term Washington hit me with, and I did it in tones. Things had gone too far for me to quit, I had to pay expenses. Mind you, the WPA gave me no problem. It was always administrators.

.

In 1974 Walton donated papers connected with the project, including correspondence with the administrator, to the Smithsonian's Archives of American Art, to put himself on record: "In addition," says the archive's website, "there are three letters from Walton to the Archives of American Art about his life and his personal reactions to the mural project."

The specific criticisms, according to Vivian's synopsis for her mother at the time, were "colors garish," "Indian mask too carnival," and "not enough design unity" – quite a contrast to the freedom he had just enjoyed executing the Mascott mural. Walton grumbled but needed the money and made revisions. This may have been when he took a short-term job with a crew surveying a tungsten mine. Final approval of his revised design didn't come until May, 1966. He was paid $4,000 for the mural, from which he had to cover his expenses. The canvas alone, shipped from New York, cost him $2,200.

The mural, titled *Life Before the Pioneer Era*, is a 6.5' x 24.5' oil painting comprising joined sections of canvas, a triptych expressing three themes in abstract figuration and muted colors: to the left, the (then unofficial) state bird, the Nevada bluebird, symbolizing "light, movement, and space"; to the right, the dialed-back Indian mask, "witness to man, nature and time"; and in the center, three heads of mustangs to "exemplify desert freedom" – these readings according to the plaque in the lobby. Walton achieved "design unity" with vertical strips containing petroglyph motifs separating and terminating the three sections; and with a discontinuous band across the bottom, abstractions suggesting basins and ranges, water courses and animate figures.

And then, Johnny Etcheberry suddenly was dead. On August 2, 1966, the *Journal* reported that just before ten o'clock the previous morning, "two prominent Reno businessmen were killed" when their small plane came down on a hilltop not far from the Virginia City turnoff from Highway 395. A witness heard a noise "and then saw one of the plane's wings fluttering to the ground. The wing was still in the air when the rest of the plane crashed to earth."

From Walton's writings and tapes it appears that Johnny's was the first death to affect him immediately and deeply. His mother Myrtle had died in Santa Paula just months earlier, and Wilber three years before. It could be that Walton grieved for his parents through Johnny. It could have been an abrupt symbolic closure to his first marriage. Or maybe it was the proximity and sudden violence of Johnny's death. Johnny was forty-eight, Walton fifty-one.

By and by Walton had a conversation about Johnny's death with Harry Murray, Johnny's brother-in-law.

I didn't want to cry on the floor

I told Harry that I didn't go back because I didn't want to cry on the floor. I said I couldn't stand to see any of them, because I was in no shape – Sara grieving, and I should go up to her and collapse. I said even now I can't bear to think of it. I told

him the story of Vivian and I driving down just the moment after the accident, with the lady coming out on the highway waving her arms. And then the sheriff's car. And we drove on and found out later it was Johnny. In that crash.

He said, "Did you ever fly with Johnny?" I said, "It was my first flight was with Johnny." "Well," he said, "Johnny would deliberately shut the motor off. Then he would put it in a steep dive and start it again." And he had some idea that Johnny had – that the motor – they had heard the motor fail on this Luscombe of [Jack] Dudley's. The examiner was with Johnny to check Johnny out for his new licence, that was what was being checked. And obviously Johnny was flying the plane. He said that they had heard it sputter, and the next thing you know it was in a steep dive, then a wing came off. It dove into the ground. Well, he said, Johnny would put them into a steep dive to start the motor. And he said he blames himself partly for the thing, because it was his urging that got Johnny back into airplanes.

So he said – and he could barely say it – he said, "I went back to see the wreckage. And looking around at the parts," he said, "it was awful." He says, "You know, the grip for the control – I found the ball. I picked it up." And he said, "There was the end of a finger that was broken off, with the fingernail, the thumb, embedded in that ball."

Well, Connolly said there was an eyeball on the dashboard. Oh, it was an impact.

▪

Reno fireman Jack Dudley's plane was a Luscombe with a Lycoming engine (Dudley is in figure 18, standing behind Marijo). Johnny also owned a Luscombe, which he modified for aerobatics in a huge garage on what was then a ranch on Lakeside Avenue where he had lived with his family since 1964. He was to set to fly it to Fallon for certification the day following the crash. These details come from Paul Etcheberry, Jr., who adds that Johnny's plane was so well made that it is still in existence and the only one of that model today certified for aerobatics.

Paul, Jr. went to the scene of the crash after the bodies were removed and took photographs, including of the separated wing, which he found in a ditch virtually intact because water had cushioned the impact. The plane itself was just a compressed pile of metal. He couldn't see how they even extracted the bodies. The passenger, John W. "Art" Sauber, had no ID and was so mangled the police guessed it might be Johnny's brother Paul until he turned up.

Paul, himself a pilot, was haunted by his brother's fatal crash. He kept feeling in his body the G-force that pinned Johnny back helpless in the spiral dive after the wing fell off.

Paul asked Paul, Jr. for his photos with a view to approaching Sara about suing, but nothing came of it. Sara's brother Harry Murray told Walton her only cash asset had been a $10,000 insurance policy. Harry converted a building on the Lakeside Avenue ranch into five rental units for her. Harry "said that Paul had gotten everything of the Etcheberrys' valuables. It seems that he has thrived and no one else has, in that family."

After the year layoff for the Reno Federal Court mural, Walton returned to Hollywood in 1967. Sales were scant. It was a card he couldn't play indefinitely. Ironically, a filmmaker wanted to shoot a documentary about him. Mike Ahnemann's *Cowboy* had received an Academy Awards nomination as Best Documentary Short the year before. But funding for his Walton film didn't come through. Another near miss.

Back home, Walton devised a moneymaking scheme: art seminars. "Richard has come up with the most wonderful idea for improving our economic status," wrote Vivian to her mother. He would monetize his knowledge of painters and technique by holding weekly courses, June through September. "Neither one of us thinks we'll be able to paint at all until October when we close down for the season."

In five evenings the course would survey the entire history of art, ancient to avant garde, to be illustrated by over a thousand slides which he set about to amass. He wanted "open discussion, to find out what had happened and where art was going, in our group judgment. And I was to be the leader in that." The fifth and last evening would be devoted to a single artist in depth.

Klee not the greatest artist

I wanted one evening of an artist alone, without the progression of art history. And I decided that Paul Klee was the man. This is not singling out Paul Klee as the greatest artist. That's not my intention. My intention was to cover an artist that wasn't particularly controversial, easy to have a response with, and one who I understood rather well, technically.

.

Klee was a major influence on Walton, an abstractionist "in the tradition of Paul Klee," says Howard DaLee Spencer's introduction to the retrospective catalog. Technically, Walton borrowed Klee's paper-painting (stamp-on) technique.

Walton added another dimension to the seminars with a program of music to match the topics of each three-hour session. Thus the opening session, "Ancient and Renaissance" art, would be enhanced by recordings of an Indian Mantra, a Gregorian chant, and 13th to 16th century compositions from France, Italy and England.

Classes would be held at "Walton Studio," or elsewhere by arrangement. Artists as well as laypersons were invited. Participants would lodge in Virginia City at their own expense. Their days were their own, classes to begin after the dinner hour.

At fifty dollars a head Walton hoped to gross $500 a week and quickly make back the outlay, which was considerable. "This is a very expensive idea," wrote Vivian. "Hope it works." By February they had spent $200 for slides, by March, $500. A slide projector cost $150, the same for ten chairs. They needed a new coffee pot and extra cups, and an answering machine to catch the many calls expected. And printing: ambitiously Walton had 20,000 brochures printed at $500, plus envelopes, letterhead, business cards, etc. Vivian Diane Walton even got a business card as his "assistant." And improvements to the property were necessary: an exterior light, gravel for the driveway. Attempting to pull up sagebrush from the driveway he put himself in the hospital and debt with a hernia. That and the seminar expenses depleted most of what remained of his inheritance from Wilber.

They gave the seminars two practice runs, once in the Walton Studio with Master Subramuniya's Christian Yoga ashram group which had succeeded Zoray Andrus's home and studio in the former Nevada Brewery, once at the Our Lady of Wisdom Newman Center serving the university quarter of Reno.

It was a good idea

And had a very good response, good audience, and I'm sure they must have picked up something. And it was a good idea, but it was too far away from a metropolitan area. I was told it would have succeeded had I done it in the Bay Area.

It was a complete flop. And I collected one of the great collections of slides of international art, the history of art. We have one of the most complete collections perhaps that exists in the world right here in this house. And I didn't get anyone.

.

There were no messages on the answering machine. They received a single written inquiry. That year Walton reported $600 gross income, net income zero. For years to come he and Vivian would use art seminar stationery for letters and scrap paper.

In spring they tried Hollywood again and "sold nothing," says Vivian. "His friends were getting divorced and moving and changing jobs." Bennie Herrmann was living most of the year in London by then. "We went home to $300 in the bank." 1968 was the end of Hollywood.

Vivian got a job. She told me about it at her house and emailed twice about it, not realizing she was repeating herself. It was a turning point in her life, and somewhat traumatic. Vivian's way is to let the details speak for themselves, and so she didn't quite say so, but evidently the reality of her future came home to her then. She was twenty-three, five years married. Instead of going to college, she went up to C Street "over Richard's loud protests" and got hired at the Bonanza Casino, first in the gift shop, then checking for underage IDs. With short breaks, Vivian would be employed by casinos for the next forty-five years.

When Virginia City's tourist business shut down in fall, the only option was Reno. By then Walton had also come to terms with reality and bought her an old Renault. She got her driver's license and a job as change girl at the Mapes, 3 to 11

pm, wearing a uniform "like a brothel lampshade" at fifty dollars a week. After a few months she was promoted to the change booth, graveyard shift 11 pm to 7. It was "scary commuting to VC in a car that kept quitting on Geiger Grade pre cell phone." She had to wait there until Walton realized she was missing and came looking for her. Then her whole shift was fired when "the key man was busted" for some irregularity, but she quickly found a new position at the Ponderosa.

Walton made an effort to find an income. In February, 1968 he proposed to the Nevada State Museum a job for himself taping and photographing Nevada history for citizens remote from the museum; in August he applied for a teaching position at an art and photography school in Santa Barbara; in September he applied for a post as health inspector, hoping to be qualified by his VD inspectorship in the 1940s; and he took a test to become inspector for the state industrial commission in November. In December he managed to make a little money preparing core samples at the Yellow Jacket Mine in Gold Hill when its owners were contemplating reopening. The job lasted only a month and paid three dollars an hour, but to be earning lifted his spirit. Yet "Richard would never," says Vivian, "apply for jobs like bartender or janitor in Virginia City which were about all there was. He didn't seem to mind that I did whatever job I could get."

Other income came from photos of the carnival at the Reno Rodeo, sold to an ad agency for one hundred dollars. And there were more schemes. One was an idea he came up with as a way to offset a large bill with his dentist, Lloyd Austin, who specialized in pediatric dentistry.

"Tommy Teeth"

And we were to get together on this children's educational project, called "Tommy Teeth" as a tentative title. These are colorful plates for children, and I think – we both think – that it's quite a device to introduce to little children some of these homely things that all well-informed people should know about caring for their teeth. They're rather comic in kind, and it's just as gentle as anything could be. And I had kind of an alligator, a crocodile image, a monster, this shocking creature, the dragon called Sugar-Gooby, which is rather personable.

And I even installed a projector in his ceiling. A little carpentry was involved. And for some time Dr. Austin projected "Tommy Teeth" on the wall in the waiting room. But he found out that it was too expensive in bulbs.

He had referred me to one house that involved itself in dental education, and [I] sent the slides to them, and they felt that it wasn't quite up-to-date. Well, I'd leaned on Dr. Austin's advice altogether on the material. That's one of those projects that just sits here, and went as far as being photographed and copyrighted. So that sits there.

•

Walton's other scheme of 1968 was more ambitious. *The Artist* (or *The Painter*) *and His Tools* was a course in painting technique, six 40-minute tapes, supplemented by slides, aiming to do for practice what the art seminars did for appreciation.

Franchises over the country

"The Artist and His Tools" was a long winter's work. I put everything I knew about painting down into short strips, and taped it. And copyrighted the material. This once was put forward by a person acting as my agent, as a basis for franchises over the country. There was some hope there at the time. I've never been able to do anything with that. This was a complete taped program, where a person could use it as a basic art education, how to paint. And it's the artist's own voice. And the thought was that a franchise could be set up – franchises sold over the country, and almost anyone who has some insight into painting could conduct an art school, using these tapes.

Well, in any case, that's an extensive series of tapes. And they sit in the vault.

•

When nothing came of the franchise idea, Walton tried to get a book out of it. In a letter he described the tapes as "a sort of Taubes audio-visual that I lost faith in," adding that the section on the technique of paper painting could become "a popular (much demanded) how-to-do-it book for a lively market." And he went on to produce a manuscript of 147 double-spaced pages, which no longer exists.

In 1968 Vivian in spite of her job exhibited oils in a two-person show at the Gold Hill Gallery. Apart from one drawing earlier in California this was her only exhibition. Also that year Marijo exhibited oils of children at the Washoe County Public Library, where Walton's Tom Sawyers had once hung. Walton had no exhibitions that year. He continued to paint in his Greek black pottery style while producing conceptual graphics on oil such as *Pax Americana II* (plate 22) in protest of the escalating Vietnam War. And he developed a new style, possibly evolved from the visual wordplay of the conceptual graphics (plate 23).

Little did I know

Now, I have a note on Letterism, after the Davis show. Well, I knew that my form in that period was Letterist. I hadn't had the word, I forget what I called it. But the month following, my copy of *Art in America* or some kind of slick magazine that I subscribed to in that time came through, and they had a review of a Parisian art movement, that seemed to be occupying much of the Paris thought. It was Letterism had arisen in Europe. And little did I know that. I had not heard of this.

Well, you're not isolated, no matter how original you think you are.

•

If Walton had had Wikipedia, he'd have quickly discovered that his magazine was picking up on a Sixties manifestation of a French avant garde movement founded in 1945 by a Romanian Jew who went by the name Isou. Like Futurism, Surrealism, Dada and other European movements, "Lettrisme" embraced all the arts. It also mixed in politics with provocative direct actions. Isou and followers aimed to deconstruct the spent basis of meaning in all foregoing history. Cultural expressions were to be reconstructed on a new foundation devoid of direct semantic

sense. The label "Letterism" points to the use, chiefly in poetry and painting, of the alphabet and other symbols in conventionally meaningless combinations.

At first look, Walton's Letterism can be mistaken for lines of writing in a lost language, like Mayan glyphs or Asian pictographs. These compositions represent a development of his philosophical idealism going back to *The Mark of Man* and the 1940s, contemporaneous with Isou's Letterist manifesto. As he explained his own Letterism, the paintings express a metasymbolic message by symbolizing that all experience is symbolic, or merely symbolic.

Everything is Letterism

That which one sees is not the reality, but a symbol of the reality, in terms of mind's reception, or an image of reflections of light. Otherwise, impressions via sound, etc., and never the full reality. On this basis, everything creatures know are but symbols of reality. Therefore, a painting of reality is merely a symbol, and is in the same category as any stylized image, even calligraphy. Abstract Expressionism, or any form of art, sculpture or painting, is also a symbol of light reflections and cerebrations. Everything is a land of Letterism via mind. There is no objective reality. There is no existence in substance, just living impressions after the fact, in sweeping time, and intercepted as sensory impressions. Nothing exists of itself.

.

In 1969 Walton had three exhibitions, two minor ones in Northern Nevada and the one at the University of California, Davis which he alluded to in connection with Letterism. This was a major show, on a campus which he regarded as at the forefront of art in the country as far as universities go. The show came about through another act of support from prominent Davis faculty member and former Walton Boy Loring Chapman. He knew Walton was struggling.

The Chapmans hosted receptions for him at their house and again at the opening, well attended by Davis faculty and administration.

I missed the youth

But I missed the youth. My show went by ignored, by the art buffs of Davis. The youth – I guess the word had gotten out, they fought shy of it. Although this was some of my most extreme work. But, you know, I do believe they were critical of it because they were against painting that was decorative in essence. Yet at the same time Letterism was the going thing, the fashionable thing, in Paris. And my Letterism was not altogether decorative, because it had the Letterist drive.

It was dreadful for me, not to be accepted wholeheartedly by the younger people coming on. In fact, I felt patronized and a certain condescension all the way along the line. This being in the middle of the so-called youth revolution, and everywhere you turned, the feel that the older people are useless. Even the older people felt that. So it discouraged me profoundly. From that point on, I haven't been quite

the same person, having lost heart – lost some of the spirit of the adventure of – involved in this painting quest.

.

Although he didn't talk about it when the injury was fresh, two decades later Walton described what amounts to another censorship, this time at Davis: his "political items weren't allowed to be shown." These included *Pax Americana II* (plate 22), which he termed Letterist, and *Tablet to a Bad Actor* (later retitled *State of the Union*), a collage of antiwar images from "the hippie press, overpainted with *see-through letterism*." How explain why, in the tapes recorded closely following Davis, he didn't offer this extenuation of the show's painful rejection by youth?

After Davis he pretty much stopped painting. The crisis came after "the youth revolution" dealt him another blow.

Artist Zoray Andrus was back in Virginia City for Thanksgiving with her son Peter Kraemer and friends. Peter was lead singer of the San Francisco psychedelic rock band Sopwith Camel. Knowing Walton for an enthusiastic chef, Zoray said, "Oh, everybody's here, let's have a turkey – I'll buy the turkey, and you fix it."

You must leave an artist of consequence alone

I'd never cooked such a big meal before, and I don't want ever to cook another one! Because they ate all the olives and salami while the cook is still in the kitchen, he never sees a thing. All the hors d'oeuvres are gone, and we have a bunch of these assholes asking me, "When is dinner gonna be ready?"

This one lad was here, and the next day he came by. And he was talking about the honesty and truth in relation to the social revolution – the youth revolution of the time – the days of Berkeley. And that you must reevaluate yourself and all that. And you know, I took it straight as hell, and did this reevaluating, and – and I just quit painting. For ever so long. [Laughs] It stopped. And for that reason, I didn't look around, for years, I didn't dare look around. Because I'm a peculiar article. If I start looking around, I start thinking, I get stopped. A long time, I got stopped at Davis, stopped cold. And it's unlike me to be stopped. I've produced so much in my life.

But just let these people go the way they wish to go. An artist of consequence is not to be fooled with. You must leave him alone. Like suddenly with Bach, let us say. You give him a whole new social revolution, and say, "Bach, you've gotta shape up, man. You gotta go like Stockhausen," and destroy him. And Bach would know that. And Stockhausen would know that, now that he's older.

.

Walton was hurt, and scarred. The final words of one version of Walton's final book, *Harry*, are a rueful epitaph titled "Letterism," composed who knows when in ironic tribute to the self that lost heart and stopped painting after Davis: "He pulled the alphabet over him and disappeared without a word."

The year of the Davis show, 1969, Vivian earned just over $5,000 in wages and tips. Walton made roughly $945: $380 doing odd jobs for Eric Kraemer, Peter's father, Zoray Andrus's ex, who remained in Virginia City; $205 from *Nevada Magazine*; and $360 as photographer for Loring Chapman at UC Davis. Loring regretted the disappointment of the Letterist show and knew Walton's situation, so he more or less invented an assignment for him. "I needed it. I needed income badly. I needed my self-respect. I needed direction, so badly." Chapman hired him to make slides for a major study he was conducting of children with developmental disabilities at Sonoma State Hospital.

So in late 1969 the Waltons closed up the house and left for Kenwood, California to live where Vivian spent her young childhood, her mother's farmhouse and former Holland House restaurant. They had a bedroom upstairs and in lieu of rent rehabbed the place. Mary lived in Fairfield, but stayed in Kenwood when not teaching and on weekends, sleeping in a bedroom downstairs and using the former restaurant as her painting studio. Walton commuted over an hour to Davis unless he was photographing children in Sonoma, closer to Kenwood.

Through no fault of Chapman's the university proved badly delinquent paying its bills. When Vivian tried to find a job to tide them over, California employers looked askance at her casino history. A once a week housekeeping situation "kept us in groceries," but when they got down to their last $300 – again! – they had to go home. In Reno her CV served her well. Harold's Club hired her as a change girl, then promoted her to dealer. She took classes to become a grocery checker when she and fellow workers expected Harold's to fire them for trying to unionize. The effort failed, and she wasn't fired. In 1980 she completed a twenty-hour course to be a travel agent. But she remained at Harold's until 1988 when she moved to the Eldorado, where she dealt various games for twenty-five years, retiring in 2013.

Walton eventually received $2,000 he was owed for the Sonoma project, and over the next year and a half worked for Chapman on another of his studies, commuting as needed from Virginia City. Chapman was a world authority on pain. Walton's assignment was to shoot a film of the monkey subjects of the experiment, those having pain inflicted on them and pain-free controls. The gruesome task lasted until May, 1972 when Chapman failed to get a grant renewed. A third project, in which Walton played a role on spec, developed out of polymath Chapman's ambition to alleviate world hunger with a high protein corn, to be tested against traditional corn in a Mexican village. A grant from the National Institute of Health didn't materialize.

In 1970 Walton had no exhibitions, in 1971 one minor group show in Virginia City, in 1972, two in Carson City, and none again in 1973. There's no knowing whether he exhibited anything new, but that he didn't stop painting altogether despite getting "stopped cold" after Davis is evidenced by three oils dated 1972 in the 1993 retrospective. One is *The Vivian Tree*, another *Paleozoic II, "Trilobite"* (plate 24), the latter prefiguring his fascination with organic forms in coming years.

Also in 1972, in a retrospective mood Walton the documenter drew up a thirty-page list of 877 works he created from 1930 to the then present. His creative energies were mostly going in directions other than painting. One was "Nexus," his manic verse diatribe against America, structured around Mark Twain's racist reports on the "Goshoot" Indians. Written while recovering from ego wounds at the hands of the youth revolution, his treatment of the toxic march of American civilization is right in line with the youth culture's going analysis, notwithstanding the names Bob Dylan and Jerry Rubin in the mix of Walton's targets. "Nexus" sounds like street theater or coffeehouse recitation as he performed the poem with gusto on tape.

Magazines such as *The New Yorker* and *Saturday Review* were rejecting his poems, but fully ten were accepted by a literary magazine, which then turned out to be another vanity hustle when they asked for money. In frustration he took a try at writing mystery stories – if his sister Florence could succeed at it, why not he? Because try as he might, he had no flair for the commercial. One story, "The Killers of Kwan Tro," was a murder mystery about a conscript seeking vengeance on a recruiter for having been sent to Vietnam where he committed atrocities. Not exactly Ellery Queen material. "Murder in the Sage," a desert detective story, didn't sell either.

"Then there was my long winter's project one year of my brainstorm, Calendar Date." As another moneymaker, Walton put his political reservations aside to prepare a feature originally conceived for newspaper, then repurposed for TV, consisting of daily installments about incidents in American history which occurred on a given date. Exceptions to the format were the firsts, given to explaining the name of each month. One of the more imaginative entries is for May 18: "On this day in 1921, The Harding administration refused to have any dealings with the Russian Soviets while Americans were still held prisoner. Irish rebels called Sinn Fein had fired on a military football game in County Cork. And in Washington, D.C., the public printer was investigating reports that liquor was being manufactured in the Government Printing Office." I have no idea how he collated such information without a search engine.

"Calendar Date"

I thought that with plates – beautiful plates, designed plates, photographed with the prism lens, to give this swirl of numbers, with the feature number central, lovely color – that that could be projected on the television screen, and the voice-over could give this very short reference to the day: what happened on the day. This is calendar date thus-and-so. And on this date thus-and-so happened. But

I wanted something that would never end, and so "Calendar Date" would go the twelve months, and it could be used over and over again. Now, that sits in my vault. It's completed. I even taped half of it, six months of it is taped in my own voice.

·

Walton submitted "Calendar Date" to the CBS-TV affiliate in Reno, who rejected it. But in a few years just such a series was broadcast somewhere. Vivian told me the story as an example, I gathered, of Walton's bad luck.

Undaunted, he conceived another moneymaker for TV and one for radio. For TV, he sent the director of NBC's Today Show samples of a feature capturing the essence of famous artists as if in their own voices, "little blurbs of recall. And they were freshly written." The director wrote back politely rejecting the feature as "too egghead" for Today and suggesting he apply to FM stations. To Walton "it wasn't so damned sophisticated, Salvador Dali flowing through the window and things like that. But I appreciated his answer to me." Walton genuinely appreciated rejections that treated him as someone in the game.

Typically for him, he shelved the idea and moved on. Channeling Bennie Herrmann, he devised a series for radio titled "Monitor," himself dilating on a musical topic du jour – Renaissance lute music, Scarlatti, Charles Ives – with connections drawn to contemporaneous visual arts, followed by a sample of the music. "Richard Guy Walton for Monitor," began each, ending "This has been a Monitor vignette." He intended "Monitor" for NBC.

In 1972, after "the Chapman money time ran out" (Vivian), Walton earned three other wages (against a "loss" of $2,115): $448 for preparing ore samples when an ill friend asked him to take his place at the Climax Molybdenum mine in Minden; then a thirty dollar odd job for Eric Kraemer; and in August, thirty-five dollars as a film extra.

It was Walton's second turn as an extra. In 1960 director John Huston had needed patrons for the Dayton bar scene of *The Misfits*. Written by Arthur Miller, starring Clark Gable, Marilyn Monroe and Montgomery Clift, this tale of Nevada types out of sync with the times rates in Northern Nevada as the region's classic art film.

So wistful

I was an extra at Dayton, because they wanted people, and went down – and Florence Edwards was one of the crowd, too. And on that occasion saw Marilyn Monroe, and I was so sympathetic for her, her hair was so bleached, and she was so alone under that parasol that they would hold for her, and on call like a trained animal. And so wistful. And Arthur Miller chewed on his pipe, preoccupied, and I could see that something was wrong with their relationship.

·

Monroe and Miller were at the end of their marriage. The drugged-up actress's performance was compromised, to be kind, and the playwright's script, to my taste, wooden.

The Godmonster of Indian Flats is on an altogether different plane. Never released in theaters, this Comstock *Godzilla* endures as a minor cult classic. The day I viewed it on the Historical Society's media equipment, I learned that some of the staff are among a small circle of Nevadans who annually celebrate Halloween with *Godmonster* parties. A 2018 web reviewer, hedging admiration with snark, revels in the movie's "hallmarks of atomic age schlock: a low budget, a mutant monster, mumbo-jumbo sci-fi nonsense, and a cast of underacting non-actors and overacting stage actors." There are two plotlines, around the mutant Godmonster killer sheep (God never comes into it) and corporate rapacity. "Lingering on the details too long could cause one's brain to swell," quips the reviewer, but considers that the two threads "crash together beautifully in the film's climax." Not really. Another reviewer of the same stripe flags the film's serious themes: "race relations, greed, fascism, tyranny, groupthink, and the burgeoning surveillance state." He could have added environmental degradation and the sins of Lucius Beebe. But if seriousness made art good, every other poet would be a Shakespeare.

This was the fourth film by director Fredric Hobbs, a painter, San Francisco gallery owner, creator of driveable sculptures, author, and counterculture phenomenon. More than a generation younger than Walton, Fred Hobbs was someone Walton had reasons to envy at that low point. Vivian told her mother he only took the job to observe camera techniques. Just as he'd quit high school on an impulse, he quit Hobbs after seven days, out of vanity, a character flaw he attributed to the director.

We parted in that friendly way

Fred Hobbs came to Virginia City with his film production crew. He is a very vain man, and he gives the impression that he is secure in the museums in the world. But I think this is fantasy. However, he does have some scores on his side. He occasionally comes out with some kind of an idea and gets a rather widespread publicity.

But it was a Western film, and he needed a lot of extras. He used many of the townspeople, paid them five dollars a day when they were before the cameras, which was about fifteen dollars a day less than usual crew pays when they come up here from the film center of Hollywood. But I was asked to be an extra by Fred himself. And I put on the Western garb, these black hats that he passed out.

Now, Hobbs is a very personable guy, a very intelligent guy, very informed and widely experienced. He has a sharp tongue, and I left that production because Fred was – as I say, he had a sharp tongue, and he popped off to me one time [like] anybody else, and I don't feel like anybody else, when I'm working with what I would call one of my peers. And if he departed from that peerage concept, the word is fucking. And so I left the set. And so, the word was, fuck Fred Hobbs, and we parted in that friendly way. I've not seen him since. I've heard tell of him now and then.

•

I kept an eye out for Walton in *Godmonster* and found him in four scenes. A freeze frame of him in the Union Brewery Saloon scene exists online. Search for the film title at houseofselfindulgence.blogspot.com. The fifth image down shows Walton to the left, and over his head Robert Caples' painting "Virginia City," traded to proprietor Gordon Lane by Caples in 1948 to clean up his bar tab. Gordie is behind the bar.

Walton had to have "heard tell" of Hobbs again after the filming, just never deigned to mention this enemy again on tape. In 1976 Hobbs and an associate, Warren Hinckle, bought the Silver Dollar, "a fleabag Hotel" that Walton's favorite colorful Virginia City personality, Florence Edwards, deceased, had rehabilitated into "the toast of Broadway producers [and] celebrity journalists," as characterized by my informant the local historian Andria Daley. Further, Hobbs and Hinckle had plans to re-revive the *Territorial Enterprise*, which had lapsed after Lucius Beebe left town. Hinckle, a freelance editor at the *San Francisco Chronicle*, had edited *Ramparts*, the Sixties New Left organ.

Worse yet for Walton's vanity, in 1978 Hinckle and Hobbs' book *The Richest Place on Earth*, a muckraking history of Virginia City, was published by a major house, Houghton Mifflin, with Hobbs' excellent illustrations. This was worse because the summer Hobbs filmed *Godmonster*, Walton was in the midst of a Virginia City book project of his own, a study of his adopted hometown in photo images and text, a coffee table book.

The idea for *Virginia City* may have formed as early as 1971, for in March that year Walton had applied unsuccessfully for a federal grant in photography. In June, 1972, he sent an informal book proposal to editor Gordon Gipson at Caxton Printers in Idaho. Gipson rejected the proposal out of hand on grounds of Walton's urgency to get the book into print. When he retracted his pressure as a miscommunication, which it wasn't, Gipson responded with pro forma interest, looking forward to seeing a complete draft. Walton's letters over the next two years were each many hundreds of words long, Gipson's brief and noncommittal. Walton, within the conventions of business correspondence, was his verbose self, unaware of imposition, tediously showing off his brilliance to clinch the outcome, but not convincing. Gipson politely waited to see the finished product.

Many of Walton's photos for *Virginia City* are well-composed but straightforward images of the great mines and historical homes and buildings in their present conditions, derelict or restored. He included a few nineteenth century

photos, such as an "1875 aerial view of Consolidated Virginia Works," and a few by contemporaries, including Gus Bundy. Another group are close-ups of architectural details and mining equipment, abstract compositions calling to mind the postwar Chicago school of photography initiated by Bauhaus refugees. Also there are portraits, as well as two outstanding long shots of the town (plate 25). His "Introduction" explained the choice of subjects.

Supporting an earlier meaning

A book of an entirely different spirit could have been made on the eve of the energy crisis, a chock-full town of tourists jamming the boardwalks with strange legs in miniskirts and unbelievable men in Hawaiian prints. Instead I have made an effort to get unobstructed shots of buildings I knew would be in the clear when snow fell and cars would be forbidden for the duration of snow removal. I shot the hardware, and certain people, supporting an earlier meaning. The cameras were carried into the surrounding mountains, and underground too. My lungs fairly burst on the climb up Ophir Hill for a single shot on one long-awaited day and hour. I have defied Greyhound buses in the middle of C Street from the top rungs of a ladder. Over 3,000 were the lot, hoping for one in ten.

•

Elsewhere he said 2,000. The "certain people," their portraits "supporting an earlier meaning," were the characters of his day who meant Virginia City to Walton, mostly men, for example his friend cowboy artist Lyle Hardin, Paiute Matthew Antunovich, "the last Indian born resident of Virginia City," Don McBride, second generation saloonkeeper of the Bucket of Blood, and Len Haffey, dealer at the Delta.

In January, 1973, Walton let Gipson know the photography was complete and he was "eager to get to the text." Gipson: "We will be glad to look at the project when it is in final draft." For some reason Walton delayed several months getting started. Correspondence ceased for a year, until in February, 1974 he sent Caxton the text together with a detailed layout and "two boxes of retouched edited photos." He hoped for the book to be available for the national bicentennial.

Virginia City, dedicated to Vivian, is subtitled *The Bonanza Queen* in one version, in another *A Photographic Portrait of the Comstock*. It contains about 350 photos in four dozen chapters running 400 pages. Of course Walton covered the boomtown past; some passages read like many a straight popular history of the Comstock. But in Walton's book the past joins the present, and the local color in such chapters as "Neglected Houses" and "The Telephone Company" is exceptionally well observed. The best of it is true to the author's distinctive voice, first and foremost in presenting Virginia City as a place where interesting personalities now reside. Take the text accompanying Leroy Wagner's "rocket photo" of Virginia's churches, St. Mary's and St. Paul's.

The last skyrocket

Loner Leroy Wagner believed colonization of other planets might free homo sapiens from Earth's crisis. Formerly a brothel, his workshop home still had red lights over the doors. The artist Bob Caples briefly used the right section as a studio in the mid-1940s [late 1940s], when it was no longer a brothel.

Fabrication, carpentry, plumbing, welding, machine and foundry work, and antique restoration were his bag. But he had buried gunsmithing in the middle, and could have added rocketeer. Leroy Wagner was a master machinist, who made superb firearms, including muzzleloaders, from raw material. Loved by Virginia City friends and repelling others, it was his sense of liberty that attracted both responses.

Leroy Wagner had labored well for many, rebuilding old houses of the town. Yet he was looked on with suspicion by those who did not understand his elaborate but clear mind. Few knew why he launched his rockets. At the nose of each was a tiny plastic camera, triggered as the rocket turned, to make aerial photographs of Virginia City. He made little money, but put a thousand dollars into no more than a dozen final pictures.

Preferring cokes and candy to all sustenance save hot dogs, Leroy personified why some people lived in Virginia City. He was documented with that in mind, and, a few short months after his photographs were taken for this record, his melancholy style caught up with him. On Easter Sunday in 1973, Leroy made an inventory of repair items and attached owners' names. He'd been seen wearing an unfamiliar Civil War cap, phantom-like on his long walks, with eyes downcast and lumbering along dejectedly. He'd painted his door in the national colors. Then, convinced his society was doomed, and with nothing left in his personal account, Leroy Wagner aimed a large caliber muzzleloader upward beneath his jaw and launched the last skyrocket.

∙

Leroy Wagner was thirty-one when he suicided.

Besides Wagner's suicide, Walton treated at length the life and suicide of Father Paul Meinecke. Meinecke had converted the St. Mary Louise Hospital, built by Father Manogue in 1875 as an adjunct to the cathedral, into St. Mary's Arts and Crafts Center. The successive priests of St. Mary's whom Walton knew, Meinecke and before him Robert Jellefe, were more a preoccupation of Walton's than was suicide per se. Suicide came with the psychology of the town, something remarked by curator Spencer in the catalog of Walton's third retrospective devoted to his Virginia City photos. Spencer put the best face on the "extraordinarily high" rates of alcoholism and suicide: the "free thinking individuals, existentialists and anti-heroes [of] Virginia City have often romantically preferred to live their lives as shooting stars – short but brilliant, rather than live a 'normal' life of humdrum mediocrity." Walton dealt with the causes more realistically: in Meinecke's suicide, the lingering agony of an amputated leg.

It is altogether to Walton's credit that in place of the stock characters of Comstock lore, the Eilley Orrums and John Mackays and William Sharons, Walton's cast were the recent and present personalities of the then actual Virginia City, although it, too, like everything in this life, was passing, a reality not lost on Walton, to the contrary – Father Meinecke with his game leg, who shotgunned pigeons in the rafters of St. Mary's; The sharp and kindly Nicky Hinch, who suffered a heart attack on a deer hunt; Florence Edwards, who took verbal potshots at tourists from a rocking chair in front of her hotel and who loved Bronco Lazari, proprietor before Gordon Lane of the Union Brewery Saloon and the author of its peculiarities usually credited to Gordie: the stool blocking the door to discourage tourists, the inviolable cobwebs.

When it came to citizens who were locally prominent and still alive, Walton sensibly pulled his punches. Take his portrayal of Don McBride.

Family-minded

Versal McBride ran the Bucket of Blood as a popular saloon, which displayed a large collection of antiques. McBride was impressive in his tall boots, and Mrs. McBride was warmly remembered for showing her glassware personally. When their son Don took over, the barroom doubled, and an antique shop was opened across the street. The International Hotel site became the Bucket's parking lot, and Don McBride took a hand in promotions. Instrumental in bringing the stars of the television program Bonanza to Virginia City, the young McBride gave each principal a gold belt buckle similar to his own, but with their names. He was consulted on most local questions, and his views carried weight. Tourist- and family-minded, his public policy was conservative, and contrasted with any that would throw the town wide open.

.

Now compare the factual and neutral tone of that excerpt from *Virginia City* to an anecdote about Don McBride, told by Walton to his Panasonic for the pleasure, the verisimilitude and the spite of it.

An odious character

Don McBride was at Gordon's bar [the Union Brewery], with his gold coin neckpiece and his golden belt buckle, and his brilliant bright red vest, looking like the bartender off-duty which he actually is in fact, although he counts the money. Later on, I took the McChesneys for a tour of the upper town, showed them the mansion that McBride lives in. They think he's an odious character.

Now, after he came back from a visit to the toilet, McBride put his arm around my neck and was telling me about his complaints about the system here. He explained that he was a good Republican, and he launched into an attack on the county commissioners and incumbents, and wondering where the hell the second license fee for Conforte's whore house went. The $4,000, he says, for the first one,

and he says $5,000 for the second, he says. And he cast all kinds of aspersions. And he's very concerned about the Conforte incumbency situation. Now, he leans over you too close. I can't stand people talking to me two inches away. But for Don that was a high social moment, and I should appreciate it. Because he has arrived in coin. Now, he laughed and returned to the ladies at the end of the bar.

Pretty soon even McBride was gone and the crowd thinned out, and I went back to take a pee before the McChesneys and I came back down to Walton Flats. So help me, on the horseshoe toilet seat there was a big spot of shit – I never saw such a thing. It was like a birthmark. When I returned, I told Gordon, I said, "You know, Gordie, I hate to inform you, but," I says, "you'd better go back in the men's room and take a look." I said, "Somebody wiped his ass on the toilet seat." I said, "Don McBride was in there last." And then we left. [Laughs]

　　　　　　　　　　•

Caxton received the first draft of *Virginia City* in February, 1974. In April, Walton wrote Florence, then at Bahá'í world headquarters in Haifa, that Caxton would "come to a decision about it very soon." He had sent Gipson a letter of a thousand politely impatient words, in the course of which he offered Caxton two new books (one of them *Pyramid*)! That impetuous offer crossed Gipson's letter of rejection in the mail. Realizing what had happened and aware that something more than presumptions drove this author, Gipson sent a last, gentle, you might say compassionate letter of explanation, encouraging him not to give up, to try larger publishers.

In point of fact Walton had already grasped how things stood and made multiple submissions of *Virginia City* to New York publishing houses. "Four of the biggest" turned him down. "They never questioned the value of the book, always stressed that it was too specific for them to invest that kind of money in, was my impression. It would take several hundred thousand dollars to put that book into print."

In June, excerpts began appearing in the *Gold Hill News*, newly revived by local historian David Toll in Virginia's neighbor town, bordering it through the Devil's Gate. "It may spread the news," Walton told Florence. "I have already hung a number of the photos in a local store and small things are happening already. That's why the paper contacted me." That year Walton exhibited his photos in a food market, a saloon, and a group art show, all in Virginia.

In the wake of setbacks with book publishers, he decided to take his chances at the University of Nevada Press, this in spite of his resentment of the university because its art department had never offered him a faculty position, and hadn't exhibited him in their galleries for over twenty years. He swallowed his pride and asked Walton Boy Jim Hulse, professor of history there and a press author, to smooth the way. Walton knew press founder and director Robert Laxalt, but Laxalt was on sabbatical writing one of his books. The manuscript, photos and layout went instead to editor Nick Cady. Walton met with Cady in May, 1975 at the press office, accompanied by Vivian.

A closed club

Of course I knew that they weren't going to seriously consider this thing. These are pragmatic people. And it seems to be a tight club, this organization.

He in a friendly way advised me not to include the layout, because publishers want to do their own selection of paper – their money and all those things would flow into that. I said, well, the layout is not terribly set. In my view it only offers guidelines to my basic thought in the matter. After all, the captions are written to a given space in every section. I said the whole book is designed. And I said somebody might be upset at that, because it would give them nothing to do in that area, if they care to go along with the layout. But he was solid on his thoughts of a book goes to a book designer, and the printer, and the publisher has little to do with the thing. Well, I began to wonder what they do over at the University of Nevada Press, if they don't lay them out and if they don't design them, what the hell is the office all about? I began to wonder what the editor and publisher does over there. And one gets the impression it's a closed club. I had the feeling that I would do better if I were talking to someone in New York, than in Reno, Nevada. He's a nice lad, but he doesn't seem too experienced. And their products are really not in their hands, they're produced by a contract process, and I really wonder what they do besides just answer the mail.

Any contributor entering this closed society of the University of Nevada Press hadn't a prayer. They have dreams way ahead, and I'm sure they're all lined up within the power structure there, with books. And it was naive to go forward expecting them to publish – Well, I didn't! I did want them to know that the material existed. Because he might be eighty years old one day, and I'm long in the grave, and somebody will say something that'll bring memories. And he can contact my widow, Vivian.

Well, she was not impressed with the thing, although she agreed that he seemed to be a pleasant chap.

·

Walton taped the story, here condensed by half, the day after the appointment. In his hurt and chagrin he willfully minimized an editor's function, which in this case amounted to saying thank you but no. The narrative epitomizes Walton's vexed and contradictory relationship to institutions – superiority tinged with supplication, respect becoming anger, collegiality tipping into contempt. He concluded he couldn't get the university interested in the book because those people all wanted to publish Virginia City books of their own.

Virginia City wasn't a project he would shelve like "Calendar Date" or *The Walton Rabbit* and so many others – the photographs were art. Immediately in the aftermath of disappointment at UN Press he abandoned the concept of an "entertaining popular book." He would "edit out the personal stuff," the vignettes about town characters and anecdotes from the author's life – Walton autobiography wasn't in order here, he realized. "But there is this valuable historical material

to present to one of the historical organizations down there" (Reno and Carson City). He tinkered with the book at least until 1980. But there's no evidence he ever did submit it again. It briefly came back to life at the third retrospective in 1994. And now here.

In 1974 Walton sold one of the photos to the magazine *Historical Preservation* for ten dollars. And he submitted an illustrated article to the magazine *Country Beautiful*, from which they cherry-picked one photo for a book, *400 Landmarks of America*. It took him two years to get his seventy-five dollar fee out of them.

Just as the excerpts of *Virginia City* were appearing in the *Gold Hill News* the summer of 1974, he announced to Florence that he had abandoned painting. "I plan to write from here on. Painting for this society is just too depressing." He said there were nineteen books "charted on the wall behind me." In 1974 the one in hand was initially called *Dear Vivian*, then *October Moon*, a sort of novel based on his courtship letters to Vivian, mailed at a rate close to one a day, sometimes more. The letters are now in the Walton archive. He had instructed Vivian to save them, for him. "He said he wanted them back at the time." Vivian wasn't surprised by my astonishment. "He knew he was an important person," she explained with a rueful twinkle in her voice, all the same a twinkle. She described his letters as more a journal of his activities for posterity than love letters. Having read them I see her point, although it's not quite fair. He complained frequently and forlornly that she didn't write back enough.

In January, 1974 he had recorded the first of his tapes, which from the outset had a writerly purpose. *October Moon* somehow metamorphosed into a one-year record of his life on those tapes, then a two-year record, with the title abandoned. He sent Florence the first draft, now lost, in 1977. The project gained dimensions never to be realized. "The main book I am talking about," he wrote to Zoray Andrus in an undated letter, "will be a grand review of my life with pictures. Pictures of my family before I was born, [etc.]. I intend to use paintings done by friends as well as my own paintings." Also photos of historic places, but this was to be "no art book," rather "a massive alive collection of life."

And in 1974 he was still rewriting *Pyramid*, and it came about that an extract from *Pyramid* in the shape of a poem, "Sheep Camp," about Marijo, appeared in a vanity publication. And "Sheep Camp" wasn't the only throwback of 1974: in October he shipped the Tom Sawyer panels to the Smithsonian for one of their bicentennial exhibitions. If Walton the abstractionist smarted from the irony of

this success of a defunct style of Americana from an earlier life, now when he had abandoned painting, I find no indication.

And in 1974 something else occurred that would lead indirectly to a rekindling of Walton's passion for painting and set it a fresh direction: underwater paintings.

In August, 1974 the *Gazette* carried a captioned photo of "successful chef Richard Guy Walton of Virginia City" preparing "Pineapple Baked Beans." He had won an all-expenses-paid trip to Hawaii for himself and Vivian in the third annual National Pineapple Cooking Classic, a contest sponsored by Dole Pineapple. He was one of nine finalists in the main dish category.

Vivian had seen the notice and urged him to invent a recipe because she wanted to go to Hawaii. His entry was remarkably complex, with a score of ingredients. She says he threw it together. An ardent chef, Walton proudly ascribed his culinary prowess to his "ties with Nevada Basques," having watched his talented mother-in-law Louise Etcheberry cooking massive meals in the Santa Fe. And Marijo was "the best cook in this part of the world, next to the mother." More than one of his love letters to young Vivian contained a recipe he'd just come up with. In the early years of their marriage, he would recite as he improvised in the kitchen while she wrote down the recipe, which he would then transcribe into "The Cook's Book," a 5" x 8" account book, with sketches throughout. He did the cooking, Vivian washed dishes and baked. Once *Sunset* magazine paid ten dollars for her green tomato pie recipe. She baked less after she went to work.

Although he failed to move up to the best of show competition, and had to see the comical side of it, Walton freely bragged about his accomplishment with Pineapple Baked Beans (figure 27). For some reason even self-effacing people brag on their own cooking if it's good, and no one ever accused Walton of self-effacement. He bragged again about winning a set of baking pans in Uncle Ben's Cook and Tell contest in 1977 with his Shrimp Rice Mardi Gras.

Before leaving Honolulu Walton approached Tuttle Publishing regarding "*Mark Twain's Hawaii*, a photo book." This was another of Walton's recycled book ideas: in 1961 he had prepared but failed to place *The Sandwich Islands of Mark Twain*, a pamphlet for the centennial of Twain's arrival in Carson City. His book proposal to Tuttle spoke of "150 or so smashingly designed Hawaii color photographs brightened by selections of Mark Twain's Hawaiian writings." He planned to "seek a federal grant," and got as far as to draw up a list of about sixty Hawaii photos from the trip. Nothing came of it.

Some painting ideas came out of the trip as well. In 1975 Walton Boy Sam Kafoury, who by then had a camera and instrument repair business in Coral Gables, gave Walton full price, $3,000, for *Kona III*, not an underwater painting, for Walton didn't go swimming, although Vivian did. *Kona III* has "a large sun with a lineal pattern suggesting sugar cane, a symbolic abstraction." They enjoyed Hawaii, and returned in March, 1976, together with Vivian's mother. Now Walton snorkeled and discovered the underwater world – not so much what exists there as how one

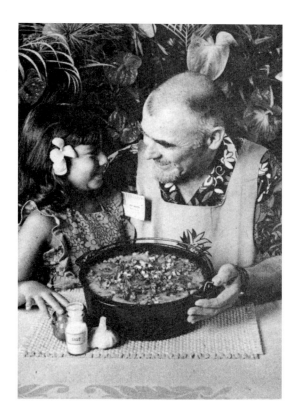

Figure 27. Walton with his Pineapple
Baked Beans at the National
Pineapple Cooking Classic, 1974

sees there. Painting to capture underwater vision became his passion. Already by
mid-June he had a one-person exhibition devoted to his "Polynesian" works (plate
26): by luck Marijo had happened to call representing the new Moana Nursery as
their advertising agent to offer him their gallery space.

Robert Caples attended the show during his final return visit to Nevada. Caples,
sixty-eight and ill, had by then well and truly stopped painting, finding himself
unable to convey his expansive spiritual clarity on a painted surface. He didn't
speak of that or his illness when he dropped in on Walton.

He knows the values of my sea painting

He said he saw my exhibition. And he said that he didn't care for paintings any-
more, that paintings put him off. And he said that the poetry world was even worse
than the painting world. So he's – in his esthetic value, he's isolated himself from
painting altogether, and showed no interest in my sea painting on the wall – which
doesn't trouble me at all. But he knows the values of it, and it's something once
upon a time he would have liked. But he showed more interest in my photographs.

.

The show was still up at Moana Nursery when Walton made a trip to Riding Rock on San Salvador in the Bahamas with the Kafourys (Vivian was working), purposely for Walton to explore "the shape of space underwater" (plate 27). In February, 1977 they went to the Virgin Islands, in November to Tahiti and Bora Bora, then the Virgin Islands again in 1978, Tahiti again in 1979, and finally Bonaire off the coast of Venezuela and Hawaii again in 1981.

Walton's fresh direction of underwater vision was really the renewal of an old preoccupation: visual perspective in the air. How he saw underwater confirmed the innovative theorizing about perspective which he had been pursuing off and on for more than half his life.

Questions found answers

I was at Riding Rock to resolve the mystery of our vision's shape: would it have meaning for artists coming up, especially for students pushed into lineal perspective – its false lines and mythic vanishing point. I never believed in the system, Leonardo notwithstanding. How do we see? What is the shape of our vision? Coming in from this first Riding Rock swim, questions found answers.

Here, we see the effects in the waters of the lagoon exactly the same as I had imagined it, and painted it, and had never seen it, and didn't know it existed in the sea. An answer for new painters shouts from this lagoon.

Walton floated on the surface looking down through goggles, prevented from diving by a ruptured eardrum.

It speaks to his dedication that Walton was not at all comfortable in the water. In *Pyramid*, Pandora invites Kane to swim. He declines, saying, "You know how I am" about entering the water. Vivian recounted how she'd rescued him "clinging like a frog to a buoy" off Moorea Island near Tahiti after he panicked because his snorkeling mask had filled with water and he forgot how to clear it. She escorted him back to the catamaran.

In one mood he expressed himself modestly on the topic of his research: "It's a product of my imaginings, and findings. And it satisfies some far-out need of mine. Now it doesn't mean that this is so damned advanced that it's the only thing in the world. But it is a different point of view that I have husbanded through long years."

He taped that in the mid-1970s, but thereafter he was in full cry, and remained so. He wrote about it to his sister in 1982.

Leonardo and Einstein

[I have given] my attention to the life and works of Leonardo the Renaissance Man – whom in a way I have tried to emulate but little suspecting that I would find him in error on lineal perspective. This is the first real breakthrough since the time of Leonardo on perspective. My enclosed paper ["Elliptical Perspective"]

gives in prose what Einstein did not give in his book "Relativity." The shape of vision didn't concern him. It, however, has been my life's obsession.

·

In *Harry*, his final novel, Walton evaluated his "breakthrough" thus: "Exploring the ridge, he uncovered a vein and struck it rich when he saw gold we all had missed." Einstein "would agree with me were he here," he believe to the end. "And what a chat we would have if Leonardo could join with us."

It began in Verdi in 1938, in the chicken shed converted to a studio/bedroom on his sister and brother-in-law's ranch. He was reading Ouspensky's *Tertium Organum*, and some conjunction of that esoteric canon with "meditations on the reflections of the moon" in the multiple panes of the "chicken window sparked my young mind, and I began to apply, not the theories, but that type of reasoning to other matters, principally vision, and the shape of things." Those ruminations produced *The Mark of Man*, for which he unsuccessfully sought a publisher during his venture to New York in 1946. The taped remnants of the book, his first, present incomplete ideas in a gratuitously arcane style under Ouspensky's influence, yet seem to contain the seeds of Walton's later thinking. It was the single most consistent aspect of his style, through all its permutations. In 1962 he wrote to Vivian about it, when he was experimenting with the stamp-on technique during his Hollywood years.

Proportions in space, new ways

I could hardly sleep last night, thinking of proportions in space, new ways. I got up once, painted some – back to bed and up at six, painting. Some gains in the work – not nearly as easy as I saw them in my mind. Oh, how they worked. It will take me years, of course – then one day I'll just be doing it – will have done a body of it. One day, one day..............

I've been thinking a good deal about the clarity of one's point of view in space. The order is clear. The round is always in the arm's reach sector of foreground. Anything behind it I treat flat. Then I use a sweeping broken basketlike mottled paint – little squares – to make the light traverse. These squares are always dry brushed over later.

·

Walton had a longstanding argument with the linear perspective of Alberti and da Vinci as practiced in Western painting since the Renaissance. The thoroughness of his effort to reform the prevailing theory from its foundations is evidenced by his emulation of Michael William Harnett for study purposes. His aim was to achieve with abstraction what the nineteenth century hyperrealist did rendering objects which rise off the flat plane of the canvas: "Walton says the lack of perspective is of great interest to him," states the program of his 1950 de Young show. "He feels the paintings should come out of the picture plane toward the viewer rather than recede" (plate 18). As he pursued these investigations during the 1950s he

sought the guidance of Walton Boy Loring Chapman, psychiatrist and behavioral biologist. Chapman had authored a book titled *The Eye*, on the subject of forensic ophthalmology. Walton asked for books on "the shape of vision – not the eye. I don't care about the eye, I mean the dimension, the graphic shape of what we see." Chapman replied "that I was on my own, and that these were original investigations, as far as he knew."

Then he learned something around which his theorizing crystalized.

The Z-Axis

Now on one of my tours to Southern California, when I was a houseguest of Sam Kafoury, I asked Sam – who was an engineer at Douglas aircraft – I said, "Sam, what do they use in the symbology of mechanical drawing – what do they use as symbol of the line forward, without perspective but directly from your nose to my nose as we look at each other: that line, a point. He said it was [symbolized] as a little diagonal line to one side. And I said, "What is that called?" He says, "That's the Z-Axis."

Now that's the first I heard of the Z-Axis. But I have always been sensitive to that dimension, rather than the dimension of diminishing volume [linear perspective]. I have used the Z-Axis from the beginning intuitively. I was never attracted to the perspective dimensions at all.

•

Walton explained his theories on perspective in two novels (*Beyond Holland House, Harry*) and a long story ("Hurricane Alley"), all autobiographical; in a scholarly article ("Elliptical Perspective and the Z-Axis") and three expositions ("Elliptical Perspective," "Elliptical Perspective, and Painting the Z-Axis," and "Elements of Vision and the Z-Axis"); in an exhibition catalog ("Las Vegas Act III") and associated interviews for press and television; and in letters and on numerous tapes. And he prepared several sets of explanatory diagrams (figures 28–30).

To convey the gist of Walton's argument, here are quotes from "Elliptical Perspective," preceded by abstracts of each point as I understand it.

Elliptical Perspective

We live in a 4-dimensional (space plus time) not a 3-dimensional world. The key to Elliptical perspective is a re-evaluation of attitudes toward the 4th dimension. This is to accept that our everyday vision – the seeing we have known all out lives – has not been in a limited world of 3D but in one of 4D.

3D, straight-line perspective presents the world as a box, a dead world. [The 3 dimensions of linear perspective] indicate the basic planes, or directions, of a given box. The old straight-line system presents the box at rest, a static image seen by an unmoving viewer. All factors are considered at rest, or unmoving. Unfortunately, this describes a dead-world seen by bloodless people with neither pulse nor mobility. We could call it "World Zero." Its people are rigid corpses and its landscape is dead.

Figure 28. Elliptical perspective, one of many diagrams, 1980

Figure 29. Elliptical perspective, one of many diagrams, 1980

Figure 30. Elliptical perspective, one of many diagrams, 1980

No creature has eyes that blink, there are no shifting glances, no in and out focus capacity. Our description is of an impossibly incomplete world shown in 3D, not a natural world in 4D with Time essential.

What we actually see is elliptical, like the inside of an eggshell, curved not straight. Do not walls, floors and ceilings bend in our illusion as they wrap around us? We can turn our heads to follow the optically bent ceiling although it was built geometrically flat. Combining the visual-curve-complex and the values of the tonal cone our visual field in a single unmoving direction suggests half an [elliptical] eggshell.

The 2D Z-Axis, not the convergence of straight lines like the railroad tracks, is the basis for full dimensional awareness. We see light years away and we then know the vanishing point is bogus. Better said, the disappearing end of the visual "egg" never comes to a point but is softly lost in the transformation of 3D to 2D, the 2D field associated with distance and sky. It is truncated. The misleading term "vanishing point" is but the imagined dot of the ongoing line of sight – this is also the Z-Axis. It is central within the cone of vision. The Z-Axis defies gravity as do other properties of thought. Its direction is sovereign and unwarped. It is not subject to perspective distortion. It is sensed rather than seen. The Z-Axis is that lively direction observed in the outer sky as celestial volume.

The 4ᵗʰ dimension, time, binds what is in front of and what behind us along the Z-Axis in a fully projected surround. With the viewer combining two opposite scenes, back to back in time, and using a common Z-Axis, a complete 360 degree visual field is achieved. This is the "One World" of human orientation and Time is its binder. Eyes are busy, right and left, in and out, and we focus and re-focus in a battery of shallow fields. Time is the bedrock of vision. The ongoing direction of the Z-Axis is both fore and aft. The visual plane cuts the "egg" in two equal parts at the apex (the widest point). Time binds the two parts together as the "glue" of sight. The visual world becomes continuous through time. Without it life would be hopelessly stuck in dead space.

Elliptical perspective takes us beyond Leonardo da Vinci's linear perspective. Such considerations were not feasible in the day of Leonardo. The question lingers: why do so many of us still insist that the straight-line perspective system applies to the globe? Or to the visual field? Its limitations are in fact pre-Columbian. Its world is flat.

But Elliptical perspective does not make the linear system obsolete as a "rendering formula," rather it is a supplementary "means for making new judgments." No single system can fully describe the nuances and complexity of what we see. Straight lines and curved lines are but symbols. We don't really paint or photograph the complex reality of nature. We only produce symbols. The most dreary realism is highly inventive by this standard, and straight-line perspective is unchallenged as a useful tool. Elliptical perspective describes more fully the structure of the visual field and the function of Time. Still, it is not a rendering formula. It gives us a means for making new judgments, a way to broaden our function in the arts and sciences.

Elliptical perspective has a spiritual aspect. It tells us that we are dead center in a personal world thought of as "the egg of sight" whose distant reach makes us one with the celestial condition.

·

I pondered and repondered elliptical perspective without making head or tail of it, and wrote it off as Walton's crackpot theory. It made it no easier that he brought in relativity, a subject that I've read about and failed to grasp more than once, and non-Euclidean geometry, something I know virtually nothing about, except that Einstein used it. I can't say at what level Walton comprehended these difficult subjects. He read about them and painted in their spirit (plate 28), asserting that the "simple meanings" of Einstein's book *Relativity* seemed difficult only because English wasn't the genius's native language, while also confessing to being "a slob at math," and acknowledging the new geometries to be "subjects far past my capacity."

Then I took a new dive when it occurred to me that some of my befuddlement over elliptical perspective arose from a fuzziness – his, mine or both – about the distinction between perception and perspective; that is, between how we project a world around us and how artists render the world on a flat surface.

The crux of his theory of perception, or vision, is that "we move about on the planet like hermit crabs in a visual shell called three dimensions." The "limit to the third dimension" came to him underwater and was first consciously applied by him in underwater paintings: *Off Riding Rock* (plate 27) "represented 30 feet of water looking down at sand below. In its way the effect is entirely skipping the 3rd dimension. You see past the area of 3-D." It was this experience which he extrapolated to vision in the open air.

He located the "soft ending" of 3-D and the beginning of "2-D diffusion" variously at 100 feet and 475 yards. "3-D," he supposed, "gives the human a concise zone of depth originally designed for primitive mankind, most useful in self-protection" – in other words, useful for escape and accident-free movement. Which begs the question whether 3-D isn't more real. In any case, I don't see how Walton reconciled his theory with his own fond experiences of dimensional spaces larger than 475 yards. Thus he recounted watching an ocean vessel approach over the horizon : "I had seen the world as a true planet that day, about twenty years ago." And he estimated the vista from his Virginia City home to reach 200 miles east: "My location never failed my research into paintable space. At New York in 1946 I had said to Barnett Newman & Theodoros Stamos at Betty Parsons 57th St. Gallery, 'What can I paint in these asphalt canyons?'"

Whether or not one agrees with Walton's theory of perception, the limitation of his theory of perspective, even by his own lights, becomes apparent when he concedes that it is *not* a practical "rendering formula" capable of superceding linear perspective at all, but rather "a means for making new judgments, a way to broaden our function." In other words, a way to conceive and generate abstract art.

As to Walton's theory of perception, I resisted it viscerally, both the verbal explications and the diagrams in the archive (e.g., figures 28–30). I explained my resistance to myself on grounds of his abstruseness and his manner of waving off conventional psychology. Then, on rereading "Elliptical Perspective," I recognized the cause for my visceral reaction in a throwaway line, a thought isolated and unintegrated in Walton's advocacy of the Z-Axis. He said, "Associated dynamics are the spaces between forms." The spaces between forms. Obviously this was a secondary factor for Walton in how we project the world. In my experience it is primary.

See the tree. It is larger than you. See the cloud past the crown of the tree. See both at once, and you see the great space between. Now the cloud is huge. When you move, they move differently, and all the space around and beyond is immeasurable, yet palpable. Now the tallest tree and your body are of one magnitude. Even if your vision is poor, your body sees space.

One's body is the key "form," the essential coordinate in the projection of space, through proprioception, the body's awareness of its own volume and relations. And the body's self-awareness from all its senses is what rounds space out by enlivening the 4th dimension, time – the body does this, rather than the line of sight, the Z-Axis. Walton left the body out of it.

Walton used the adjective 'celestial' twice in "Elliptical Perspective," to speak of "celestial volume" and "the celestial condition" – the direct perception of the enormity of the universe, and the apperception of belonging to the universe. If he meant that the enormity brings the belonging, I couldn't agree more. That relation is more important and fundamental than any theory of the Z-Axis or proprioception.

Here I must invoke an old favorite *New Yorker* cartoon, showing two men in intellectual argumentation. Says one, "Your crackpot theory doesn't hold a candle to my crackpot theory." Although, to tell the truth, I'm more convinced of the rightness of my crackpot theory than the wrongness of his.

Walton told of carrying copies of his latest writing on the subject in his pocket to bestow on anyone he struck up a conversation with who showed an interest. Heaven knows what they made of his theories. Some of his friends and acquaintances took them on board. One was Jim Hulse, who wrote appreciative program notes for the 1982 exhibition "Las Vegas Act III": "Restless with the tradition in painting that seeks to represent three-dimensional experience in a two-dimensional medium," Hulse wrote, "he wrestled with [the] non-Euclidian geometry of the German mathematician George Riemann and with the reasonings of modern physicists (the Lorentz Transformation) and rendered them in paint. The yearning to account in a two-dimensional format for the fourth dimension as well as the third provides a basic clue to his work. In several of the paintings that flow from darkness into light (or is it the opposite direction?), we are invited to contemplate the space behind us which we can never see unless we turn, whereupon we create another void at our back." Hulse repeated his analysis, which benefitted from Walton's own explanations, in the *Nevada Historical Society Quarterly* in 1990.

Another Walton Boy and academic, Loring Chapman, told Walton (said Walton), "It's so simple when you look at it right."

More convincing is Walton's taped account of the reaction of another Walton friend, noted photographer Oliver Gagliani.

"I have composed that way always"

I was surprised by the appearance of Oliver Gagliani at the door. He brought with him his book of photos. And this book establishes Gagliani as a major artist of our times. We had a very pleasant interval, a conversation again, about a half hour. And Oliver Gagliani said, "Say, what was that you were telling me about perspective?" He said, the "point" and the "unperspective." I thought for a minute and – He said, "What was that word?" And I said, "Oh. Oh, you mean the Z-Axis." He said, "Yes, I never heard it before." I said, "Well now, I had never heard it either. "Well," he said, "you know, I was thinking about what you said, and I have composed that way always. I always think in those values." He wanted me to tell him more about it, and I went through my song and dance about my perspective findings.

∙

Other receptions of which there is a record were noncommittal or outright negative.

Jean Berghmans was a filmmaker from Lancaster, Pennsylvania whom Walton met on San Salvador Island in 1976. Walton told him he came there "to resolve the mystery of our vision's shape" and had done so "in a single swim." He explained himself, and concluded, "I'll play around with this in Virginia City." Back home he sent Berghmans one of his expositions. Berghmans responded evasively: "Your outline of Vision and the Z-Axis is extremely interesting and I will have to read this a few more times to absorb all this fully, thanks many times for sending it to me." There was no follow-up.

Dr. William and Anita Rowley (granddaughter of Comstock banker William Sharon) were old friends and collectors who had moved from Nevada to Upstate New York. Walton sent them the "Las Vegas III" program along with his latest exposition. Rowley answered diplomatically: "I must question that even with your super brain you can conceive the degree of happiness you created in our simple minds with Las Vegas Act III plus your heroic concept about the 4D." Then, "Your Elliptical Perspective is truly fascinating but far too erudite for my age."

Walton's artist friend Robert McChesney was not one to mince words.

Even my closest friends

Mac, I'm sure, doesn't see my dimensions. And some painters see it as a disunity, that I don't know what I'm doing, that the one form is out of gear with the other. But it is a conscientious approach. And in my hands it's a valid one. Because this is my form. And I've done it again and again. Yet even my closest friends are not very aware that anything has happened. And my painter friend, McChesney, is not alert to it. He sees it as a not coming off thing in his area. Well, God know it doesn't come off in his area, it has nothing to do with his area. And we never discuss theory at this depth. And I just let it pass, and someday somebody may dig what this is all about.

•

Walton unsuccessfully sought publication of his theorizing with a book proposal to a senior editor at McGraw-Hill, Ellen Pollar. It was "Dr. Loring F. Chapman" who steered him to her, he began by saying. Pollar may or may not have heard of Chapman. The title was to have been either *Art and Vision* or *The Shape of Space: Visual Perception and the Artist*. That was in 1980. Parts of a typescript survive.

In 1981, Walton submitted a lengthy article on elliptical perspective to *Leonardo*, a journal at the intersection of art, technology and science. The idea to write up his theories for *Leonardo* originated with Ward Jackson at the Guggenheim Museum in New York. Walton had come East in 1979 with several objects, one being to seek Jackson's advice about where to take his art for recognition.

I turned from the West Coast

In despair, I turned from the West Coast, Nevada in particular, Reno especially – turned my back and came to New York, at great cost: this is costing all – well,

in the neighborhood of $1,500. And here I am, I go to the Guggenheim, and get in the basement, and Ward Jackson, and he goes through his huge ledger – and comes up with the University of Nevada! That's where I should go for an exhibit!

.

Jackson also advised Walton he might take his slides of underwater paintings to the aquarium on Coney Island. He gave it a try.

Water, but without fish

I entered the aquarium and asked to see the director, according to my instructions from my Guggenheim friend. And how wrong you can be. These people are running a very small aquarium. If they had enough money to buy a painting, they'd buy another beluga whale. I got the assistant director, and he was totally bewildered. They never had such a situation as an artist asking to make their acquaintance in passing. I showed him the paintings, and I could see the look on his face. Later I understood, because he saw into that water all day long, so to him, so what? Another body of water, but without fish. So it was a peculiar day, and it clarified the fact that my advisor in the basement of the Guggenheim is someplace screwy.

.

Screwy Ward Jackson's third piece of advice was for Walton to turn his theory about perspective into an article for *Leonardo*. Walton submitted "Elliptical Perspective and the Z-Axis" in 1981.

While waiting for *Leonardo*'s decision, Walton wrote a letter to J. T. Fraser of the International Society for the Study of Time. The purpose of the letter wasn't explicit, whether to enlist Fraser's support with *Leonardo* or to place an article in the society's own journal, *The Study of Time*, which Fraser edited, or something else. As was typical of Walton, he wandered inappropriately for the occasion between his aspirations as a theorist and the details of his biography.

Hypothesis in prose

Your name has been sent me from abroad by one who has seen my recently published [?] paper on Elliptical Perspective in which I present my hypothesis in prose as a painter who has assorted the values of the shape of human vision over a period of long years (almost 50), and I presently look forward to my 68th birthday this coming May 18, 1982.

.

Walton went on to cite Jim Hulse, a name surely strange to Fraser ("Dr. James Hulse put his reputation on the line as he believes in my case"). Then he apologized for his lack of academic preparation, only to claim revolutionary accomplishments. He even threw in a paragraph about something he and Einstein had in common, not realizing how any such comparison must sound to someone in the position of Fraser, whose response if any isn't in the archive.

The submission of "Elliptical Perspective and the Z-Axis" to *Leonardo* was followed by a year and a half of correspondence without a decision. Walton's final letter expressed his consternation upon discovering in the latest issue of *Leonardo* an article by a different author, Georges Coppel, "containing half my original material." This strong hint at the journal's complicity in plagiarism ignored the facts: Coppel had submitted his article before Walton did his, and Coppel used mathematics far beyond Walton's competence. Walton asked for the return of his manuscript and diagrams.

The world knows Walton as a painter if at all, I said at the beginning. Myself, it happens I knew Walton from his words before I ever saw his art, having delved into his archive for my book about Robert Caples. Here in this biography I hope to have given Walton the writer his due. Failure to receive recognition as an author was his greatest artistic frustration. As a visual artist he did achieve successes.

Walton's output in either medium was enough for a full career and more. Taking the two sides of him together, his output was prodigious. Poetry, short stories and stand-alone essays aside, Walton laid claim in 1974 to nineteen books, most of them already written. Eighteen have been mentioned (if I count *Pyramid*, *Pandora* and *A Pyramid Called Pandora* separately), and I can name six additional titles conceived or created after his reckoning of nineteen: *The Comstock* (a projected sequel to *Virginia City*), *The Walton Reader* and *The Compleat Reader* (both compilations), *Kermis* (about a trip to Europe with Vivian and her mother), *37 Poems* (selected poems), and a collection of essays, "the 20th century in a nutshell." Not a single one of his books was published.

Certain things that aren't painting

Well, that's the way it's been with me, I'm a man of near misses. Vivian said today, "It's a lot easier in the painting field than in the writing field, isn't it?" I said, "Well, it would appear so." I've done really well when I was in a position to hustle paintings. And when I'd get a mural, I did better. So it goes.

But I have this urge in my life to do certain things that aren't painting.

.

As to painting, his output was such that every five years or so he could afford to incinerate the accumulation of suboptimals in "cleansing fires." A purge in 1962 left him with 500 of worth in his possession, and 300 more out in collections, he estimated. By 1975 he figured he had burned thousands. "And I have a tight group

of perhaps a thousand prime examples remaining, of drawings, paintings, oil on paper, oil paintings, and things in various media."

Another token of his output is his range of styles. In 1988 he had an exhibition titled "Five Faces of Richard Guy Walton" at the Edward S. Curtis Gallery in San Anselmo north of San Francisco. His most recent substantial show had been "Las Vegas Act III" in 1982. There were two other small shows that year, followed by a lapse of six years. "Five Faces" and then a second show at Curtis in 1990 were to be his last major shows to feature current as well as older works. The number five may have covered the styles on view there, but greatly understates his range, the "dozens of periods that I've been into." And even dozens doesn't do him justice. He wrote on this subject to friends apropos the "Five Faces" show.

I made up a new style as I painted

I have seen painting as a matter of the need of the subject at hand. Method and style were never a problem for me, I mastered many styles and invented most of those I used. This confused the "dealers" who may even be ignorant of art. I never looked at a subject or an idea and thought, "Now what style should be used?" Hell, I made up a new style as I painted. Perhaps I'd have a run of stuff in that manner, and perhaps not; I bore myself easily."

.

"You do many kinds of paintings," says Pandora in *Pyramid*. "This is my mistake," Kane/Walton observes, mindful of the dealers his range of styles confused.

Walton connected with the Curtis Gallery as a walk-in, introducing himself to gallery owner Kirk A. Rudy with his slides, his stories, and his discourse ("He really knew his art"). The two shows together cost Rudy $10,000 to mount. Both failed, because critics from the San Francisco papers wouldn't come over the Golden Gate Bridge to review them. Why then a second show? Because during the first "a buddy of Walton's" came in and spent $3,500. Rudy couldn't call the name to mind. I guessed McChesney, and was right. Another instance of a friend supporting Walton, this one anonymously.

The remainder of Walton's exhibition history is as follows.

Also in 1990 he was one of "Eighteen Nevada Painters, 1860–1960," exhibited at the Nevada Historical Society, this in conjunction with an issue of their quarterly with short essays on each, among them Jim Hulse's on Walton.

In 1993 and 1994 came the three retrospectives at Reno's Nevada Museum of Art, earning him recognition at eighty as the "'Grand Old Man' of abstract art in Nevada." Having learned how self-promotion gained Walton the Curtis shows, it occurred to me to ask curator Howard DaLee Spencer how the idea for the retrospectives originated. At this remove he couldn't remember. "However," he added, "my guess is that somehow Walton got in contact with the Director, Richard Esparza."

Also in 1994 he exhibited twice in Carson City, a group show at the Nevada Capitol Art Museum and Gallery, and "Of Thee I Sing," a one-person show with

a political slant in the Nevada Legislature building. Five years passed, then in 1999 he had a two-person show, again in Carson City, in a nineteenth century landmark hotel. In 2000 several of his Virginia City photos hung at a gathering for the release of Mary Beth Hepp-Elam's book about local artists, *Mining the Treasures*. His final show, in 2004, was again in a Carson City landmark. Vivian can't recall who handled that show on behalf of Walton, who was by then severely demented and bedridden. It was a one-person show.

With the exception of getting "stopped cold" temporarily by the fiasco of the Davis show in 1969, Walton's self-confidence as an artist never flagged. "If the roof fell in at this moment," he said when introduced to McChesney, "it would set western painting back one hundred years." "Western" didn't signify regional: McChesney and he were "two of the country's best painters." Vivian holds her husband to be an international class artist with a regional reputation, an assessment no doubt mirroring Walton's own. "God knows I have every means at my command to do whatever I think of," he said, and he described himself as "one of the most versatile and smooth painters who ever practiced the craft." Among his acquaintances and teachers he acknowledged Jean Varda his superior in color and collage, Frederic Taubes in oil technique, Carl Beetz in knowledge of anatomy, and Robert Caples as a draftsman. But as technician and creator he, Walton, had the whole package.

There's no getting around his self-centeredness. "I'm always documenting," he said of his Reno novel, *You Wouldn't Believe It*. "I'm not as inverted [introverted] as some think me, because for one reason, I'm always thinking about the documentation of the world about me." Yes, but. I was telling Vivian about one of Walton's writings, it was about himself, I said, when she interjected, "His favorite subject." And his incessant talking on that subject. "I have a long memory and am talkative," he told a prospective biographer of Bernard Herrmann. "Any of my friends you meet will remember me as talking too much. [Norman] Corwin himself pleaded for a word. But I listen, too." And he did, although self-involvement often caused him to lose track of the other person. Vivian says he had "no tact." She gave the example of the day the couple who bred her Trakehner horse came to see how the animal was getting on. In the course of the visit Vivian left them in the house with Walton as she performed some chore outside. Returning, she saw the couple hurrying to their car, the woman in tears. Vivian asked Walton what had happened. He had only volunteered that since Vivian went regularly to the gym, she could advise the woman how to deal with her weight problem.

Vivian added that she had friends who wouldn't visit her in Virginia City because of Walton.

Walter Van Tilburg Clark had accused Walton of "public condescension and discourtesies." He attributed the brash overconfidence of Walton's manner to a lack of "real confidence and direction." Clark didn't like Walton, and was a judgmental person. Furthermore I don't fully accept his psychological interpretation; not all overconfidence is based on underlying insecurity. Still, Walton did say in *Pyramid*

that he could feel as he had when he was "the lost little boy left alone on Market Street with the San Francisco traffic and the mother gone." It may be telling that he used the same expression, lost little boy, about his friend Ted Garland, with his "lofty feigned superiority," and about the infamously superior Lucius Beebe – they too were "lost little boys."

One of the first things I learned about Walton as I got acquainted with him during my Caples project was that our mutual friend Caples had been corresponding with both of us as death approached. I liked Walton on first meeting because Caples liked him. Reading their letters – Caples' exquisite calligraphic originals, saved by Walton with retyped copies he made of his side of the exchange ("I'm always documenting") – I saw that with Walton Caples mostly bantered ideas and traded stories like the old chums they were, whereas with me, an admirer thirty years his junior, Caples kept up a more reserved persona but also exposed more of his inner life. Walton's reaction to Caples' death in 1979 won me: "My loss is so heavy that I feel simply heavy. The rains will come later." It further won me when I learned, from a letter to Zoray Andrus, Walton's droll opinion of Caples as a writer: Caples, he said, was "a major quantity in personal letters while, at the same time, his book scatters many toward the vomitorium" (a word he picked up from Hitchcock at Republic Studio when introduced by Herrmann). That's accurate. Caples was an epistolary genius, while his spiritual testament in the form of a long children's story makes tedious reading.

But then when I got around to studying Walton's archive for its own sake, I liked Walton less. I returned to the archive planning only to evaluate it as an omnibus local history source. Instead I became intrigued by his unusual personality, even if his egocentrism put me off. A gifted egocentrist repels and attracts. The standing joke that developed between me and Michael Maher, the librarian at the Historical Society, was obviously defensive. After each session of listening to Walton tapes, I would give Michael a comical synopsis of just how Walton went on about himself yet again.

Then in the course of writing this book I came back to liking Walton. I even grew fond of him, taking him as I could in doses of my own prescribing. Wordy, yes, but a great respecter of language. Egocentric, obviously, but with a capacity for love and friendship. Grandiose, but a "major quantity," as he might have said, a man of qualities and talents. I even warmed to his interminable theory of perspective, discovering that we shared a sense of space and time – shared the sense, not the theory.

His last formal effort to advance that theory was the article he submitted to *Leonardo*, pulled back in 1983. That same year Robert Debold, married and living in Japan, tried without success, as he had once before, to set up a show for Walton there. Also in 1983 Walton recorded the last tape of those he would gift to the Historical Society in 2000. He had mostly ceased recording narratives in 1977. "A change of procedure has been declared," he said. Vivian "loathes" the taping. She "tells me too

much time is spent with the recorder, that I'm wilful and bad company." There were then "300 some odd tapes" telling (and repeating) his "life story." For no declared reason the 1983 recording was added onto a tape from 1975. In 1983 he said, "Vivian and I were married in 1963, and the years between – those twenty years, twenty years it is, this is 1983 – have been very happy years, and very productive years."

Walton's gift to the Historical Society in 2000 included a daunting 180 tapes. After Vivian with my aid doubled his archive by transferring the bulk of what she retained in the way of tapes, papers and ephemera, there were well over 300 tapes total. By and large the added batch were not narrative tapes, apart from readings of novels and other autobiographical writings. But I could be wrong about that. Walton's labeling is often misleading, and there are many tapes and portions of tapes in both batches I haven't listened to. There's plenty left for another biographer, local historian or art historian to delve into. Call it unprofessional, my psyche drew a limit.

I expelled a single self-pitying laugh and tipped my imaginary hat to Walton when, in the media room of the Historical Society for my umpteenth session of listening and transcribing, he told me that "whoever's listening to this tape has certainly got more time than I have."

Among the batch of tapes added to the archive is a set of fourteen reel-to-reel tapes of Walton reading the whole of *Beyond Holland House*. Having read the manuscript, I didn't listen. The set is undated, but probably coincides with recordings he made of three other of his books in 1992. *Beyond Holland House* is the major product to evolve out of the whole taping enterprise that began in 1974 with the original goal of recording one year, then two years of audio notes for a novel initially called *Dear Vivian*, then *October Moon*. Even for someone who spent much of his adult life processing memories, *Beyond Holland House* is markedly retrospective. In 1981 he joked about it to artist Louis Siegriest: "Lou, I'm hot-wiring my coffin: I'm writing my memoirs." His tapes, he estimated, would yield 4,000 pages. Three years later he had selected 1,200 pages. By 1986 (figure 31) he wrote to various people that he had "just finished" a memoir of 600 pages, the length of *Beyond Holland House* (602 pages), "a ten year project." But he continued to edit. At last in 1988 he told Florence he had "entirely finished" his "celebration of life," then reassured his sister that he hadn't been "overly candid" about intimate matters, which is so. He added: "Loring Chapman believes the nearest writer to me would be Dylan Thomas but he was a sissy by comparison."

Figure 31. Walton in 1986

Strangely I find nothing to indicate that he ever submitted this principal late-life undertaking to a book publisher. He did write to the managing editor of the *San Francisco Examiner*, his former boss at *Nevada Highways and Parks*, Frank McCulloch, asking him to serialize the book, seeing as how the *Examiner* had once "had a great success" serializing Robert Laxalt's *Sweet Promised Land*. Walton did not stop there in comparing his memoir to Laxalt's, claiming to "extend" Laxalt's material, Basques in Nevada, with new material about the Santa Fe Hotel and the Etcheberry sheep camp. Well, in a way he did, though falling far short of Laxalt's universal classic of the immigrant experience in every important respect. Walton didn't let the enclosed sample chapter speak for itself, instead claiming to write "better than most admitted writers or your name isn't McCulloch, so I'm not shy about that."

McCulloch responded with a friendly letter letting Walton down charitably: "It was a delight to read your sentences again, but I see no way in the world the Examiner can accommodate such material. The reasons are complex" etc.

Among the books Walton taped in 1992 was *Harry*. The typescript he read from carries a copyright date of 1989, as do those of all Walton's major books. His spate of copyrighting in 1989 symbolically marked the actual end of his book writing, as if to say, "I'm done."

Harry emerged out of *The Walton Reader*, a compilation of poems, short stories and extracts. "This is *The Walton Reader*," his tape of it begins, "Chapter One:

Arrival," followed by something written almost fifty years earlier, the passage from *Pyramid* with which I started this book: "My life seems to have begun in some strange way when I came in on a train." On the hard copy of *The Walton Reader* he made the notation, "last edited 12–15–88." *Harry* came after, so *Harry* was written as well as copyrighted and recorded in 1989. It was Walton's last book.

The character Harry, a recurring alter-ego of Walton's during the 1980s, debuted in the story "Hurricane Alley," then developed into a fully fledged literary device in *Hey, Jesus*, Walton's rewrite of his 1951 novel *The Delta Queen*. In *Hey, Jesus*, Harry is a writer to whom the narrator had told the story of his early life for Harry to write up as a book which the narrator, an artist, would illustrate – writer and artist, Walton's two sides. As *Hey, Jesus* opens, Harry the writer has gone missing, may be dead, so the narrator and Harry's other friends search his belongings for clues to Harry's fate. In the process they uncover fragments of Harry's book about the narrator, who reports on their search at intervals as he introduces newly found fragments. These progress chronologically, and constitute a more concise version of the story of boyhood told in *The Delta Queen*. Yet "it wasn't easy to see these segments as a book," the narrator concedes, thereby disingenuously calling attention to the narrative frame by which Walton attempted to achieve formal cohesion, without quite succeeding. *Hey, Jesus* comes off stiffly.

Walton used much the same formal device of frame and fragments in *Harry*, only now the character Harry is the painter, as we learn in the narrator's clever preamble in which he laments that too many of the milestones in the painterly career of Harry were unhangable (unsaleable), naming a 1963 *Venus* with a graphic pubis down to the individual hairs, and his *Self Portrait* of Hitler (plate 10) – in short, Walton's own body of visual art. Harry wished these paintings to illustrate the book on which he and the narrator have agreed to cooperate – in this book Harry hasn't gone missing. He and the narrator are collaborating on this book you are reading, constructed by the narrator with running commentaries on Harry and the fragments of writing, which in this book are again Harry's. For this Harry is more than a painter, he is also an author, while the narrator is only commentator and "compiler of Harry's output" – a miscellany of Walton's other body of work, his writings, as in *The Walton Reader*. Harry is now both creative Waltons. Then who is the unnamed narrator? He is Walton taking an overview of his life.

So here is Walton recycling his writings yet again, but now with more of an introspective mindset.

A dark side

I said, "Harry, what makes you think you know so much about people you've never seen? Just because you have a flair for writing doesn't give you the right to invade *my* privacy, or the privacy of those I have spoken of in confidence. Conversation at times is a sacred trust, and your dim theory of grist to the mill doesn't go with me. Back off, Harry!"

But I might as well have been pouring water in the sand. In a week he came by with a Xerox copy of his latest adventure into prose. There's a dark side to the man, and in the depths of his particular gloom, he put together a macabre fantasy that I hope will never see the light of day. What does a person do when he finds himself trapped like this?

•

Which of them was trapped, the narrator or Harry? One way or another, Walton was saying that he, Walton, was trapped.

The fact that Walton felt trapped in himself is epitomized by one of *Harry's* fragments, "The Whitely Report," a late sci-fi short story or narrative poem of several pages. Walton preserved it as typescript and tape in six iterations. It begins:

"My name is George Whitely. I first fell in love at sixteen. My mother was a seamstress, and my father left us when I was twelve. I like chocolate cream pie the way mother made it, three inches high. No, that's wrong. All settings should advance. Switch over to Dream 6, if you must."

It continues in this vein, with Whitely repeatedly attempting to retrieve the whole of a memory of early love, then issuing instructions to improve the process:

"My name is George Whitely. I first fell in love at sixteen. Her name was Paula, and poppies were in bloom, and we turned off the highway and had gone down a dirt road and turned off again. I stopped the roadster in hub-high grass. No, you can't schedule me, I must do it this way."

The poppies must be California poppies, and Whitely's memory be based on a Walton teenage romance in Stockton. The story continues, "My name is George Whitely," through ten tries to bring up the entire memory, first becoming longer, but getting interference from different memories, then tapering shorter, as his futile instructions fade to nothing. Then comes the explanation.

He had given his brain

"Be on call for this afternoon, Marjorie," Dr. Stanton said to his assistant at the console, then turned to a man in a sports jacket. He had been monitoring the equipment of a large glass case where a human brain was kept living. It was connected to Stanton's console, in an arrangement developed in the experiment the press had named Simeon 3, the work of the late Dr. Whitely, former chief of Behavioral Biology at Colorado Control. The scientist had given his brain as a last contribution to Project Brain Bank.

•

A wired brain in a jar. I want to give Walton credit for being conscious of the image, the story, as a projection of himself late in life, as ever attempting after decades to capture himself as an instance of a human life in words. And therefore conscious that his efforts had come to the end of their vitality.

And yet, if you read *Harry* as a written performance in Walton's visual style, as an abstract treatment of a figurative subject, namely himself, it may be his most

successful book, both psychologically and artistically. It was his last book, and I think he knew it, for he repurposed the aphorism he wrote after the debacle of the Letterism exhibition at Davis as its closing line:

"He pulled the alphabet over him and disappeared without a word."

It was once when explaining that altogether his tapes might amount to a book of 7,500 pages but that he envisions cutting it to about 1,000, that he was reminded of "Bob Caples' joke about the guy who got the big novel down to one word, and then finally threw that away."

Has it occurred to the reader of this book, the book in your hand, that the author, Shafton, stands in the same relationship to Walton as does the narrator of *Harry*? We are both compilers and commentators of Walton, his life and works.

Some time ago I sent Jim Hulse an update on my research, something about the copy of *The Sandwich Islands of Mark Twain* which Jim had donated to the University of Nevada, Reno library. He responded:

"If Walton is sitting out there in some other sphere – an afterlife version of his retreat in Virginia City – he is grinning in triumph and saying 'I told you so!' He was convinced that the crude generation into which he was born and which had denied him the recognition he deserved would eventually be replaced by one, or someone, who would get the idea of what he was up to.

"You are the one he was waiting for and for whom all those papers and paintings were intended."

I was astonished and moved to receive this from a fine historian and former Walton Boy, this affirmation which sort of made me an honorary Walton Boy myself. But it crossed my mind that Jim didn't realize my treatment of Walton was far from uniformly positive. But of course he realized, we've talked about Walton enough. The question is, would Walton be pleased? Would he be satisfied to be remembered by the ironies of *Harry*?

I also wonder what Walton would say I've left out or underemphasized.

His appearance. He was about five feet ten, and stocky-muscular. "His polarity lies between the young and healthy and contemporary Marlon Brando," he said of himself, "and the Victorian Monty Woolley." He had "the wild-eyed" look of his mother's side which came from "the Cherokee influence, and even I have made folks nervous with the same organ." He was proud that he "had a beard when no one in Reno had one." When he went out he wore a Stetson. He cultivated his image. He was vain, but not hugely.

His films. Besides his few Hollywood assignments for others, Walton made sketches for *Cinnabar,* his own cartoon film about "a little cowboy who rode a tiny horse," and he wrote scenarios for two experimental short films, "4,280" and "The Gulls," both about the sorry state of the country. He treated film scenario as an art form of its own.

His cars. "I'm puzzled as to why you have no interest in Walton's construction of a sports car," queried Robert Debold, with good reason. Walton was a true American and true Renoite in his passion for automobiles. He had stories about Wilber's cars in Stockton, the Stutz of Robert Caples' uncle Ralph which in 1931 he parked and dusted as a sixteen year old attendant in the "Triple-A" (AAA) garage on Sierra Street in Reno before he had heard of Robert Caples, and the several vehicles he modified or built with Johnny Etcheberry. Walton held the American automobile to be "an art form cresting in the 1930s." But I'm just not into cars, I told Debold.

His dogs. He always had dogs, and loved them. There was Cuddly Puppy, who couldn't adapt to society and had to be put down, whom Walton likened to antisocial Biscaya. There was Sammy, who traveled with him to Hollywood and observed him build the house, a Black Labrador/German Shorthair mix, son of his female full Lab Dunkel. "Sammy thought I was crazy, and that he could take care of all things better than I could." Walton and Vivian had Corgis, Freddie the best loved, and Lady, a Collie mix. And there were others. It's just something I missed. I am into dogs. My Nammy was even a Black Labrador/German Shorthair mix like Sammy.

His smoking. He started at around twenty and quit at forty-eight the summer before marrying Vivian, never to resume.

His spirituality. There was the brush with Episcopalian Rev. Thomas, and AME Rev. Booker, and Bahá'í. But spirituality as such is something he rarely talked about except glancingly, as when for a reporter's benefit he identified the "good spook" on display at the de Young in 1950, and as in one courtship letter to Vivian: "The easel painting went well yesterday. Mystic values in atmospheres – a painting called The City of Kings." He pointed to the spiritual, but didn't articulate it.

During my meet-up with Walton's daughter Kendall Scott at Vivian's house in 2019, I put it to her that Walton's preoccupation with perspective had impeded his spirituality. We were standing in front of one of his late paintings. Kendall adamantly disagreed. Herself an artist, she sees the evidence of his spirituality in the very esthetic effects I was citing. I countered with his story about Biscaya and "Mexicali Rose, I love you" to illustrate how he walked up to the deeper meaning of things, only to back away. Kendall's sense of the spiritual and mine are quite different, but even so she influenced me, and now I see painting, above all elliptical perspective, as Walton's spiritual practice. There's this in *Harry*:

Stumbling into the divine

Regarding himself as a social realist, Harry stumbled into the divine like a barn boy pitching manure. When I put it that way, he countered, "Don't you forget it:

The birds of paradise find sustenance in the seeds of degradation." He didn't even leave us ways to say Bullshit!

Exploring the ridge, he uncovered a vein and struck it rich when he saw gold we all had missed.

.

I quoted that last line earlier, in connection with elliptical perspective.

His connection to nature. His few extended descriptions of nature, all connected with Pyramid Lake, tend toward over-inventiveness. In painting, elliptical perspective and therefore abstraction was a way of loving nature. I didn't know him ever to speak directly about "nature," until I came upon this advice he gave young Vivian.

Hold for nature

It is wise to hold for nature – nature gives more than we can imagine and in quantities unpredictable if we let it through. It is the most stupid and insistent quantity of the human mind – to block this flow from the world of nature. Once you understand it and know how to release yourself to it you gain the source of that army which supplies the strength of birds, the power of the sea and the might of the greatest mountains. Take this well, and not lightly – it is high time you listened to the rumble of depth.

.

This is conventional advice, or better said universal, yet powerfully expressed. It's not amiss to note that a few years after the three retrospective exhibitions he identified himself as a "Neo-Impressionist."

His Americanness. Cars came with that, and nature, and Nevada. Walton's American identity was pervasive and complicated. Among his very late paintings is *Call 1-800-1860* (plate 29), "a tribute to Abraham Lincoln as he might have appeared on TV." By 1992 he was "already deteriorating," says Vivian, but it doesn't show. *Call 1-800-1860* combines graphic skill, command of color, his old stamp-on effects (I'm not sure the squares are actually stamped on), elliptical perspective (deliberate suppression of depth), and a recurrent political theme, the sorry state of the American polity. The patriotism is implicit. His grandfather, fighting Jesse Foose, shook the hand of Lincoln in Washington. That was a foundation story of Walton's life, along with Wilber and the Golden Rule, Caples and Nevada's WPA, Marijo and the Basques, Jewish Bernard Herrmann and Hollywood. All this and more got folded into Walton's conscious Americanness.

This American experience

It will be noted that I'm aware that I'm a complicated quantity. And the more I consider the recordings, the clearer I see how complicated I am. It's not a matter of vanity, it's a matter of fact. I'm looking at these rather exotic paintings from my inner self, that I've painted over a period of decades. One up here's from 1947.

I see another, 1960s. Some the middle and late Sixties, and they're rather – I'm a different person! Than my origins. And the beginning man is a different quantity. I can't relate it to this. It's some kind of a dream, it involves – and the painting, reading for a dream, and I'm – This exotic thing on the wall here of this [inaudible] and – You know me now, you know me plenty. Somehow, it's not alive but it just is another side, a totally different side. I have these exotic tastes. Yet I'm a plain product of this American experience. And I can't shake it.

.

In 1991, conceivably while *Call 1-800-1860* was on the easel, Walton wrote wordy, overlong letters to the Smithsonian American Art Museum and the National Portrait Gallery proposing an exhibition about himself. He envisioned a juxtaposition of his family photos and memorabilia, his personal writings and other documents, and his paintings old and new – "An American Album" would capture a life, his life, unique yet exemplary of the American experience. As so often, he miscalculated his effect. The approach elicited polite refusals from both institutions.

His last style. In 1999 Walton contributed an artist's statement to Mary Beth Hepp-Elam's book about Comstock artists, where he said he was writing a collection of essays summing up "the twentieth century in a nutshell." When Hepp-Elam met with him at the house, she observed him making notes on other notes ostensibly for that collection. I assumed it existed only in the old man's imagination – until, after *A Nevada Life* was accepted for publication and already in proofs, Vivian emailed that she had come upon another batch of Walton's papers in the back of a closet. The thirty large manila envelopes she delivered held over 200 "essays" for *Dot-Com-Slash: The Twentieth Century in a Nutshell,* with five associated envelopes adding some sixty more. It totals up to yet another book of and about Walton, a scattershot of memoirs, diaries, reflections on society, political news and commentary, and developments of his theories of vision and perspective. *Harry* wasn't his last book after all.

Scattered among these handwritten pages were dozens of new details about his life, quite a surprise considering how many times he'd gone over the same ground. A bigger surprise requires a major correction: I had not understood that Walton's theories of vision and perspective culminated in a late style of painting.

Walton's thinking on elliptical perspective had coalesced out of underwater vision and been applied in paintings of that realm. These developments led him to cosmic speculations – *"the undersea of outer space."* In *Dot-Com-Slash,* he maintained not only that "3-D dissolves into 2-D" at relatively short range, and that Leonardo's vanishing point has no basis in experience ("that is not how human beings see"). Now he went further to assert what had been hinted, that seeing in 2-D on the line of sight gives us visual access to outer space and to infinity: "The 2 dimensional field is infinite in space. The 2 dimensional field is the tapestry of time and the bosom of the universe. It is seen in the direction before us, the direction known as the Z-Axis." The Z-Axis is our best approach to ultimate reality:

"While vision dies, where and when the human dies, a basic 2-D remains in place with an ongoing value clearly eternal."

Late in life Walton verbalized the connectedness of art, nature and spirituality which had previously been implicit: "It is my understanding that Buddhists believe in *creation* (Dalai Lama) but not a *creator*. As a documenter of humanity and nature, as well, I have an unshaken belief in outer space which can be called *creation*. And what piety goes with it! Is such a believer an atheist?" Then lined out: "I think not."

His "last painting" was a "space painting." *Before Eden* (1997) portrays "particles in space unifying into a final garden. You almost see the coming together of natural plants in early space where God was lonely. My science friend, Chapman, likes to use its second title, 'God's Dandruff.'" Walton, who by then had no illusions as to his physical decline, where art was concerned had less humility than ever: "I suggest that new painters of the coming century take a hard look at this painting and carry-on from there as indicated. Good luck!"

In following months, as he neared the end of his capacities, the space painting which preoccupied him wasn't this last one but one of his first. *Red Star* (1984) is a large canvas showing a splash of red against a blue-black background shaded from light to deepest dark, embedded with small rectangles symbolizing celestial bodies. What engaged Walton about *Red Star* was the realization that he "had painted something bigger than the current thought when painted." The something bigger was an apprehension of change on the cosmic scale. The star seems "stable, or unmoving, in a set frame of space. [But] if you see *Red Star* as I do now, it will be gone in a moment for it is ablaze in brief 'time'. [Black space will remain.]"

His meditations on *Red Star*, which he kept for contemplation on an easel, grew delusional as he declined further. In February of 1999, he connected *Red Star* to "the astrological prediction of the world of '*earth*' ending at 2012." How not see this as a projection of his own death or dementia? In June, the once "stable" star had become "an asteroid on its way through earth's atmosphere where our planet will be struck in five seconds." This from the third to last entry for *Dot-Com-Slash*.

One of Walton's last quasi-technical reflections was to extrapolate from the fallacy of the vanishing point that when the universe contracts it must reexpand before ever reaching a "point" (the singularity). As he lost his grip on his theorizing, its latent psychospiritual aspect became exaggerated. Earlier I said he could point to the spiritual but didn't articulate it. Now he did. Some of the undated notes associated with *Dot-Com-Slash* have a kind of esoteric plausibility. The Z-Axis is advanced as a spiritual practice: "In this way we are one within the greater one – where outer space is conceived as a straight line and time as an infinite point; One." That pronouncement is at least coherent. Not so what seems to be the principle of the One rendered as a table (or is "I" not the Roman numeral but the pronoun, or is it both?).

I

$$1 + 15 + 85 + 1000 + 3 \qquad = I$$
$$50 + 95 + 555 + 8 \qquad = I$$
$$105 + 15 + 300{,}000 \qquad = I$$
$$\bigcirc + .01 + \cdot + \boxdot \qquad = I$$
$$\square + \blacksquare + \bigcirc + \bullet \qquad = I$$
$$- + - + - + - \qquad = I$$
$$| + | + | + | \qquad = I$$
$$x + x + x + x \qquad = I$$
$$+ + + + + + + \qquad = I$$
$$+ + \bigcirc + \bullet + \cdot \qquad = I$$
$$\text{Total} \quad I$$

Toward the end Walton's speculations floated up and away like balloons into realms of specious clarity.

Last but not least of what I've left out or underemphasized, *his friendships*. I have talked about his friends, Robert Caples, Bennie Herrmann, Eddie Star, and of course the Boys, Loring Chapman, Jim Hulse, Bob Debold and the rest. Other friends have been glimpsed, Lyle Hardin, Zoray Andrus, Joanne de Longchamps, Norman Corwin, Laurie Mascott, "Mac" McChesney, his wife Mary Fuller, Rae Steinheimer, Ted Garland and others. I could name dozens more who have merely been sighted at a distance or not even that, the likes of Bea Brooks and her children, Phyllis Walsh, Homer Smith, Florindo Nanini, Father Jellefe, Irene and Harry Bruce. It's the paradox of this extremely egocentric man – which is to say it strikes me, being the person I am, as paradoxical – that he had such an appetite and capacity for friendship.

He could be quite judgmental even of friends he held in affection, especially when it came to what he deemed their compromises to achieve worldly success, seeing by contrast purity in the conduct accounting for his failures where others might see eccentricity if not envy. He said so to their faces. Chapman and Hulse came in for this, even Herrmann mildly. Although not to Caples' face, he also judged this esteemed friend, whom by one account he followed behind "like a little Pekinese." Debold, who never met Caples, remembers Walton referring to him "from time to time, always in a negative manner that I regarded as jealousy." Walton the author of unpublished books resented Caples doubly for self-publishing with the funds of his millionaire wife. Yet "my loss is so heavy," he said when

Caples died, this man who had "marked [his] life as much as any person on this earth." Yet he could say soon after, "When old RCC passed the holy Laser, he'd soon cultivate the upper class of heaven." Swings like that between high regard and disparagement are a Walton characteristic, and not only where resentment or envy or paranoia were in play. When I first encountered the pattern I put it down to splitting or compartmentalization. Later I decided that I was oversimplifying, that his apparent inconsistencies came down more often than not to seeing people in the round – came down to acceptance. The way he accepted his brothers-in-law Johnny and Paul Etcheberry "at their declared level."

How did others view him? Vivian's friends may have avoided him, but the traffic of friends who made the drive up the Geiger Grade to visit in the months without snow is striking. "Richard cooked a lot of spaghetti in the summer," Vivian confirmed.

He was "a character." That's the word acquaintances use to sum him up. If friends don't utter the word, it comes across in the half-smile, half-frown they wear as they talk about him, expressing fondness mixed with ridicule, admiration with compassion. I'm thinking of Walton Boys Jim Hulse and Sam Kafoury and their wives. Also Bob Debold, whose attitude I know from emails. They all admired him for his talent and ever-present drive, his vivid presence, against their impatience with his inflated ego and exhaustion from his intensity. They're uncomfortable having been so much under his sway, almost as if they had been duped, but really they had been impressed. When he wrote *Harry*, Walton admitted he was this character, if he didn't know it already.

Insidious but not inane

He was one of those characters who slips into your life by social osmosis. Semi-permeable he was, and the treacle in his aspirations glued you down before you realized it. At times I felt like a fly being consumed by a strange meat-eating plant. Harry was more than awful, he was insidious. But not inane. And if you listened to him at all when he arrived at your door, the first thing you knew, Harry had got inside your privacy again, and without facing your plight, you found yourself chatting with Harry as though he was a true person and not an artistical writer.

Near everyone of us were fond of Harry, despite our suspicions.

•

In the end his friends liked him and indulged him, and they helped him, sensing helplessness in his self-importance. Even Eddie Star tried to help him by getting up a letter writing campaign to Nevada senators Paul Laxalt and Howard Cannon to have *Tom, Huck and the Dead Cat* made a postage stamp.

The trajectory of my own experience of Walton from a distance resembles that of his friends: I started by admiring him, then viewed him as something of a grotesque on account of his egocentric tapes and writings, then gradually grew to see him in the round. In spite of all, Walton had the saving grace of a large social appetite, with genuine warmth and respect for people.

He wasn't for everyone. Vivian once said to me, "I spent so many years shielding his feelings from those that didn't appreciate him that I get lost." She herself evinces some of the same ambivalence as the friends who stuck by him, to which add a spouse's love and devotion, and resentment.

I can't close without recognizing Vivian as an invaluable informant. Vivian is reserved. At first it was disappointing and eerie, hearing her reprise the same repertoire of Walton stories I already knew from the Walton archive. Happily that changed as we became familiar with each other and she saw what I was after. She has Walton's slides of his art and possessed a mass of materials which it became our mutual task to prepare for another gift to the archive, occasioning exchanges which otherwise wouldn't have taken place. She generously gave me the Caples *Moby-Dick*. She engineered the introduction to Walton's daughter Kendall Scott. More than once she said, "You can ask me anything." I used that license, within the bounds of her reserve and mine.

Vivian's life could be the subject of a book. It would be a novel, to do justice to the nuances within her range. In Walton's book she plays a secondary role. In her novel she would be the primary character, a woman, in the shadow of someone else's self-importance, a man. We would watch her become autonomous, but not completely.

Vivian was a dealer for forty-three years. For twenty-five of those years she drove the same VW bug down the Geiger Grade and back up in all weathers. "She works all day down there at that casino," said Walton on tape, "and for God's sake, it's my humiliation, but that's chauvinism again. So I swallow my chauvinism, and accept the fact that she's got the steady job around here." As an afterthought to telling me Walton had a temper, Vivian disclosed that Walton was intensely jealous of her. I asked how he dealt with her working in casinos. "Since I was making the money he didn't want to go there." His jealousy waned with the years.

Her father the dependable Dugan Washburn died in 1977. To free up his estate there was a long conflict with shady lawyers and realtors. Vivian's mother Mary VanderHoeven died in 1980. They scattered her ashes in the same spot as Eddie Star's on the hill west of Sugarloaf, with taped gamelan music rather than Eddie singing the Coyote Song. Between the two inheritances Vivian didn't receive enough to leave the casinos, but she was able to afford riding lessons and her first horse. In 1982 they built a horse barn, then another. Vivian sent me a 1990 photo of Walton stiffly holding the rope to Flashdanz, one of her Trakehners. "He never normally got near them without a fence in between," it pleased her to inform me.

Even by his retrospectives in 1993–1994 he was "tottery," Vivian said. A younger friend who had moved to San Francisco wrote, "You always seem so vibrant – full of ideas. I am using you as my role model for being over 60 (or 70). I want to be half (at least) as alive as you when, in 35 or 40 years, I'm your age." Walton was eighty, and summer visits from friends were dropping off. "The last ten years he got a lot more difficult," Vivian said.

Hotline
I know
You don't like
My reading
What I've written
But you are
My last connection
With humanity

·

Whenever "Hotline" was composed, it describes how things stood then.

Walton wouldn't travel now, so Vivian vacationed in Hawaii with a friend every year 1994–96. By 1996 he was "barely functioning." Still, Vivian could make a horseback trip in Ireland in 1997. Walton has asked Sam Kafoury to spend time with him in case he dropped dead and left the animals unattended. "I have no friends left in Virginia City whom I would ask to check on me day-to-day. And I feel further unrelated to Nevada as my case goes on." Vivian horsebacked in Portugal in 1998. Then back to Hawaii the following three years. She needed breaks, and self-assertion.

In 1999, at the age of 84, he sent his "material" to the Museum of Modern Art, the Whitney, the Met, the National Museum, and the Tate in London, also "to Jim Hulse for his records on Nevada." Where his letters of self-promotion once ran on interminably, the identical cover letters to the curators of 20th century art at these institutions where he hoped to leave his tracks were almost telegraphic, ticking off the Federal Art Project, the Taubes seminar, the Tom Sawyers, his Hollywood sales and "undersea findings and outer space vision." *My name is George Whitely.*

Also in 1999 he created the trust leaving his unsold inventory of artworks to the Nevada Museum of Art.

On December 22, 2000 he signed his deed of gift to the Nevada Historical Society. He withheld diverse materials for fear he would lose the copyright, still imagining he would write a book. By then he was having falling spells, from which he would recover and be more or less himself again. His short-term memory was going.

During the pandemic of 2020, as the first draft of this book neared completion, Vivian emailed me a diary fragment from 2001 with the explanation that when she wrote it she had been at home for four months with injuries from being knocked off her feet by their Collie mix Lady.

"Half a day is all I can stand. Richard swears/yells/wails/forgets. I feel sorry for him yet when he screams epithets at me daily it just makes me want to cry. He was always periodically verbally abusive but now it is every three days instead of every three weeks. I feel physically ill at home – the animals are a comfort and a responsibility. Without them I don't know if I could make myself stay. This is not good for me mentally or physically. How sad."

In 2002 he had to be stitched up in the ER when he fell and struck his head on a

corner of the marble slab under the wood stove. He was diagnosed with ischemic strokes. After that he declined further into senile dementia. He watched CNN incessantly. Vivian was still going to her job in Reno. She hired in-home daycare to travel up from Reno because none was available in Virginia City. She tried putting him in a Reno nursing home, but after several months took him out. He was miserable there and the cost was beyond her budget.

By 2003 he had "totally lost his mind."

"That whole period was so horrendous I have put it out of my mind to maintain my sanity. Being a caregiver is Hell and no one who hasn't done it really has a concept of how bad it can be."

As Vivian was caring for Walton, she was also caring for an old friend, an associate from Harold's Club with lung cancer whose house was near the foot of the Geiger Grade. When that man died he left the house to Vivian, who soon after moved down there with Walton. 320 Union Street went on the market as a "cute 1,200 sq. ft. home" on a "one-of-a-kind property, was an artist's retreat." That was in 2003. She was still working. His dementia was now such that home care wouldn't have been feasible were he not totally bedridden. In Reno "it was more doable. The caregivers showed up. A couple of great people and a motley crew of others. R couldn't even remember if he had lunch or someone came but I could tell from whether things were moved or not in the kitchen and his room. He could talk slowly or scream literally if something was wrong but that was it. Sometimes he said he didn't want to live like this and why didn't I kill him? Of course that wasn't going to happen. So sad for someone to deteriorate to that point from a very amazing intelligent person who was a unique and unappreciated painter."

He died at home in 2005. There was no obituary. Vivian's lawyer recommended against it, on account of thieves who read the obits for opportunities to break into houses during funerals. But there was no funeral or public memorial. "Richard's ashes were scattered above Virginia City," Vivian answered when I inquired. Her friend Judy who lives in Six Mile Canyon and Judy's husband drove her up Ophir Hill in an ATV. "We scattered them in the wind looking out at the same view of his wonderful VC photo that was published in Art and Architecture."

Of their old home, she said, "The barns still look the same except the contractor tore out the horse doors and replaced them with garage doors. And tore up part of the fencing around the smaller barn. It makes me ill to drive by the place of shattered dreams so when I go to see my friend Judy I avoid it."

After Vivian retired in 2013, she began making fused glass jewelry to sell in support of local animal shelters. Her inclination is toward the three dimensional arts. During the marriage she got certified as a welder with a view to sculpting, and took other classes in pottery and silversmithing. The first time I visited her in the home below the Geiger Grade, she took me into her back garden to look at several Mary Fuller sculptures. The garden is a large expanse with irregular sections of flowers and bushes separated by winding paths, all of it recreating, she said, the

environs near her childhood home in Kenwood, California. "When I had a donkey I used to ride over to Kenwood Creek and tie her up in the grass. Wading in the creek and building dams was a magical time." Walton called up something about the place in *Beyond Holland House*, a memory from the days he and Vivian lived there when he was filming monkeys in pain for Loring Chapman after the Davis show. "We'd stroll to Kenwood Creek and she told me of playing there as a child."

On a train

My life seems to have begun in some strange way when I came in on a train, in the late Twenties, and looked out the window just above Verdi, when I picked up the feel of this country. It was in winter, and I will go to my Pyramid book and see what I have on that.

Now this book may not amount to anything more than a sentimental tract by a greenhorn writer. But the principal character says, at one point when asked:

"When I was a boy and came here, not to this place but to this country, I'd not yet started smoking. Sometimes I'm afraid that I am still on a train, and didn't stop and get off for all the years."

A sacred trust

As a boy I had no concept of art and it came to me in my teens that art was very important to mankind.

I see that in my way I have reconciled mankind's history and some of the case of earth's mysteries from fossils to elements of outer space and as a sideline have written more than I ever hoped. I can say that painting for me has been a sacred trust.

Credits

[Known or presumed titles of artworks are given in italics, descriptions in lieu of titles in regular font.]

I am grateful to the Nevada Historical Society for the use of numerous photos and drawings in the Richard Guy Walton Collection, MS/NC 732, as well as for permission to quote extensively from manuscripts, letters, tape recordings, catalogs and ephemera in that collection. I am further grateful to the Nevada Historical Society for permission to reproduce *Chinatown II*, a painting by Richard Guy Walton, gift of the artist.

I am grateful to Vivian Walton for permission to use her photo of *Chinatown II*, and for permission to reproduce the following artworks by Richard Guy Walton: *Abstraction*; *American Flat XXIII*; *Call 1-800-1860*; *Casino*; *Egg*; Figure (like the censored nude); *Hanoi No, Kleenex Si*; *Homage to George Riemann*; Lamb Marker (undated); Lamb Marker (1944); *Letterist*; *Malalo Ka Kai*; *Malefactors*; *Maze at Ithaka* or *Triptych II*; *Montara Inn*; *Nude "X"*; *Odysseus Rex*; *Off Riding Rock*; *Paleozoic II, "Trilobite"*; *Pax Americana II*; *Riverhouse*; *Self Portrait*; *The Bats*; *The Pink Pandora*; *Vine Torso*; *Virginia City II*.

I am grateful to the Smithsonian American Art Museum for permission to reproduce *Aunt Polly's Sid* and *Tom, Huck and the Dead Cat*, paintings by Richard Guy Walton, gifts of the artist.